MR. TECHNICOLOR

MR. TECHNICOLOR

by Dr. Herbert T. Kalmus
with Eleanore King Kalmus

MagicImage
FILMBOOKS

MR. TECHNICOLOR

FIRST EDITION

Published by MagicImage Filmbooks
740 S. 6th Avenue, Absecon, NJ 08201

Library of Congress Cataloging-in-Publication Data

Kalmus, Herbert T. (Herbert Thomas), 1881-1963
 Mr. Technicolor / Herbert Kalmus
 p. cm.
 1. Kalmus, Herbert T. (Herbert Thomas), 1881-1963.
 2. Cinematographers--United States--Biography. 3. Color
cinematography--History. 4. Color motion pictures--History.
 5. Technicolor, Inc.--History. I. Kalmus, Eleanor King,
1903-1990. II. Title.
 TR859.K34A3 1993
 778.5'3'092--dc20
 [B]
 90-61034
 CIP

editorial assistant: Christopher Mock
Printed in the U.S.A. by McNaughton & Gunn Lithographers
Typeset by Computer House, Absecon, NJ

DEDICATION

This book is dedicated to the memory of my beloved husband
Herbert Thomas Kalmus--history's "Mr. Technicolor"--
who began the manuscript, and to my dear family and friends,
who sustained and encouraged me to finish it.
To my agent, Morton Dorchin, my editor, Martha Moffett
and to William C. Spengemann, additional thanks
for bringing the book to life.

-Eleanore King Kalmus

TABLE OF CONTENTS

THE AUTHORS

HERBERT T. KALMUS (1881-1963), founder and president of Technicolor, Inc., was one of a group of scientists and engineers who invented a method of making color motion pictures which Kalmus named Technicolor. It proved to be so successful that "Technicolor" is often used as the generic name for any color motion picture. The process existed in four different versions after its first workable demonstration in 1915. As black and white films were still in their infancy at that time, it was necessary for Kalmus and his associates to master additional technical problems. Special cameras, photographic material, lighting, and projection equipment were created when needed and improved along with advances in the color process itself. Herbert Kalmus organized the scientists, technicians and engineers associated with him into a tightly knit group and directed the production and development of this remarkable invention. On another front, the motion picture industry had to be persuaded to try the new process. And all along there was the matter of raising funds and attracting investors; the work would take many years and an investment of millions. A major figure in Hollywood's golden years, Dr. Kalmus guided and controlled the course of Technicolor over four decades as he saw his dream of bringing full color to the motion picture screens of the world realized in such films as *Gone With the Wind*, *Snow White*, *The Wizard of Oz*, *Black Narcissus*, *My Fair Lady*, and hundreds more, films that cannot be imagined without the added dimension of color. This autobiography focuses on a lifetime of struggle and triumph in the creation of Technicolor.

ELEANORE KING KALMUS (1903-1990), an educator and journalist, met Dr. Kalmus in Los Angeles, where she wrote a syndicated column and taught women's workshops at the University of Southern California. Mrs. Kalmus formulated and taught the first class in behaviorism in a major university in the United States, and her popular books on self-improvement have been best-sellers. She has contributed additional material and guided the editing of this book.

A Personal Note

With her first byline at age 14 in her hometown Dickinson, North Dakota paper, Eleanore Brodie King Kalmus knew she was a writer. She later considered a singing career and left the University of North Dakota to study at the Conservatory of Music in Cincinnati. From there she decided to join her brother, Aloysius, in California.

Eleanore graduated from the University of Southern California with a Bachelor's degree in Education. She returned for her Master's and later turned her thesis, *Personal Presence*, into the textbook for classes and lectures on charm. Her work was the forerunner of what we know as behavior modification, though no one at that time knew the terminology.

Personal Presence was published, by Prentice Hall, followed by *Glorify Yourself*, which also was the title of Eleanore's daily column in the Los Angeles Examiner, later syndicated by King Features.

As a charm coach, Eleanore trained airline hostesses at USC, Samuel Goldwyn's stars at his studios, and several thousands of women throughout Southern California.

She was married and divorced, with two daughters, before she met Herbert Thomas Kalmus -- "The Doctor." She cut her daily column to a weekly and began a new career as partner to the charismatic professor. She ran two homes, traveled with him constantly, entertained his friends and associates, and perhaps most important, she always listened to him.

- Cammie King Conlon 1990

PUBLISHER'S PREFACE

It is with great privilege that we present to you the long-awaited autobiography of Dr. Herbert T. Kalmus.

Although few people have heard of him, he stands as one of the great figures of the Twentieth Century. As you will learn from reading this book, the invention of Technicolor had a worldwide impact far beyond the addition of color to the motion picture screen.

"Doctor", as he was called by his wife and friends, wrote his autobiography after his retirement in 1960. He completed the manuscript in 1963 and died on July 11th of that year at the age of 81.

I met Mrs. Eleanore Kalmus at her home in Claremont, California during the spring of 1990 when MagicImage agreed to publish the work. It was a privilege to meet such a great lady, and to spend a few hours reminiscing. In honor of the Doctor, a special room was set aside in her home in order to display photos, mementos, and the special "Oscar" presented for ". . . contributions in successfully bringing three-color feature production to the screen." Eleanore passed away on November 23, 1990 at the age of 87. Her daughter, Cammie King is one of the few surviving cast members of the great motion picture, *Gone with the Wind*, having played the part of Bonnie Blue Butler, the daughter of Rhett and Scarlett.

Hopefully, the next time you watch a Technicolor film, you'll think of Doctor Kalmus, the sacrifice, the genius and dedication that brought this wonder of modern technology onto the screeen.

Michael D. Stein, President
MagicImage Productions

PREFACE
By Martha Moffett

The Golden Age of Hollywood--the 1920s and 1930s--was full of "firsts"--the first full-length feature film, the first color motion picture, the first picture with sound. And the era was full of the names of giants--Samuel Goldwyn, Cecil B. DeMille, Louis B. Mayer. One name has not received the same attention as the others, partly because of his quiet, formal nature and partly because the process he brought into being and controlled through four decades overshadowed the man himself. He is Herbert Thomas Kalmus, "Mr. Technicolor."

A Bostonian and a graduate of MIT, Kalmus was one of a group of young scientists who offered their services to American industry in one of the very early attempts in this country to bring together in a systematic way industry and scientific research. It was 1906, the heyday of the Nickelodeon, and one of the first problems they were asked to apply themselves to was an adaptation of a movie projector. Seeing beyond the immediate question, Kalmus was quick to jump ahead: Why not do something original? Why not make a scientific contribution to the field? Why not put color on the screen?

In this book, Kalmus tells the story of his life, and the story of Technicolor. An account of one is an account of the other; Kalmus was to spend more than forty years bringing his process to the screen, to the delight of millions all over the world.

The technical steps in improving the process and making it commercially feasible are only a part of the story. Hollywood resisted color in the same way it resisted sound; it had to be persuaded. And before the process reached its full development, funds had to be raised--millions of dollars were needed to fund the research and development. This meant that investors had to be found and courted; directors had to be kept informed; stock-holders had to be reassured and pacified. Kalmus was not only a visionary scientist--he was a master at organizing and running a modern corporation.

Kalmus tells his story with the same energy and involvement that he brought to his career. This slice of American history is from

a viewpoint that has not been heard from before. Kalmus's account, as he goes from a great--but didactic--financier to a great--but unpredictable--producer, gives the reader a sense of immediacy and drama lacking in historical texts. The man's memory is phenomenal, whether he is remembering Douglas Fairbanks' ideas on the use of color or recalling the shared laughter, deep, boyish and total, as he and Walt Disney sat alone in his private projection room and watched Mickey Mouse cavort across the screen--in color. All the movers and shakers of early Hollywood move through his pages: Jock Whitney, Joseph Kennedy, Mary Pickford, Jack Warner, Alexander Korda, Al Jolson, and many more.

There is one painful area of his life that Dr. Kalmus omitted from his autobiography. This is the story of his marriage to Natalie Kalmus, a talented and difficult woman who contributed to the success of Technicolor, Inc., but who made his life a lonely wasteland, within the marriage and for years afterward. It would be a glaring omission, in telling the story of Technicolor, to ignore Natalie's contribution; therefore, Eleanore King Kalmus has filled in this hiatus with a compelling and sympathetic contribution.

After the years of struggle came the years of triumph: *Gone With the Wind*, *The Wizard of Oz*, *Ben-Hur*, *How the West Was Won*, *Black Narcissus*, and so many, many others. What would the history of films be without color? This is the story of the man who devoted his life to bringing color to the motion picture screen and whose brilliant contribution to mankind will continue to touch each of us for centuries to come.

MARTHA MOFFETT, writer and editor, was born in Alabama, worked in New York City, and now lives in Florida. She writes in a number of fields, including fiction, travel, and essays. She received writing fellowships at Yaddo and Columbia University, and a Florida Council on the Arts grant for short fiction. She is currently completing her fourth novel.

INTRODUCTION

On the evening of September 21, 1917, I marched to the platform at Aeolian Hall in New York City to explain the marvels of a new photographic process my associates and I had developed which I called Technicolor. It had long been my dream to put color on the screen--not just a tint or two, but full natural color. What we had accomplished was about to be revealed to the public. We hoped it would do no less than revolutionize the country's favorite form of entertainment--a hope naturally shared by our financial backers.

More than a lecture, I had a practical demonstration. I had the reel of the first feature film produced by Technicolor Process Number One, a process we had been working on since 1912 when Daniel Comstock, Burton Wescott and I first began to think about the possibility of projecting natural color on the motion picture screen. Like a motion picture, which results from the collaborative work of writer, director, actor, cinematographer, and so many, many more, Technicolor was not the result of one invention, one patent or one process. It was the result of progressive development, one step at a time. Indeed, it could never have been done in one step. Because it was still so early in the history of motion pictures, problems in many fields had to be solved. We had to invent and build new machines, new processes, new lights, new dyes, and new techniques as we went along. But now we had a camera that could photograph a scene registering both halves of the spectrum, the red and the green, simultaneously. When projected onto the screen in register, we found that we could achieve remarkably beautiful, lifelike pictures.

Because the motion picture industry was proving as reluctant to adopt color as it would be to give up silent pictures for sound, we had decided to raise the money to produce our own Technicolor feature film. That would give us a product we could lease to theaters to recoup our costs, but more importantly it would show the industry that we had a process that worked.

The script was developed from a story by Anthony J. Kelly. Actors Grace Darmond, Niles Welch and Herbert Fortier were hired to play the leads. We filmed on location in Jacksonville, Florida, chosen for its bright sunlight and exotic scenery. In fact,

1

I expected the last scene, a glorious sunset over water, to impress our audience and leave viewers with an indelible memory of living color.

Dan Comstock himself was on hand to run the projector, along with Eastman Weaver, who had been one of his brilliant students at MIT and was now his first assistant. While I did the talking, Dan was in charge of the prism, the thin adjustable wedge of glass that kept the two pictures in register. We had rehearsed it many times-- in our own projection rooms and for a group of friends at the Algonquin Club in Boston--and it had worked perfectly. In fact, we were justifiably proud of the process and of our first film, *The Gulf Between*, which was an improvement over the only other existing feature film, *The Glorious Adventure*, made in England by the Kinemacolor process. Both were additive processes--that is, red and green, two of the primary colors, were projected overlapping onto a screen, adding together to produce a realistic effect. Since Kinemacolor photographed the color components one after another, shooting alternate frames at double speed through a rotating red and green filter on black and white stock, and projected them in the same way, it was not unusual for a horse to appear to have two tails, one red and one green, or for color fringes to wash across the screen whenever there was rapid motion across the lens.

The Technicolor innovation, I explained to the audience, was in making two simultaneous exposures through a single lens, producing geometrically identical pictures--and no fringes.

When we first ran our print through a projector, two frames at a time, with one beam of light passing through a red filter and another beam of light passing though a green filter, and with the two components brought into register on the screen, we found we could achieve remarkably realistic effects.

We needed a stronger light for projecting color, so Dan had invented a horizontal magnetically controlled arc lamp that gave us one third more light than the existing vertical arcs which were used for black and white projection. Dan's lamp could also be relied upon for constancy of position, providing a light that was not only brighter but steadier.

Much depended on the key device we had patented for keeping the two frames in register--that thin prism, or wedge of glass, which could be rotated slightly, permitting the red or green picture

to be adjusted each relative to the other. When this was done just right, the picture on the screen was simply beautiful.

As I was explaining to the audience how fringes were impossible when two components were photographed simultaneously from the same point of view, something happened to the adjusting element in the projector. In spite of frantic efforts on the part of the projectionists--who as well as the evening's projectionists were after all two of our top scientists and technicians--the filter refused to adjust. We were displaying fringes wider than anybody had ever seen before.

It was a disaster.

Both the audience and the press were very kind, but Dan and I returned despondently to our hotel, where we attempted to say what we could to one another in the way of consolation. I wondered if we had created the problem ourselves when, before the show, we gave a little exhibition of the prism and how it worked. At any rate, it didn't work when we needed it and it meant everything.

I had to face one pressing problem. Technicolor was running out of money. We needed $100,000 to pay off the indebtedness the company had incurred in making *The Gulf Between* and a further sum to make prints and distribute the film to theaters.

To cover these costs, the directors of Technicolor Motion Picture Corporation met and decided to offer stock pro-rata to the stockholders of record which, if entirely taken, would provide the company with $96,000.

The stock was not taken.

In a little town 3,000 miles away called Hollywood, producers were arguing against the idea of color in vociferous tones. Color hurt the eyes, they said. Color detracted from the story. Too much light was required for color photography, actors would refuse to work under such intense light. Actors and actresses, for their part, were terrified of a new technology that might not flatter them, indeed, might end their careers. And everywhere we heard the complaint: "Color costs too much!"

But I was convinced that we should go ahead. Contracts were already made with theaters operated by Klaw & Erlanger in Buffalo, Syracuse, Rochester and Baltimore to show *The Gulf Between* for one week in each city. In order to do this it was necessary for the company to make expenditures amounting to $20,000, which

we managed to raise from our two main investors. The receipts from the theaters turned out to be disappointingly small, although the audiences were enthusiastic and pleased with the color and the reviews were, in general, complimentary. One reported, "The new process throws upon the screen a continual succession of pictures in natural colors that copies nature with the fidelity of a finely executed oil painting. Many of the landscapes and water scenes are. . . remarkable." What was clear to me was that *The Gulf Between* did not have the dramatic power or star performances to pull audiences into the theater, and color could not do the job alone.

The projector we had used at Aeolian Hall was transported around and used in the theaters of the Klaw & Erlanger chain, and we continued to have intermittent trouble with it although most of the time it operated satisfactorily.

I went up to Buffalo for the opening there, and it was another of those times when things went wrong on the screen. The film had to be put and kept in register from the projection booth, which is relatively far away from the screen. The necessity for special attachments on the projector required an operator who was a cross between a college professor and an acrobat. The pictures produced by our two-component additive process were very beautiful, but using two negative prints made special projectors necessary. This would always prevent the process from having wide commercial value. For general use, I decided, color motion pictures were going to have to employ standard projectors generally used in theaters and they were going to have to be capable of being operated by an ordinary projectionist. We must find a way to put color on positive film, and do away with special projectors.

For me, that night marked the end of our first experiment, Technicolor Process Number One, and the beginning of the next. It was a crucial point. But even this first disappointment didn't lessen our keenness to do this thing.

In 1912, when Daniel Comstock and I were physics instructors at the Massachusetts Institute of Technology,* we decided, with an immeasurable amount of youthful energy and ambition, to make ourselves available as consultants to the world of business and finance. All we needed was to find a partner of great mechani-

* Until 1916, MIT was known as Boston Tech, and was located on the Boston side of the Charles River.

cal genius to combine with our own theoretical and academic knowledge, and we found him in William Burton Wescott. That year Dan was 30, Westcott was 33, and I was 31. We called ourselves Kalmus, Comstock & Westcott, Inc., and our company represented one of the very early attempts in this country to bring together, in a systematic way, industry and scientific research.

That year William H. Coolidge, a colorful Boston lawyer and prominent financier of the Coolidge family of Boston and New England (which also produced Calvin Coolidge), invited us to his office. With his partner, C.A. Hight, he had put together the United Shoe Machinery Company, the American Zinc, Lead and Smelting Company, and the United States Smelting Company. He was known as a heavy plunger.

He commanded the respect--if not the awe--of the young men who sat in front of him. He had a ruddy complexion, a broad flat nose, piercing black eyes, and a long crop of snow-white hair. I was to become very familiar with his habit of rotating a well-chewed cigar around his tongue; the more agitated he became, the faster the cigar rotated.

Perhaps to counteract this awe, I deliberately introduced myself as Dr. Herbert Kalmus. "And may I present Dr. Daniel Comstock?"

"Doctor?" I had caused Mr. Coolidge to raise his eyebrows.

"Of physics."

"Physics?"

"We are Tech graduates in that department. Among the first. We received our Ph.D. degrees in Europe."

Unfazed, Coolidge said, "In that case, take a look at this." He showed us a diagram of a machine he said was a new kind of movie projector called a Vanoscope. Its inventors claimed that it would eliminate the irritating flutter in motion pictures-- "take the flicker out of the flickers," was the way Coolidge put it. He saw in it his own grand entrance into the motion picture business--in fact, he was willing to invest $1 million in the invention--but first he wanted someone to go to New York and examine its feasibility.

I was instantly engaged. Of course I was familiar with moving pictures. The first motion picture I ever saw was in a little store called a Nickelodeon on Hanover Street in Boston. There was a barker outside urging people to see *The Great Train Robbery* for

a nickel. When I went inside, I found myself in a small, dark cigar store with a muslin curtain mounted on one wall. The film itself didn't last more than ten minutes. That had been a few years earlier, maybe 1906; by 1912, Nickelodeons were common but the day of real motion picture theaters had still not arrived.

We traveled to New York to look at the Vanoscope and found the city seething with politics--Woodrow Wilson had just been nominated by the Democrats--but we didn't find the device a promising investment.

The next contact I had with Mr. Coolidge was after he had received our bill. "I don't mind paying you for your services as experts or for your time as scientists," he said, rolling his cigar, "but I'm damned if I'll pay for your telephone bills!"

He went on to complain about our organization. "My partner has been up to your laboratory to look over your set-up, and he says it's all Greek to him. There are plenty of machines here and there with wires running into the walls. But who knows whether these wires go anywhere after that?"

I was speechless.

But it was not the last time I heard from him. Several months later his voice came booming over the telephone. "Those damned Vanoscope people are pestering me again. They say they've made some improvements. What do you think?"

I found myself telling him exactly what I thought. "If you and your associates want to get into the motion picture business in a serious way, why not drop the Vanoscope, which at best can marginally improve black and white pictures. Instead of taking out a minor irritant, why not put something new in?"

"What are you suggesting?"

"Color," I replied. "Why don't we see if we can put color on the screen? After we looked at your Vanoscope, my associates and I became intrigued. . . we've been thinking about nothing but motion pictures. Comstock is already working on a new kind of camera. If you want to invest a large sum of money, why not do something big?"

I put this to him in a low key, but in fact Comstock and I were full of excitement. If ideas can intoxicate, we were drunk.

"Hmmmnn," he growled. "I'll send Hight over to see you."

"We have nothing to show," I cautioned. "Just some ideas on

the way it could be done. To put these ideas to a test will require money for research and experiments."

"Explain it to Hight. He's got a technical mind."

Hight descended upon us the next day, and it was soon apparent that Mr. Hight, although he was later to become one of our staunchest supporters, was not at all of a technical mind, although we did our best to demonstrate that the wires leading into the walls did indeed "go somewhere." Finally he asked his question.

"How much?"

"Even if we estimated the cost of producing a working sample, that would only be a start. . . and of course a successful application must necessarily be problematical."

"How much for a sample that works?"

"Ten thousand dollars."

"Whew! For a sample?"

"The most you could lose is what you put up; we'd make no further call on you without your consent."

"We'll be in touch."

From the moment Coolidge and Hight's financial support began, KC&W went to work to put color into motion pictures. In eighteen months the results of our research became so promising that applications for patents were already being drafted and filed.

Coolidge decided that a more formal understanding should be established between us and suggested a holding company which was formed in March, 1914, under the name The Scientific Development Company. He and his associates were to supply the new company with funds for research; KC&W were to do the work at cost; all patents, patent rights and other products of the research were to be owned by The Scientific Development Company, and its stock was to be divided equally between the Coolidge interests and KC&W. To maintain this equality, we agreed that each time the Coolidge group provided money to the Development Company they would take shares of its stock, and at the same time KC&W would take out the same number of shares.

From June 20, 1914, through the year 1915, we applied for nine patents** which made Technicolor Process Number One

possible. These were not basic patents--that is, they were not new scientific breakthroughs--but they represented engineering ability and know-how and gave us a start in pursuing the project. After all, the scientific principles of color had been known since Newton. What we had set out to do was to solve the practical problems.

And as 1915 turned into 1916, I began to feel that we might do it--contribute to American scientific achievement, revolutionize the motion picture industry and--put the rainbow on the screen.

By late 1916 we were already making test prints, developing them in a pilot laboratory set up in the basement of our Boston offices, and successfully projecting pictures on every available wall. And while my partners and the technical staff were busy with cameras, projectors and other apparatus, I was turning my mind toward the question of how to transform our process into a practical and commercial success.

I felt we needed to attract to our organization someone who could understand our laboratory operations, lend a practical touch to our scientific work and give us a first-hand feel of the motion picture industry.

C.F. Willat had spent his life building, designing and operating motion picture laboratories serving the eastern film establishment. He was acquainted with the officials of the Triangle Company, an active producer and distributor of black and white pictures, and was a close friend of Jules Brulator, whose exclusive agency for the sale of Eastman Kodak products was all-important to the industry. Willat's younger brother was a motion picture director at Paramount and had married Billie Dove, a popular young actress. Still, the idea of color was so intriguing and the challenge of what we were doing was so great that when I asked

** These patents were: William Burton Wescott, "Continuous Projector," June 20, 1914; William Burton Wescott, "Continuous Projector," October 9, 1914; William Burton Wescott, "Continuous Projector," November 10, 1914; Daniel F. Comstock, "Keystone Correction Device," June 21, 1915; Daniel F. Comstock, "Optical Grid Beam Splitter," October 5, 1915; Daniel F. Comstock, "Projection Arc Source," October 20, 1915; Daniel F. Comstock, "Projection of Two-Color Part Images," October 22, 1915; Daniel F. Comstock, "Double Non-Adjacent Images," October 22, 1915; Daniel F. Comstock, "Continuous Projector," December 1, 1915.

Willat to join our team, he did not hesitate to give up Willat Studios and Laboratory and the New York Motion Picture Corporation and join us.

We went south to do some test work in Florida's bright sunshine--indoor shooting was not yet possible. Our team included Willat, who gave close attention to the combination of laboratory and technical work being done; Professor E.J. Wall, who had worked with color photography at the University of Syracuse and was with us to check theory against any change we made in procedure; Dan Comstock, who was keeping an eye on his new camera; and J.A. Ball, who, along with Eastman Weaver, had been a promising student of Dan's at MIT. In Palm Beach, the day was not long enough to photograph all the things we wanted to see on screen; sailboats coming and going in different light, scenes of rich vegetation, sunsets, women in their bright costumes, moonlight on the water--everything imaginable that was full of color and life. And as fast as we printed them, we rushed to show them to our friends in Boston.

As soon as Coolidge saw the first of these scenes, he arranged to demonstrate them to his friends at the Algonquin Club. Their enthusiasm evidently matched his, for on November 18, 1915, he and Hight called me to their offices where they announced they were ready to undertake the production of a feature-length picture. I was jubilant as I listened to his decision.

He said to me, "The Scientific Development Company has served its purpose, but now we need something more. I'll have my attorney organize a company with broader powers and scope. We'll need a name for the company--something we can attach to the motion picture and its advertising and demonstration." Coolidge looked at me, but his circling cigar brought no inspiration. "Bring me a name in the morning," he told me.

Brooding over Mr. Coolidge's assignment, I made my way to my apartment at 1688 Beacon Street in Brookline. It was my nature, when charged with a specific responsibility, never to let it get out of mind before taking some action toward its accomplishment. I often told the men at the laboratory, "If you cannot do what is expected of you promptly, give reasons why it cannot be done. And if reasons cannot be given, give reasons why reasons cannot be given!" Now, trying to fulfill my responsibility to think

of a name for the new corporation--the right name--I looked around my room for inspiration.

At home, I could always find an hour for relaxation at the piano, which I had played since I was a boy. My music cabinet was well stocked with volumes of Beethoven and Mozart sonatas and collections from popular operas--Don Giovanni, Lohengrin, La Traviata, Faust, Aida, and Carmen. I struck a few notes, but the sound was soothing rather than stimulating.

I turned to my bookshelves. There were my companions of a lifetime, books that had traveled with me from Boston to Europe to Canada and back to Boston. The complete works of William Shakespeare, a copy of the "Golden Treasury of Songs and Lyrics," "The Otherwise Man" by Henry Van Dyke, Eddington's "Nature of the Physical World," the collected poems of James Stevens, "Seven Plays" by George Bernard Shaw, "Alice's Adventures in Wonderland" by Lewis Carroll, the works of Robert Service, "The Dark Hours" by Don Marquis, "Dream Days," a particular favorite, by Kenneth Graham, Masefield's "The Everlasting Mercy," The Confessions of Saint Augustine, "Orthodoxy and Heretics," by Gilbert Chesterton, the collected verse of Rudyard Kipling, and Emerson's "Essays." I had many books of a scientific and technical nature on my shelves, but these dozen or so books that were the heart of my library had given me the most pleasure.

A heavy volume with an ornate brown leather cover lay on the desk in front of the bookshelves. On the cover was the title "Technique 1904." It was the annual year book of the Massachusetts Institute of Technology of the year of my graduation. I found myself fingering the leaves of this book, reflecting on the life of a "Tech" man. We had passed through four years of vigorous technological study at MIT, and this embossed word, "Technique," stood for that life. The title, that name, the word "Technique," was impressive, was meaningful, was beautiful and smooth. The more I studied it, the more I pronounced the word to myself, the more fascinated I became with the combination of its significance to the mind and its agreeableness to the ear. I thumbed through the book, remembering.

It was now late afternoon, and I decided to take a walk and clear my mind. I still needed a name, a name for a company that would own, control and embrace all we had done so far in our

endeavor to put color into motion pictures as well as all we would attempt in the future. As I walked up Beacon Street toward the reservoir the word "technique" sank into my mind and into my emotions. It struck me as a perfect word in appearance and euphony, and its meaning was made to order for my purpose. "Technique" was exactly what all of us at Kalmus, Comstock & Wescott must possess to realize our dream--technique, method, details, procedure.

As I took my first turn around the reservoir, I suddenly added "color" to the word in my head. I pronounced it out loud over and over again, and I visualized it in print. I had it! I knew I had it! I simply changed the last three letters of "technique" into the first consonant of "color"--"TECHNICOLOR"--a beautiful name, a meaningful word, easy to remember, hard to forget, and possessing a full measure of significance for a company aiming to revolution- ize the motion-picture world.

I can see myself stepping off the elevator and eagerly entering Mr. Coolidge's office the next morning, a lanky New England chap, six feet, two inches tall, weighing 156 pounds. As I presented him with my brainchild, "Technicolor," I couldn't know that this name would come to be mine; that it would take me around the world; that it would absorb a half century of my lifetime and be my life's interest, my life's work--that it would BE my life; that I would live it 19 hours a day for 47 years; and that it would become one of the world's great trademarks.

Mr. Technicolor

CHAPTER ONE

My Early Years

One day late in the last century, my grandfather Thomas Gurney, a singer in Boston's Handel and Hayden Society, introduced the young pianist for that group, Benjamin Kalmus, to his daughter Ada. I have seen a gracefully composed letter from grandfather Gurney written in answer to my father's request for permission to marry Ada Isabella Gurney. I am told that she was beautiful. I can, in fact, remember watching my mother standing before a full-length mirror brushing her chestnut colored hair, which flowed over her shoulders and reached her knees.

I was born on November 9, 1881. Soon the young couple moved from Chelsea, my birthplace, to South Boston; I have often wondered why a young man of German Jewish descent and the daughter of English Episcopal parents chose to settle on Pacific Street in the midst of so many devout Irish Catholics. My parents were not religious, but my grandmother Gurney early taught me the Lord's Prayer--the Episcopalian form, ending with "for Thine is the Kingdom and the Power and the Glory forever and ever," which even now, memory leads me to repeat after the Catholic congregation has finished on the words "Deliver me from evil." My father, an intellectual man, had very little patience with grandmother's devout ways. He thought anything depending upon faith was nonsense.

Mama and Papa's life was formed around their shared interest in music, books and art. They went often to productions at the Shakespearean Theatre and dined in the best restaurants. I realize now that they were very happy together, and that perhaps the intensity of that relationship left me out. I can recall very few marks of affection or outward evidences of love bestowed upon me as a child. For example, one day Mama was making molasses peppermint candy. When the crucial moment came to add the essence of peppermint to the hot melted sugar, the volatile mixture

exploded and in my four-year-old opinion blew everything to smithereens. I remember the scene in great detail, but I don't remember being reassured and comforted the way I am accustomed to see my grandchildren loved and comforted by their mothers and by their grandmother Eleanore.

But I was a happy enough boy, playing with the Harty children next door, especially William, who was my age and more than willing to join me in raiding his mother's cherry tree and other neighborhood pranks. Later, I played baseball with the other boys, who waited impatiently for me to finish the last agonizing minutes of my daily hour of piano practice.

One day I managed to catch a ball in such a way as to slightly damage the little finger of my right hand. It was not a serious injury, but when my father saw me returning home nursing my hand his immediate thought was that baseball was a stupid way for a boy to spend his time. He possessed none of the spirit of the youth of America, much less the spirit of the boys of South Boston. He presented me with a choice: baseball or piano, and I promptly and perhaps unwisely chose baseball.

I was eight years old when father came to school one day and took me out of class. He led me by the hand to our house, several blocks away. Without a word of any kind he brought me into the room where my mother lay in her coffin. She had died of acute appendicitis. I am sure Papa was suffering terrible anguish, but he was unable to try to help a small boy cope with such a loss.

My father married again, dying three years later, when I was eleven, of Bright's disease. One of my last recollections is seeing him struggle, with his failing eyesight, to tell the time from a cuckoo clock which hung on the wall of his room.

I was given the choice of living with my grandmother, who was now living with her son, my uncle John, or with my stepmother's family in Dorchester. For reasons not in the least known or remembered by me I chose the latter--perhaps because there were children of my own age in the household. At any rate, it was another unwise decision, for the move took me out of the district of Boston Latin School, which meant that later I would not have the Latin requirements to enter Harvard.

I attended the English High School until I was sixteen, when my guardian summoned me to say that his sons had not gone to

college and he saw no reason why I should need to study further. He suggested that I go into town and find a job--or he would find one for me. I left the next morning, carrying a small paper suitcase filled with my few possessions, including a mug of continental silver that had come to me from my grand-parents in Germany as a gift when I was born, and which now sits in my living room. I always blamed a problem of poor circulation in my feet on that walk to Boston--in bitter cold weather, with holes in my shoes.

I found a job as office boy in the firm of John H. Pray & Sons on Washington Street. The Pray Company imported and sold Oriental rugs and other household products. The office manager encouraged me to improve my penmanship by imitating the writing of one of the bookkeepers; at the same time, I learned to do his job, and was soon promoted from keeping one book to another until I was doing most of the Custom House work--and at an age when I was not yet old enough to swear to certain of the firm's papers before a notary! It was then that I picked up the knack that has never left me of rapidly adding four-column figures--I can still do it to this day.

I increased my starting salary of $3 a week until I was earning $15; I was also playing the piano at the YMCA on Boylston Street for $5 a night and saving my money for college.

At 18, I took the entrance examinations for the Massachusetts Institute of Technology. My inclination lay in a classical direction; I would rather have been heading for Harvard University, perhaps to study law or medicine. As it was, I seemed to have very little to do with determining my future. And yet, looking back, some of those undirected steps eventually became of utmost importance to me.

I passed the examinations and was accepted at MIT. I had saved enough money to carry me through the first term and optimistically counted on scholarships and tutoring jobs to get me through the rest. But first. . . I would see the world.

With $10 in my pocket I set out to spend the summer bicycling through Europe. I wanted to see as much as I could, and I had an unspoken desire to see my father's homeland. I earned free passage (actually, law required me to be paid one shilling) for the easterly voyage on a cattle boat, the Steamship Devonian. Although its principal cargo was cattle, it did carry a few passengers,

15

and I played the piano for their entertainment through their luncheon and dinner hours and in the evening for dancing and concerts. Except for the times when I was at the piano, I was free to bask in the sunshine on deck or read to my heart's content.

I disembarked in Liverpool, mounted my bicycle and rode across England to London; traveled on the Hook of Holland line to Hamburg, Germany; and pedaled from there to Berlin and back. In the countryside, I could buy milk and cheese for a few pennies, and sometimes earn a day's pay picking cherries in the great fields of cherry trees. It was an enlightening and exciting summer. I did not, as I had hoped to do, find any trace of my father's family; I did become adept enough at the language to explain, again and again, that yes, I was an American, but no, I was not therefore a Red Indian.

In the autumn of 1900 I became a freshman at MIT. After a few months, each freshman was called upon to choose the course he would elect to follow. The choices were Civil Engineering, Mechanical Engineering, Mining Engineering, Architecture, Chemistry, Chemical Engineering, Electrical Engineering, Physics, Biology, or Naval Architecture. I chose Mining Engineering, which I fancied would take me to the great open spaces of the West, perhaps even California, with the prospect of striking it rich--a very young man's dream.

After a month or so of geology and mineralogy--cracking rocks with a small hammer and determining the mineral content in the flame of a small torch--I went to share with the Dean my feeling that this was very dull stuff.

The Dean introduced me to a young Assistant Professor of Chemistry, Dr. Willis R. Whitney, and no greater good fortune ever befell a confused young student. Dr. Whitney was commuting back and forth between Boston and Schenectady, New York, where he was founding the research laboratory of General Electric, now one of the great institutions of the industrial world. Nevertheless he found time to hear my story, discuss it with me, and pronounce me with contagious enthusiasm to be good material for his chemistry course.

In the laboratory, I learned that by putting a certain chemical in a retort, adding another, and heating, a distillate would result which would be collected in another retort connected to the first by

a glass tube. I learned this over and over. I found that unless these exercises were accompanied by an explanation on an intimate level of what was happening to the ultimate particles involved--and why--chemistry, too, was dull.

When I confided to Professor Whitney that this chemical laboratory seemed too much like a cooking school and that I really hadn't much enthusiasm for it, he took me for another long talk. Finally he concluded that the course in physics was for me, that it was exactly suited to my state of mind, and a wonderful training for--well, for almost anything.

"What do students in physics do after they graduate?" I asked.

He informed me that thus far [1901] there had been only two graduates in physics in the history of the Institute, which had been founded in 1861, and they had become teachers.

"Why do so few students choose it?" I next wanted to know.

"Well...possibly because it is very difficult and theoretical and, in fact, includes all the mathematics, physics and theoretical chemistry taught at the university."

"Are there at present any students in the physics department?"

"Yes, there is one. His name is Daniel F. Comstock."

When I first met Dan, he lived with his widowed mother and his brother, a student at Boston Latin School who was preparing himself for Harvard Law School. Although the small household had everything it needed, I had the impression that Mother Comstock could not have given her two sons a college education without practicing every economy herself. I was always made welcome at their apartment on Huntington Avenue, and never begrudged Dan for having so much that I had missed because they all made me feel I was sharing the great wealth of a close and affectionate family life.

I began to be able to pay my way at MIT through scholarship grants and tutoring. Sometimes I had five or six students in a little "class" on such subjects as mathematics, chemistry or physics, and generally put in eight to ten hours a week on tutoring. But school

was neither a drudge nor a grind. Friends congregated at Charlie Wirth's beer tavern where the best imported Munster could be had at 10 cents a glass. Another favorite haunt was the Hotel Brunswick across the street, where we held serious conversations that often turned into songfests as I was elected to sit at the piano and we sang a song that began, "I want what I want when I want it," and "Pardon Me, My Dear Alphonse," and George M. Cohan's songs from Broadway.

One of our gang that year was Harry Doherty. He and I taught ourselves to box the compass and signed on together in the summer as able-bodied seamen on a two-masted schooner carrying goods between Middle Atlantic and New England ports. We thrived on the demanding work, simple food and fresh air, and I believe I owe the soundness of body and limb I enjoyed afterward to Captain Hank Greenlaw and the Coastwise Schooner Francis R. Baird.

The last three years at Tech were full of rewards, not the least of which was the discovery of Louis Pasteur's experiments of some 50 years before. His work was thrilling to me, and I found personal comfort in the story of his life. His initial discoveries in crystallography led him to the study of microscopic organisms; these led him to the study of what he called "germs." Pasteur possessed characteristics rarely found together in one individual. His devotion to scientific research was complete; despite a stroke which partly paralyzed him at the age of 46, he continued to work with incredible intensity.

France's important wine industry turned to him for the solution of the problem of wine and beer souring as they aged; was there some way to prevent that? The young chemist set to work and developed the process of pasteurization. The silkworm industry faced extinction; anthrax was ravaging herds of domestic animals; rabies was a deadly disease. Pasteur tackled them all, deriving his problems from industrial and medical situations but always pursuing the larger theoretical concepts involved. I imagined that I would follow a similar course.

For a man who worked almost in isolation, Pasteur had an immense gift for public debate. I studied his celebrated debate with the philosopher Ernest Renan. Somewhere in the debate--I can't remember the words today--Pasteur pronounces the edict, "Nobody ever gets something for nothing." I have always believed

that and I have repeatedly expressed that opinion--nobody ever gets something for nothing.

Pasteur maintained steadfastly that there exist spiritual values that transcend scientific approach. I realize now how persistently I clung to his convictions through many years that were inwardly desolate.

When I graduated from MIT in the year 1904 with the degree of Bachelor of Science, the value I derived from the rights and privileges of that degree and from its use as an introduction or a recommendation does not compare with the value of the training I received while working for it. Even if advanced mathematics or theoretical physics had come to have no practical application in my life, the discipline and training of those four student years, mastering facts and methods, were responsible for habits of concentration and the energetic attack of problems that have been of immeasurable practical and personal value to me.

As I write, my beloved wife Eleanore comes into the Round Tower where I have my study and reads over my shoulder, as she sometimes has the habit of doing.

"Haven't you left something out?" she asks me.

"What's that, dear?"

"You've left out the fact that in your junior year at MIT you met Natalie Dunphy at a school dance, and that in your senior year you were married."

"Yes, my love. I have left that part out."

Note: The history of Herbert Kalmus' marriage to Natalie was a bitter story that he rarely referred to and that he could not bring himself to include in his autobiography. And yet her name would become better known than his; the public would identify her name with Technicolor far more readily than his. The story of that marriage, one of the strangest of relationships, and the power struggle to take over one of the biggest corporations in America comes many years later. I will undertake to tell it in the final chapters of this book. --Eleanore King Kalmus

Mr. Technicolor

CHAPTER TWO

Training and Innovation

At the end of the spring term, it was customary even in those days for a horde of representatives of universities, government agencies, and corporations such as General Electric and American Telephone and Telegraph to descend upon MIT graduates and pick them over. In the spring of 1904 I received my bachelor's degree and was in line for some of these attentions.

One of my interviews resulted in an offer from a San Francisco high school to teach physics and mathematics in the coming year. There was a decent salary, but the main attraction to me was the chance to go west and see California, one of my heart's desires. A classmate, Arthur Willard, accepted a job with the same school. The only reservation I had was whether I should not go directly into research in one of the laboratories at MIT. Or, if my career was really to be in teaching, wouldn't it be advisable to start work on a Ph.D. degree and begin as an instructor at my own alma mater?

But these practical matters dissolved in my delight in exploring the hills overlooking San Francisco Bay. I took the electric tramcar to the beach every time I had a chance, fascinated by the great stretches of sand dunes and the enormity of that western ocean. I devoured the little towns across the bay, ferrying over and renting a carriage to visit Sausalito, Oakland and Alameda. The fine restaurants of old San Francisco were an education for a young man with his first earnings in his pocket.

The University School, a private San Francisco preparatory school, recruited me as principal a few months into the school year. Hurrah for my compulsory course in law at MIT, where law was defined as that which every man should know, which no man does-- and for which the Supreme Court is paid to have the last guess. The agreement I made to run the school was to last "as long as the school was in active operation and not destroyed or shut down by casualty, epidemic or other acts of God beyond my or any reasonable human control." A year later, when I had left the school in my friend Willard's hands, the San Francisco earthquake and fire reduced the school to rubble. Willard returned east, eventually to

21

become president of the University of Illinois.

I, on the other hand, had received a telegram from Dan Comstock on a day that I count one of the happiest of my life: Dan and I were appointed Austin Fellows, the only two from the class of 1904 to receive this fellowship for advanced study abroad. It came at exactly the right moment for me. I wanted to pursue graduate studies, I had the fellowship to cover the expenses of studying and living abroad for two years, and I had saved more than $8,000 from my two years of teaching, which meant that I could enjoy Europe in a way that I later felt gave me an "edge"-- something I defined as a level of experience or degree of polish that ordinarily I would have hoped to achieve much later, after a long period of working and saving. And to have Dan, a marvelous companion, traveling with me was one more piece of good luck.

We set out for the University of Berlin, where we intended to study under Paul Drude, a renowned physicist in the field of optics. In the middle of the first semester, Professor Drude left his classes one day for luncheon; within the hour the news that he had committed suicide was posted on the bulletin board. It was a blow to the scientific world, and of course to Comstock and myself. We moved from Berlin to Zurich, where I enrolled as a graduate student both at the University and at the Polytechnikum. Dan was not happy with the curriculum, so he matriculated at the university in the neighboring city of Basel.

In the next year and a half, we spent some of our free time in the northwest of France, particularly at Dieppe and Etretat. The latter, a fashionable little seashore resort, provided tourists with every conceivable amusement, including a number of casinos where visitors could part with considerable amounts of cash.

Dan and I became intrigued with the roulette wheel. After some study, we decided that since it was a mechanical instrument, it must have a "habit." There must be some imperfection in the rotating wheel or its support, a little scratch or irregularity, which would give it an individual character and prevent it from always repeating its action perfectly. Consequently the little ball must stop at some number or some section of numbers more frequently than chance would allow.

But which section? If we could solve that, we could beat the bank.

We set to work with pencils and a large sheet of paper to record the numbers, out of hundreds and hundreds of numbers, upon which the little ball came to rest time after time. . . time after time. . . until we had recorded its behavior at one table from shortly after noon until midnight.

Just as we thought. The red 5 and 34 and the black 22 came up more than their numerical share of the time. All we had to do was go back the next day, put our money on those numbers, and we were bound to win. I did not for a moment hear Pasteur's words in my ear, "Nobody gets something for nothing."

For the casino's managers had spotted the same possibility, and at the close of business each night they routinely transferred the rotating wheel of one table to another, so that when the gambling house opened the next day, every wheel sat on a different table from the day before--and who knew which was which!

The day came when I had completed my thesis, "Electrical Conductivity and Viscosity of Fused Electrolytes," and it was time to take my oral examination. Luckily I had picked up German very fast, for all my studies had been in German and I was about to have to defend my education in that language.

The ordeal is extremely formal. A group of professors sit around a long narrow table, at the end of which stands a blackboard and the person of Herr Candidat, who is dressed in a long double-breasted morning coat, a "Prince Albert" we called it then. One after another, the professors ask their questions. As soon as the candidate appears to be able to answer correctly, the professor interrupts with "Genug!" and another takes over.

Astronomy was the subject on which I was least prepared and which I feared the most. So when Herr Doktor Professor Geheimrath Wolfer raised his voice to ask a question having to do with a very special method of astronomical calculation, I felt the chalk crunch in my hand. I had only the faintest idea of the schemata I was expected to display on the blackboard. But I did know that this method had been evolved by Professor Edward Everett Hale, former lecturer at MIT, author of the wildly popular tale, "The Man Without a Country," and a man with whom I had a slight acquaintance. I began the answer to the question with full reference to this acquaintanceship. Professor Wolfer rose to the bait and became so engrossed in questioning me about Hale's

personality and accomplishments that he completely overlooked the original question and I finally fell into the hands of another professor.

I mention this incident because I think it throws some light on why in later years my corporate colleagues always sent me out to do the business of negotiating while they retreated to the scientific atmosphere of the laboratory!

Comstock and I returned from Europe in late 1906, proud possessors of our Ph.D. degrees and ready to conquer the world. Only, how should we proceed? We spent hours on the return voyage discussing our future. Should we teach? Should we go into pure research under H.M. Goodwin in the Department of Physics at MIT, or with Arthur A. Noyes in Physical Chemistry? Or should we strike out for ourselves, and organize a laboratory for industrial research?

We hadn't a shadow of a doubt that we could do any of these things. I was raring to get started. I longed for the excitement of doing something new, something independent--something that would bring me into active contact with the world of business and finance.

We hit on a practical solution. We would offer our services as instructors to MIT--we both felt we owed the school a debt because of our scholarships--and then we would be able to use the library and the laboratory with its apparatus to take on a few small consulting jobs to more or less try our hands at the business.

Dan was appointed instructor in the Department of Physics and I became a research associate at the Physical-Chemical Laboratory, moving on the next year to teaching physics. I was interested to find how much I liked teaching. I was quite ready to discuss with students any point they might raise and I never failed to answer--or try to answer--any question that was asked in class. I thoroughly enjoyed teaching physics to sophomores; but I think I would have enjoyed teaching anything to anybody. In fact, in later years after I left the university I often felt that I was teaching all the time! Teaching customers that we had what they wanted. . . teaching investors that we were a good bet. . . teaching our employees the difference between a few small-scale experiments that worked and moving into the heart of a major industry.

But in Boston, in 1906, we were asking ourselves, "What

next?" I had felt from the very beginning of my association with Comstock that if we could recruit one man of great mechanical genius, we three together would possess enough talent to tackle any job we were likely to get. And we found him in W. Burton Wescott, not a classmate at MIT, not even a college graduate, but nonetheless the engineering genius we had been looking for. From our earliest association, we three fell into the pattern of supplying the following ingredients: Comstock, an original, inventive mind in the field of physics; myself, the ability to discern what could be done and to organize to do it; and Wescott, the practical mechanical know-how to make things work.

KC&W came into being in 1912, and it was the start of many projects--to myself I call them campaigns--which resulted in hundreds of patents, several commercial processes and at least three profitable corporations. It was funds from these projects that enabled us to stick with Technicolor through years and years of experimentation.

In my early research, I keenly felt that whatever I did should deal significantly with the human as well as the physical aspects of life. Like Pasteur, I wanted to solve problems that had practical as well as theoretical applications. One of my projects was as personal a matter as I could have found.

As far back as I can remember, even, I would say, earlier than verbal memory, whenever conditions were just so--when I was tired, or when the light had a certain dull glare--I would be seized by a pervasive fear which welled up from my subconscious mind. This fear created such a devastating panic that for a moment that central core constituting personality was gone--obliterated--and nothing existed but fear.

More people suffer from panic attacks than is generally known. Most of those who experience it consider it to be mysterious and very personal, something no one else can understand. Consequently, it is rarely admitted to. As a very young boy I went alone to explain this trouble to doctors at the Out-Patient Department of Boston City Hospital. They prescribed a little bromide and advised, "Let it alone and you'll outgrow it." The problem was that

the greater the fear, the more I dwelt upon it, and the more I dwelt upon it the more importance it assumed in my mind, a vicious circle going round and round and increasing the fear until it triggered the state of panic.

When I was a student abroad, I went to the famous Dr. Pierre Janet in Paris, who told me that my fear stemmed from some fright I'd had in early childhood, the memory of which was buried in my subconscious mind. "If you will leave it alone; cease thinking about it; it will gradually disappear for want of fuel," he said. "And even if it returns from time to time, it only lasts a moment, so why make of it such an important thing?"

But it was important, as anyone who has felt its devastation knows. Later, I was introduced to Dr. Boris Sidis, a Boston psychiatrist whose specialty was the rediscovery of childhood traumas. I was first his patient and then his lifelong friend. His method was to induce a hypnotic state and then ask questions about events in the past. In a series of sessions he carried me back and back until we reached an incident at about the age of four when I was buried in a snowbank by an older boy and then pulled out, semiconscious, by a playmate, Billy Harty. I had no conscious recollection of this, but I called on my former neighbor Mrs. Harty and discovered it was all true.

I was not entirely persuaded that this was the source of my trouble, for it seemed to me to go back to an even earlier time, but at least Dr. Sidis convinced me that my condition was not organic but purely functional. He would repeat to me the key words "fear," "mystery," and "importance," and say that the syndrome was important only because I made it so by dwelling on it. If I concentrated on that thought, it would set up a counter emotion which tempered the moment of panic. If I dismissed the worry and persistently turned my thoughts to other things, even though it was not always easy to do so, it worked. When the panic fear would rise I began to recognize it as an old acquaintance, familiar and not mysterious at all.

The ability to cope with this panic state gradually became a source of great satisfaction, a victory, an asset. I could sometimes discern that others were suffering from a similar condition, and I was often able to help them with the same formula that had helped me.

Dr. Sidis and I talked about many subjects in his field and in the subject of physics. I demonstrated some of the equipment in the laboratory to him, and after one discussion we concluded that if a patient such as myself were put in an electrical circuit in series with a galvanometer, valuable observations on his emotional state might be made. One could actually get a reading from the electromotive forces set up in the human body by emotions.

A galvanometer is an instrument with a small mirror which rotates as the strength of the current flowing through the instrument varies. A certain current flows through the patient (and the galvanometer) when he is in a state of normal mental and physical equilibrium. But if he is suddenly excited, his heartbeat and other physiological conditions change and consequently the electromotive force in his body changes, the current changes, and the galvanometer deflection indicates and measures it. Together the doctor and I published a paper entitled "A Study of Galvanometric Deflections Due to Psychophysiological Processes," which appeared in the Psychological Review of September 1908 and January 1909. This paper stated the principles of the instruments which would later be used for making electrocardiograms in the study of the heart, and in making the lie detector.

Another early interest was the study of bacteria under the influence of ultraviolet radiation. My interest arose in a very simple way: a friend was suffering from a spreading infection on his shoulder that was driving him to despair. After much reading and experimentation, I arranged a spark discharge rich in ultraviolet radiation and placed the patient so that the radiation from the spark was concentrated over a region about an inch in diameter by means of a quartz lens. I moved the focus until every part had been rayed for half an hour. During the next six months, the affected area shrank to nothing. The condition, which had been diagnosed as lupus vulgaris, did not return. I called the experiment to the attention of several physicians, but at that time treatment involving complicated apparatus was not considered to be within the curriculum of office practice. This was before the days of X-rays and electrocardiograms. I published a paper detailing the technique entitled, "Destruction of Bacteria by Radiation from Electrical Discharges."

But soon I was pursuing a more practical device my partners

and I had invented and were trying to market. We called it the Photo-Speed Recorder.

The instrument was a compact assembly of two cameras and a stop-watch. The two cameras were mounted one over the other in a small box 7 inches by 7 inches by 3 inches, weighing about three pounds and convenient to carry. By simply pressing a lever, the operator could record the speed of a large moving object. It worked like this:

The operator points the device at an automobile as it retreats and presses the lever. This starts the watch and flashes the upper lens, followed a second later by the automatic flash of the lower lens Since the automobile retreats a certain distance during the short interval between the two pictures, the second photo is smaller than the first; the exact time lag between the two exposures is indicated by the shadow of the hand of the watch against the divisions of a dial which are 1/5 of a second apart, and which appear on the photograph. By using the actual dimension between the two rear wheels and making measurements of that dimension as it appears on each of the two photographs and noting the exact recorded time between the two exposures it becomes a simple calculation to compute the speed at which the object is moving. The Photo-Speed Recorder was a precision instrument.

It eliminated the personal element. A motorist who had been stopped did not have to rely upon--or argue about--the officer's estimate of his speed. Nor need the officer be concerned about the protestations of the indignant motorist. The Photo-Speed Recorder was an impartial and accurate witness. Moreover, the license number of the car in question was shown in the picture.

It was my job to demonstrate to various police departments that we had something they very much needed.

My first appointment was with Charles S. Whitman, then District Attorney of New York County and later Governor of the State of New York. He suggested we go over to Seventh Avenue with two police motorcyclists and try out the Photo-Speed Recorder.

Unfortunately our first offender turned out to be the famous heavyweight champion Jack Johnson. The Police Department was unwilling to face the publicity of a test case with Mr. Johnson as defendant.

I had better luck getting it tested closer to home, and in Boston I soon saw the first conviction of a speeding driver by means of camera testimony. The driver was fined $20.00 for driving at an excessive speed. The way seemed clear to manufacture these instruments in quantity and sell them to every city and town in the country. But alas, the officer on the beat did not care for it. Whether it seemed complicated, whether he didn't like to carry it, or whether he preferred his old interpersonal methods, I never discovered. But I was never able to sell a single instrument.

One day in 1910 I had just finished teaching a class when I was called to the office of the President of MIT and introduced to William A. Harty, who had a problem. Yes, it was the same Billy Harty who had once pulled me out of a snow bank--the world is that small.

Harty represented a group of 21 manufacturers of abrasive grinding wheels, each company independent of the other and independent also of the two giants of the industry, Norton and the Carborundum Company. Harty's group relied on emery for the cutting material to make their grinding wheels, but the mines from which they obtained this mineral were almost depleted. It was necessary to develop an equivalent of the artificial abrasives alundum and carborundum, which the big companies had under their tight control. "We don't want to infringe on the existing patents," Harty explained. "But we've got to find a substitute or face extinction." Speaking for the group, he invited me to research the problem.

At the same time, I had been offered a professorship in the Department of Physics at Queen's University, Kingston, Ontario. I countered with the request that I be allowed to have a research laboratory on university grounds, access to an abundance of electrical power, the privilege of employing research assistants whose salaries I would pay, and the stipulation that any results of my independent research would be my property or the property of KC&W. An agreement was reached, and in 1910 I moved to Kingston, where I taught physics through 1913. That year, still at Queen's, I was concurrently appointed Director of the Research

Laboratory of Electrochemistry and Metallurgy for the Canadian Government.

This appointment led to research on the properties of the relatively little-known metal cobalt, covered in six articles published by the Canadian Bureau of Mines. This was new and basic work, but none of us then dreamed of the significance cobalt would later come to have.

By 1913 I had made headway in developing an artificial abrasive. We had worked out a way to manufacture aluminum oxide from a very common and abundant mineral called nephelin syenite--I'd staked out claims to properties in Ontario where this mineral could be freely mined and shipped. Later, we would switch to bauxite as a cheaper source.

By summer, I had the Queen's campus lawn so strewn with large tanks, from which fumes rose in columns, that it seemed like a factory site rather than a college green. We were producing aluminum oxide, and when I fused it in a small electric furnace the abrasive product was pronounced extraordinarily good by the people for whom I was working.

As a result, three patents were applied for and granted, and in 1914 the Exolon Company was formed. I served as Vice President of the company until 1919, when I was elected President. We built factories in Thorold, Canada, and later in Buffalo, N.Y., and began to produce products for the abrasives industry we called "carbolon" and "exolon"-- thus the name of the company.

As soon as the Thorold plant was running, William Harty along with one of the senior members of the abrasive group made a trip with me to see the new plant in operation. I never forgot their disappointment when we came up over a rise in the road and the plant came into view. They expected to witness tall chimneys with clouds of smoke emerging, whereas there was none at all since no coal or oil was used as fuel--only electricity. They were soon cheered by the mountain of raw material stacked in the yards and a look through dark glasses at the white heat of the furnace.

Another day was memorable as well. Burton Wescott and I were on our way back from Thorold to Boston. We missed our connection in Buffalo and had a two-hour wait for the next train. Strolling about, we passed a slaughterhouse. I thought it might be an interesting place to visit. We introduced ourselves to the owner

and were allowed to tour on our own. "Boys, look around and let me know what I can do for you," Jacob Dold told us.

One of the things we noticed was that during the slaughtering process rich blood flowed in gutters to large reservoirs outside where it evaporated to make a very ordinary fertilizer product. It was almost a classic classroom problem: A high potential product was being transformed to a very low-grade product, a tremendous drop in potential. Was there any way to recover this potential?

With Dold's permission, we went back to Boston to think about it. Soon Wescott filed an application for two patents, "The Art of Collecting Blood" and "Trocar," the instrument for drawing blood. As these experiments progressed I presented the matter to a banking house in Boston. In four months research had so far progressed that Protein Products Corporation was founded. Its purpose was to make albuminous products suitable for human and animal food and hemoglobin products; a pilot plant would be built at Dold's.

I neglected to say that the bank I dealt with was banker to the Armour Company. The operation of our pilot plant so interested Armour that they took over the American Protein Company in the year 1925; once again, Kalmus, Comstock & Wescott received a substantial sum for its interests.

When I personally withdrew from the presidency of Exolon to turn to other projects of interest, KC&W also realized the company was no longer primarily a research problem and sold out its interests. It was successful projects of this kind that gave me and other members of KC&W the experience, the reputation and the financial strength to survive the long, severe struggles with Technicolor that were to come.

Of course, the years I've just detailed also cover the years of the World War I. Canada joined in 1914, and I helped the first Canadian contingent to organize and embark for Europe. I said good-bye to a very dear and gallant friend, George Richardson, who was killed leading his company in the Battle of Ypres.

Despite offers of the University, I decided to return to Boston and devote my time to the projects being developed there by KC&W. During those years, I had worked pretty much around the clock, making trips from Canada to New York to Boston to Buffalo to Thorold; to Buffalo and back to either Boston or Canada almost

every week. I negotiated a deal with the abrasives companies, organized the Exolon Company and our contracts with that company, negotiated an important interest for us in the American Protein Company, and negotiated the contracts covering every important step of our activities in the development of Technicolor.

Back in Boston, most of the scientists at KC&W were given a war classification which prevented us from enlisting in the service but assigned us to other duties. Specifically, we were assigned to the naval station in New London, Conn., and began work to perfect a deep-sea sounding device, an instrument attached to the bottom of a vessel which operated electrically to record the depth of the water under the vessel. Carrying that idea further led us in the direction of an instrument for detecting the presence of submarines. In World War II that research would lead to the development of SONAR.

But the overwhelming focus of our attention was Technicolor. I can remember snatching an hour here or there, between the war work and the technical problems in the research lab, to sit on a bench and let it sink in--we were finally seeing our theoretical work on color motion pictures become practical.

CHAPTER THREE

"Let's Do It"

Our earliest Technicolor laboratory was a railway car. We took an ordinary pullman car, gutted it, and installed a complete laboratory on wheels. Inside, we had everything we needed for sensitizing, testing, perforating, developing, washing, fixing and drying negative film; printing, developing, washing, fixing and drying positive film; washing and conditioning air; filtering and cooling wash water; examining and splicing film; and making control measurements and tests. My lovely Eleanore says that she wishes we could have preserved it, just as it was, with its offices, laboratories, power plant and darkrooms, and the words "Technicolor Motion Picture Corporation" displayed on its side. What a museum piece it would be!

When Mr. Coolidge and the other investors put up the money to produce a feature film, we picked a story that was set in the tropics so that we could employ the bright light and lush vegetation of Florida. Through Willat, who was proving to be a good contact with the movie industry, I found a leading man in Niles Welch and a leading lady in actress Grace Lamond, along with experienced technicians and scenario writers. In 1917, our railway car rolled over the tracks from Boston to Jacksonville, where we parked it on a siding up against an ice house, which provided cooling water for temperature control. We were using Comstock's new camera, and the process we called Technicolor Process Number One.

Early in the development of a process to photograph and develop prints of a color motion picture, two decisions must be made: First, how far to depart from standard equipment and materials, and second, where the special color processes will take place--in the raw film manufacturing, in the photographing, in the laboratory processing, or in the projecting. In the beginning, we worked under the assumption that special cameras and special projectors were permissible, provided that films of standard dimensions were used.

This first camera of ours recorded on negative film the light coming in through the camera lens. Just behind the lens was a

beam splitter, which allowed us to photograph simultaneously, through a single lens (in effect, from one point of view), two geometrically identical images of each instant of the scene before the camera. One of these images recorded the color values in the green half of the spectrum while the other recorded color values in the red half of the spectrum. The negatives are not actually colored, of course, but it's convenient to label them this way. The negatives are simply a black and white record of the red and green elements of light. When the negative is developed it looks silver; held up to the light, the pictures look black and white and show no color. In the projector, we beamed one light through a red filter and another through a green filter to obtain our colored motion pictures.

But the difficulties we found with the special projector were responsible for the first great disappointment in the history of the infant Technicolor Company. *The Gulf Between* was not the triumph we had hoped for.

Boston headquarters was not a scene of depression, however. I fully believed that color motion pictures could be made, and I believed absolutely that the scientists and technicians of Technicolor could do it. The company was born of research, and more research would lead us out of this momentary setback. Whenever we faced tough engineering problems at the laboratory, I always said to the staff, "If you can't do it; it can't be done," but in the case of color films I firmly believed that it could be done. Moreover, because we were constantly trying different approaches, we had already made samples of positive film with the color on the film itself, which could be used in any standard projector. We were on our way to Technicolor Process Number Two.

But we would not get there in a single step. In every stage, we had to use the best and most workable results from the stage before, solve as many problems as possible, and get closer to our goal--all the while showing successful results along the way. And I had to stretch existing funds and keep new investments coming in.

One day in the first half of February, 1920, an incident took place which might have been extremely discouraging to the future of Technicolor.

We had always been confronted with the necessity of a de-

pendable source of negative film, positive film, and positive blank. Generally we dealt with Baystate Film, a small manufacturing company near Boston. Its research facilities were limited and its production was neither large nor dependable. I girded myself to face the lion in his den. I decided to call on George Eastman himself in the city of Rochester.

Our contacts with Eastman up until that point had been negligible. I knew Dr. Kenneth Mees, Vice President and Director of the Eastman Kodak Research Laboratories, but not very well. And Mees had introduced me to a young war hero who had recently joined the company, General Edward P. Curtis. He was from Rochester, and had left in his sophomore year at Williams College to join the American Ambulance Service in France. When the United States entered the war, he trained as an aviator in France and joined the Air Force--still not old enough to be legally admitted. He was one of the first Americans to go to the front as a fighter pilot with the 95th Pursuit Squadron. While still in his teens, he was one of three flight leaders, and one of the first American Aces. This young hero had joined Eastman and was gaining a reputation as a sales dynamo. Certainly the first time I met him was memorable: He walked into my office one morning at 10:30, just off the plane and ready to talk business. This was in 1919, and it was the first time in my life a businessman had used an airplane for transportation to come to my office on a matter of business. Mees and Curtis were both to become close colleagues of mine, but on the day I took my case to the founder and president of Eastman Kodak Company, I had no allies in Rochester.

I was a young man in my thirties, introducing myself to a much older man--about 65--head of a giant corporation which he had founded, and having perhaps the last word on matters that meant the most to me in the technical and business world. And I must say he looked the part. When I was led into his office, I found him sitting at an enormous desk and wearing a skullcap, a figure of dignity and authority, and master of all he surveyed.

Dr. Mees was present, and I addressed my well-rehearsed words to both of them.

"Gentlemen, I have not come to ask for financing nor to ask for investment or credit. I know that scarcely a week passes that some inventor doesn't appeal to you to help give birth to his

brainchild, but I come before you as a potential customer.

"I would like to show you some samples of motion picture scenes in natural color made by an entirely new method. I ask you to examine the film and discuss with me our means of preparing it, with a view to becoming our source for the raw stock we need for this process. In short, we need a large and dependable source of supply, one with a strong research department that can tailor film to our demands. We hope in turn to be able to provide the motion picture industry with prints they can afford; the public will benefit from improved quality; and you and I may be mutually helpful in our common purpose."

Our engineers had made samples--short lengths made by hand laboratory methods--of the new kind of film we had been working on. I projected these short scenes, accompanied by rather longer explanations of how we did it and how we intended to develop and improve our methods. Then I was sent off to have what seemed like an endless luncheon and tour with Mr. Lovejoy, who in later years became President of Eastman.

When I was finally escorted back to Mr. Eastman's office, I was astounded to hear that they had come to the conclusion that practical commercial motion pictures for the theater could not be made the way we were making them nor by the improved way we proposed to continue!

My train ride back to Boston was a gloomy one. It was apparent that George Eastman's faith in our prospects was at an absolute zero. As I watched the bare winter woods from the window, snow began to fall. If only I could have had a glimpse of the future--of a time when I would be welcome in the executive offices of the Eastman Company, when I would be the house guest of Dr. Mees whenever I turned up in Rochester.

And it would have brought a smile to my face to look into the future to a time when Technicolor was firmly ensconced in Hollywood, with Ted Curtis making long trips to the West Coast to confer with us.

But that was far in the future. As I traveled alone on the train, looking out at the falling snow, thinking of what I would say to the young research staff waiting for me in Boston, a thought suddenly occurred to me. "It took them an awfully long time to say no," I said to myself. I had been kept out of their way for more than three

hours by that endless luncheon. There must have been something in what I said if they had to discuss it for that length of time.

When I went into the Technicolor laboratory at KC&W the next morning, I said to the staff very simply, "They say it can't be done."

Then, before the words could sink in, I added, "Let's do it."

The process we were now embarked on was a two-component subtractive process. What the eye sees as white light is made up of a mixture of all the colors of the spectrum. If white light is projected onto a screen and a dyed filter is inserted in the beam to absorb--or subtract--one or more of these colors, then the eye sees only the colors that remain. A yellow filter, for example, subtracts all colors except yellow. Any color can be produced on the screen by filters of the three subtractive primary colors, yellow, cyan (a greenish blue) and magenta (red). But a full three-component system was far in the future. For the moment, our work with the red half of the spectrum and the green half of the spectrum yielded satisfactory color, especially in skin tones and in natural outdoor scenes.

The first step was to obtain a record upon a negative of the color aspects of the scene, using our Technicolor camera.

The next step was to make two prints from this negative using a special printer which transfers the red images to one positive film and the green to another. These two films are run through special solutions which develop the latent images in gelatin reliefs instead of the ordinary deposit of metallic silver, as in black and white film.

These reliefs represent the gradations of the positive color aspects, defined in the thickness of gelatin--low in the highlights and high in the lowlights. These two relief images, one for the green and one for the red components, are run through a machine which welds them together back-to-back in register. Then the two sides, one after the other, are floated over baths of dyes and dried. That is how we made double-coated relief images in dyes. When you look through a frame of this film, you see a two-color reproduction of the original scene.

The laboratory on wheels had become too confining, and we had to expand in the building already occupied by KC&W and the Technicolor staff.

These were thrilling days for Dan Comstock and myself. We

talked endlessly about the new double-coated film. We recognized the importance of the fact that we now had a subtractive process. Color wasn't being created in the act of projection, as had been the case at Aeolian Hall.

Along with our desperate need for a source of raw materials --thus my trip to Rochester--we had perhaps an even greater need for money. The Coolidge group had invested more than $300,000 by now, and had not seen a penny in profits. It was clear to them from the way we talked about future plans that much larger sums would be required. The Board of Directors of Technicolor had authorized me to sell 150,000 shares of stock, hoping to raise one million dollars. Mr. Coolidge suggested that I look for money in New York instead of Boston.

I had a very good friend in William P. Daniels, a Boston banker, who offered to introduce me to a classmate of his named William Rand who was practicing law in New York City with the firm of Guthrie, Jerome, Rand and Kesel. I met Rand and put my best effort into explaining our process to him, but he protested that it was too technical for him. "But it's just what my partner, Judge Jerome, would enjoy," he added. "He's got a very strong scientific bent. He has a home workshop with lathes and all the latest tools-- spends hours fiddling with things."

And that was how I met Judge William Travers Jerome. He was a man of some fame. He had been presiding judge in the Harry K. Thaw murder trial. Thaw had shot and killed Stanford White, a prominent architect, in Madison Square Roof Garden because of his love affair with Thaw's wife, Evelyn Nesbit Thaw. The sensational trial had been reported in the press of the entire country.

As well, Jerome had served as District Attorney of New York County during a tumultuous period. To a considerable extent the tumult was of his own making, as he was determined to "clean up" New York and rid it of the grip of Tammany Hall.

Judge Jerome was a man of medium height, solidly built, with a handsome head, rather conspicuous flat nose, and an impressive manner. And yet the many caricatures of him in the press--with the head of the Tammany tiger, cigarette in mouth--captured him in some odd way.

Once, in later years, strolling with the Judge in Washington, I was stopped by his hand on my arm. "Herbert, if I had wanted

to play the game, I might have lived there," he said.

"What do you mean?" I asked, looking up to see The White House.

"When the Democrats nominated Woodrow Wilson, they ignored New York State and reached over to New Jersey for a candidate. I had been asked to run for governor of New York; that office practically assured nomination. Had I accepted, I would have been the Democratic candidate, not Wilson."

"Why did you refuse?"

"I did not like the men they told me I'd have to appoint and carry into office on my coattails."

After Rand introduced us, the Judge decided to come to Boston to see what we had for himself. He arrived in my office about ten o'clock one morning and asked me to have my secretary arrange for his return on the one o'clock train. I told him that left too short a time--it would be impossible to see our laboratory, much less make a study of our experiments with the Technicolor process, but he waved me off and proceeded with his questions and observations.

He remained with us for three days and nights. Before he left, he invited me to New York and offered to arrange appointments with a number of his friends and clients who he thought might buy stock. "I can lead them to the water but you will have to make them drink," he told me. And of course that was what I intended to do.

After that, I had the pleasure of dining with the Judge on countless occasions at his home in New York City. He had more friends than almost any man I have ever known; and he had a vast collection of stories and anecdotes about himself and others. The conversation at his table covered everything--New York politics, national politics, foreign relations (he was a cousin of Winston Churchill's), political economy, literature, the stage, and important New Yorkers of his time. He was a genial host and a charming man, though not without a flash of temper born of impatience. He sat forty guests at his well-appointed table, and his hostess was a famous New York beauty, a former opera star whom he obviously adored.

Sometimes I describe these long-ago events to my lovely wife, who finds the details absorbing. "And was that when you went to charm school?" she teases me.

"More like boot camp for gentlemen," I reply. But it is true, I was moving in circles where I felt my dry New England manner and my professor's garb were lacking in sophistication. I put myself in the hands of a man named Muldoon, who kept a gymnasium in New York and took twenty men at a time--corporate executives mostly, although one of my "classmates" was Andrew Mellon--and put us through hell until we learned his rules for grooming, dress, carriage, exercise, posture, manners--right down to the proper haircut and manicure. Afterward, I was never without the hair brushes and body brushes and clippers and buffers and other paraphernalia he prescribed. Muldoon was tough and profane. He was determined to break me of the habit of standing as if I were giving a lecture. "Can't you get it into that stubborn skull that you do it THIS way?

"Observe. Now, do it!"

His aim was to instill correct behavior, accomplished effortlessly, naturally and unaffectedly. I don't know how much of it took--I have always studied ease and then chosen formality--but I remember waiting to go into L.B. Mayer's office for the first time and quickly reviewing Muldoon's uncompromising lessons.

In New York, the Judge introduced me to an advertising executive, A.W. Erickson; to William Hamlin Childs and Eversley Childs, makers of Bon Ami; James C. Colgate, a banker; Alfred Fritzsche of Grinnell, Inc., of Cleveland; Marcus Loew, of the theater chain, and his Vice President Nicholas M. Schenck. Eventually they all "drank," and several were interested enough to serve as directors and help with the future financing and management of Technicolor.

Later, through Erickson, I met Harrison K. McCann (this was before the formation of the McCann-Erickson advertising agency), Albert W. Hawkes, President of Congoleum, and John McHugh, of the Chase National Bank. From the time he became a director, McCann was most active and helpful, and introduced me to James Bruce, director of many large corporations, including Republic Steel and American Airlines, and to William G. Rabe, director of Manufacturers Trust, both of whom became directors of Technicolor.

Eversley Childs introduced me to Lester G. Clark of Bon Ami, Colonel James H. Hayes, a lawyer, and John L. Anderson, all of

whom joined Technicolor's board, along with George F. Lewis, a member of Judge Jerome's law firm, and one of his partners, Murray D. Welch. The men were in the highest echelons of finance in the city. Only two were connected with the motion picture business.

Marcus Loew had begun buying up theaters in 1899. In collaboration with Joseph and Nicholas Schenck and Adolph Zukor, he built up a vast theater chain which became Loew's, Inc. Loew bought the Metro film production company in 1920 and presided over its merger with the Goldwyn and Mayer firms, creating the parent company of Metro-Goldwyn-Mayer while remaining one of America's largest theater owners.

Loew and Schenck remained on the board of Technicolor a very short time because it was thought--and they agreed--that it would not do to have one important customer represented when none of their competitors--who were also important customers-- were represented. The major film studios had to feel that Technicolor would treat each one fairly and impartially and to its best ability.

An odd story comes to mind. I had been authorized to sell 150,000 shares of Technicolor stock at $7 a share. I began negotiations with Judge Jerome by offering him 150,000 at $8 a share, leaving myself room to come down to $7 if necessary during the course of the negotiations.

After a trip to New York, during which the demonstrations of our film seemed most satisfactory to the Judge and his friends, I waited for our next meeting, which was to be in Boston on the following Monday.

On the Saturday before, I was surprised to be invited to the home of a prominent Boston banker with whom I'd never done business. He gave me an elaborate lunch during which he told me that he knew that I was authorized to sell the stock, knew my price, knew the price I would ask of Jerome, and then subtly injected doubts on whether Jerome would close the deal.

I was aghast. How he gained this information I would never know. He began to argue that it was my duty to sell the shares to him immediately at $7 a share. Didn't the company need that $1,050,000? Then he would meet Jerome with me on Monday and if the sale was made at $8, the lawyer and I would have a profit of

$150,000.

It was true that I had been haunted by the thought that the Judge might change his mind over the weekend--and once I turned down this offer, there might be neither $1,050,000 nor $1,200,000. But I was stunned by the banker's audacity. I found myself telling him a story.

"Have you heard the one about the two Boston bankers who appeared at the Pearly Gates of Heaven appealing to St. Peter for entrance? St. Peter left them standing there while he went to examine their records. When he returned, he found that the bankers were gone. So were the Pearly Gates."

That ended our meeting.

Judge Jerome did appear on Monday, and closed the transaction for options on 150,000 shares at $8 a share for himself and his syndicate, which included Eversley and William Childs, J.C. Colgate, and A.W. Erickson.

With this firm financial backing, we could now proceed with Technicolor Process Number Two.

By the beginning of 1922 we were ready once again to produce a Technicolor motion picture to show the industry what was available. It was never our intention to regularly enter into the production of motion pictures in competition with our customers-- our real business was the color photography of motion picture productions and the manufacture of positive prints for distribution. But Hollywood was still reluctant to take a chance with color. Producers could not convince themselves that color would pay for itself--that a color film would attract a greater audience, thus returning its cost.

We set up a separate production company, Colorcraft Pictures, Inc., to produce our first film with Technicolor Process Number II. It was financed by myself and several of our largest stockholders. And we decided to film in Hollywood.

The basic reason for this was that Joseph and Nicholas Schenck continued to be interested in our affairs, and Joseph had offered the use of his studio's facilities, a director, and one of his stars-- without charge. I agreed; it was time we set our feet in this Pacific suburb.

Dan Comstock went west as technical consultant and to represent the point of view of Judge Jerome and myself. When he

wrote us that the script was to be a version of *Madame Butterfly* based on an old Chinese folk tale, the Judge and I took rather a dim view of the choice. It seemed a depressing story for our first feature-length picture for general distribution. Jerome was trying to sell Technicolor stock and thought the story would not be appealing to the people with whom he was dealing. I had hoped for something a bit more lively and happy.

But Schenck's judgment prevailed--it was his studio, after all--and the first actual shooting of *The Toll of the Sea* began on May 4, 1922, starring Anna May Wong, with Chester Franklin directing, D.F. Comstock, technical executive, and J.A. Ball, Technicolor cameraman.

Anna May Wong was a beautiful American-born Chinese actress whose high cheekbones, heavy-lidded eyes and lovely smile had made her popularly known as "the world's most beautiful Chinese girl." When I saw the early rushes, I realized that she was radiant in color as the girl who drowns herself in the sea. Privately, Comstock was reporting that the actors were a big problem--they scarcely took their work seriously because they did not believe that the picture would reach the screen. Color was too new and too experimental.

As in any new art, there were various delays. For instance, Chester Franklin insisted on screen tests for the Chinese costumes. He knew, from experience, how they would look in black and white but he was not sure about color. Joseph Schenck, originally very far from being what I would call a color enthusiast, after seeing a few scenes seemed to be on the point of changing his mind. "If you can really photograph what we have arranged to enact, you will have a splendid little motion picture," he said.

After too many takes and retakes, *The Toll of the Sea* was finished and Nicholas Schenck arranged for its release by Metro. The first showing was given at the Rialto Theatre in New York City in November, 1922. The critics were enthusiastic. We received letters of praise from artists Maxfield Parrish and Charles Dana Gibson. Douglas Fairbanks telephoned and talked about producing a color film someday. It was a very gratifying event.

We could not supply prints fast enough to follow this opening and it was not until 1923 that the picture was in general release, showing in thousands of theaters across the country. It grossed

more than $250,000, of which Technicolor received approximately $165,000.

The prints of this historic first color feature film were manufactured in our original pilot plant in the basement of the KC&W building in Boston, a facility we were fast outgrowing. The manufacturing cost was about 27 cents a foot. (By comparison, forty years later, in 1962, the price was 4 1/2 cents per foot.) We made our prices very public, but producers were still not sure that the additional expense of color would pay for itself.

Jerome and his group informed me that they had decided, for complex business reasons, to form a holding company to be called Technicolor, Inc., which would own 91.8 percent of the stock of Technicolor Motion Picture Corporation, with me as President. Thus the company I had established in 1915 evolved into Technicolor, Inc., in 1922.

And there was yet another step in this eventful year--we opened a laboratory in Hollywood.

CHAPTER FOUR

Ben-Hur: A Foot in Hollywood's Door

Cecil B. DeMille was one of that early trinity, DeMille, Lasky and Goldwyn, who formed Lasky Feature Play Company, with the original purpose of transposing stage plays to the screen. Feature Play became Famous Players-Lasky, which in turn was to become one of the giants, Paramount. An early arrival in Hollywood, C.B. dressed like a director and acted like a director, his boots, loud-speaker and director's chair leaving a permanent image. He created the Hollywood epic, the extravagant, lavish spectacle with its exotic scenery and thousands of extras. There was a Hollywood joke about the psychiatrist who arrived at the Gates of Heaven to be greeted by a relieved St. Peter with the words, "We're glad you're here, Doc. We're very worried about God--He thinks He's Cecil B. DeMille." In Hollywood, for nearly three decades, DeMille was the most powerful and influential man in movie-making.

In our first contact with DeMille, we provided color inserts for his 1923 version of *The Ten Commandments*. He decided to shoot a few sequences in color, big scenes where it counted, to give moviegoers a taste of color and yet save money. Because the movie was a great potential showcase for Technicolor, we struck a bargain with him: We would set up our cameras alongside his black-and-white cameras and shoot key scenes in color. If he liked the results, he could buy the footage; if not, we would absorb the cost and that would be that. As it happened, he was very enthusiastic about our offer. More important, our gamble paid off.

What we had to show, thus far, were these and a few other short inserts (*So This Is Marriage* for MGM) and one feature production, *The Toll of the Sea*, which we had financed and produced ourselves. We still could not give Hollywood what it wanted-- cheap film and fast rushes.

Then one major producer made us an impossible offer--which we could not turn down. Jesse Lasky agreed to produce in Technicolor *Wanderer of the Wasteland*, a western based on a Zane Grey novel--but under the following conditions. In his budget, he would

appropriate no more money for this picture than for the same film in black and white, and he would make no concessions for time--we were to film under a regular schedule.

During the six weeks of photography, our entire staff worked from early morning until late at night seven days a week. Many scenes were shot in the desert around Yuma, Arizona. Exposed negative was shipped at the end of each day to our small new plant in Hollywood.

Lasky or one of his staff expected to check rush prints and quality of the negatives daily.

At one time we were accumulating negative which we did not dare to develop because of inadequate facilities in our early lab. These were shipped back to Boston for processing. I had long lived with a recurring nightmare of the loss of film through fire--a blazing inferno of destruction. Early nitrate film was dangerously flammable, and this permeated my dreams. Now I was living with a real nightmare: Willat and I shared the fear that we did not know whether we would finally obtain commercial negative--the entire Famous Players investment might be a write-off.

But the film was a success. *Wanderer of the Wasteland*, starring Jack Holt, Noah Beery and Billie Dove, the first feature-length Technicolor picture by a company independent of our own production division, was released in several thousand theaters in mid-1924. We had proved we could deliver under actual motion-picture conditions.

And the fact that we manufactured no fewer than 175 prints from the *Wanderer* negative with the latest prints differing in quality to no degree from the earlier ones answered the question of whether we could obtain an adequately large number of prints from one negative.

The work was done and billed to Lasky at 15 cents a foot, and Technicolor realized approximately $135,000 on the project.

The public's reception of the film was encouraging, although again we had some technical problems. In the process we were using then, the red and green images of Technicolor double-coated film were not quite in the same plane. Focusing had to be exact. In addition, the double-coated film was thicker than ordinary black and white, and it tended to warp and cup as it sped through the projector.

But Lasky was pleased. He had caught on to the technique whereby the use of color can heighten drama. In one particular scene, the hero, tracking the wounded villain to a gold mine, notices a trickle of muddy water flowing from the mill sluiceway slowly turning red--and he follows this clue to the villain's hiding place.

Up to this point we had no experience photographing under artificial lights and no proof our process would work under studio conditions. We welcomed an order from Samuel Goldwyn for inserts in a film titled "Cytherea," starring Irene Rich and Lewis Stone. The color inserts were to be used for two dream sequences. George Fitzmaurice directed the film on the United Studios lot in Hollywood.

Our first experience in photographing an interior set on a dark stage was successful. The New York Times review of the film mentioned "the exquisite sequences of color photography in which one enjoys the varied hues and tints of Cuban costumes and scenery."

Another insert order came from Louis B. Mayer. This was the occasion of my first meeting with the legendary Hollywood executive.

Mayer, a one-time scrap dealer, began buying up nickelodeon arcades around Boston and made a fortune by acquiring the distribution rights of *The Birth of a Nation*, D.W. Griffith's early epic. He made films in a Brooklyn studio before moving to Los Angeles, where he and Samuel Goldwyn, unhappy in partnership with his brother-in-law Lasky, merged into Metro-Goldwyn-Mayer. For the next twenty-seven years, according to legend, he was the arbitrary, ruthless ogre who ran MGM.

When he acquired rights to *Ben-Hur* in 1922 from the family of author General Lew Wallace, the book had already had two lives as a best-selling novel and a successful stage play. Mayer intended to bring it to the screen.

We sent six men and four cameras overseas, as initial shooting was to begin in Italy. This was soon followed by reports of trouble on the set. Accidents accompanied the filming of the sea battles at Livorno. There was political unrest in the area. Unsatisfactory local workmanship was causing loss of time and film. In addition, the rainy season was approaching. Mayer himself made a trip to

Rome to see what was causing the delay--and, incidentally, to determine what portion of the picture would be in Technicolor. We had agreed to photograph a minimum of 1,000 feet of film, from which they would order not fewer than one hundred prints; I urged them to use the thousand feet in one continuous piece, because our double-coated film would tend to jump in and out of focus if we had to pass back and forth too many times from black-and-white to color.

Finally the unit was brought back to Hollywood to complete the film. Mr. Mayer called me to his office with a problem: Under his contract with the Wallace family, he was forbidden to show the figure of Christ on the motion picture screen--it was thought to be considered sacrilegious by the public. Unfortunately, in some of the Technicolor scenes, the figure would appear. What did I propose to do about it?

Thinking on my feet, I suggested that perhaps a shadow of the figure would be acceptable.

In a few days his office advised that such an arrangement was permissible under the contract, and with that news we went back to work. Mayer was pleased with the final result, although to our disappointment very little of the colored footage was used in the final version of the film. I thought the Nativity sequence, filmed in Technicolor, was memorable. *Ben-Hur* won its place in motion-picture history not for color but for its brilliantly filmed chariot race, one of the most exciting scenes the public had yet witnessed on the screen.

L.B. (the initials alone were enough to identify him) was always a fascinating enigma to me. At times I found him to be the most considerate of friends but at other times he was unnecessarily severe and unreasonable. One occasion comes to mind.

Mr. Mayer's secretary telephoned my office in Hollywood and asked me to come to his office in Culver City immediately on a most important matter. When I arrived about half an hour later, he was seated at his desk surrounded by a dozen men to whom he was giving orders. As soon as he spied me entering the door he rose and shouted, "Kalmus, you are ruining my company! You know perfectly well that MGM receives nearly half its revenue from its foreign business and yet we are unable to get foreign prints from Technicolor. It's impossible. I won't tolerate it! I tell you, you're

ruining my company."

I was taken aback. "Mr. Mayer, you asked me to come at once with out telling me the subject of this discussion. I have no immediate explanation. I will certainly find out why you have not received foreign prints. There must be some good reason, and I will let you know as soon as I get back to my office. But nothing could be further from the purpose of anybody at Technicolor than to ruin the business of one of our best customers."

At that, one of his men rose hesitantly and interjected, "Mr. Mayer, I think you should know that as yet we have not delivered the foreign sound track of the picture to Technicolor so that it's been impossible for them to deliver any prints."

If I expected an apology--then or ever--from L.B., I was disappointed; he immediately started an inquisition to locate and reprimand the member of his organization who had failed to keep him informed.

Eleanore reminds me that I had known L.B. some twenty years before she met him for the first time. "Remember, Margaret Ettinger invited us for tea, along with L.B. and Lorena Danker, whom he later married. I thought Lorena the most beautiful girl I had ever seen in Hollywood, on or off the screen," Eleanore recalls. "I anticipated a formal occasion, but Margaret led us straight to the dining room of her home, which had been Carole Lombard's house, and there we found L.B. and Lorena at the table confronting five dishes heaped with coffee ice cream and generous servings of white grape fruit cake. I could see right away that it was to be a board meeting of ice-cream buffs. I remember how the women laughed, watching you men racing for seconds. It was after that day that we were often a foursome. The L.B. I knew was warm-hearted and generous and a flawless host."

There were times when Mr. Mayer talked to me about the motion picture industry, and at those times he was "full of business" and very wise. And it is to him I owe one of the most meaningful relationships of my life. Each year when Cardinal Spellman passed through Los Angeles on his way to his missions in the Far East, he was a guest at the Mayers' home. That was where Eleanore and I met him, and where a warm, friendship began that developed through the years.

In 1925, we had a process that worked--Technicolor Process

No. II--and in the research laboratory were hard at work on an imbibition process that would be an improvement over that. Under optimum conditions, we could deliver prints at 15 cents a foot. We had worked outdoors in natural light and on indoor sets. The public had expressed its pleasure in the Technicolor scenes it had viewed so far. With these successes, we found ourselves puzzled by the fact that Hollywood was still reluctant to use color. The industry was turning out hundreds of films, and yet caution and cost-consciousness prevailed. No one had yet seriously undertaken real color work, as I envisioned it--careful color work, with adequate preparation, by someone ambitious to do great work and who was at the same time sympathetic to the technical requirements of color photography.

What we also needed--what Technicolor needed--was a star. The star system was already in place in Hollywood, and there were many names in that firmament: Charlie Chaplin, Rudolph Valentino, Gloria Swanson, Mary Pickford, Douglas Fairbanks, Pola Negri and more. Any one of them could "make" a film by the powerful draw of the name alone. Where were we to find the brilliant and sympathetic star to show our product to the world?

CHAPTER FIVE

Douglas Fairbanks Takes a Chance

When *The Toll of the Sea* was released in 1922, one of the most gratifying responses was a telephone call from Douglas Fairbanks. He was intrigued by color, he said, and considered our process the most successful he'd seen. He talked about "producing a feature someday."

That "someday" seemed a long time in coming. In 1924, I was in Europe discreetly looking for a location for an English Technicolor plant but also surveying European commercial color development in general. In Berlin, I ran into Mary Pickford and Douglas Fairbanks. They were eager to make some tests in color. The two of them had a tremendous capacity for fun and while enjoying the city in their company and driving into the country for picnics, I managed to get the test shots done.

They seemed pleased with the results, and Mary spoke of "doing a picture in color next spring." They were then negotiating with Joseph Schenck to merge his interests with theirs in United Artists Corporation, the company set up by Fairbanks, Chaplin, Pickford and D.W. Griffith to declare their independence from the big studios. Was their time completely taken up with these business details, I wondered, or was Mary satisfied with her career in black and white and unwilling to risk a change? For the truth was I would have given anything to see her become the first big Technicolor star.

United Artists was unique in that the company owned no studio of its own, but rented studio facilities for each production. It owned no interest in theater chains, and had to arrange the distribution of its film. Instead of being a drawback, this seemed to work well for them, and they produced films of great merit.

Mary's keen business instincts and judgment were perhaps the best in Hollywood. She and Doug were indisputably the reigning couple of the film world. He had a tremendous amount of energy and organizing skills and was an innovator in film production and distribution. He was knowledgeable about every phase of filmmaking, and took a hand in the technical side, too. He had a

particular gift for set design, and always put his own mark on a film. It is well-known that he did his own stunts, but perhaps not so well known that he did a great deal of historical research in preparation for a project.

And of course he was a great star, handsome, debonair, and graceful. The kind of swashbuckling adventure film he perfected was never improved upon.

It always seemed to me, from our conversations, that Doug felt the art of the screen was something entirely apart from every other art form, that it was almost purely emotional. He recognized that the mere telling of the story could be better done by words, but he believed that a series of impressions or emotions could be better conveyed by the motion picture, which could select what was dramatic and significant and fail to recognize anything else. The camera literally points to the subject matter; the audience watches and in an almost collaborative and creative way understands.

What Fairbanks saw on the screen photographed in Technicolor he found to be not a hard picture outline of the subject matter but something that was softer and beautified and glorified, actually depicting more on the screen through the use of color than the eye itself sees.

Doug was convinced that the screen had never caught and reflected the real spirit of piracy that is found in the books of Robert Louis Stevenson or the paintings of Howard Pyle. He believed he was ready to capture it with the use of color.

"This ingredient has been tried and rejected countless times," he said. "It has always met overwhelming objections. Not only has the process of color motion picture photography never been perfected, but there have been grave doubts whether, even if properly developed, it could be used without distracting more than it adds to motion picture technique. The argument is that it tires and distracts the eye, takes attention from acting and from the expression on the face of the actor, and blurs and confuses the action. In short, it is felt that color militates against the simplicity and directness which motion pictures derive from the unobtrusive use of black and white.

"These objections have been entertained, I think, because no one has yet succeeded in dissipating them. A similar objection was raised, no doubt, when the innovation of scenery was introduced on

the English stage--'It will distract attention from the actors.' But I can no longer imagine piracy without color....''

In disagreement with Hollywood, Doug voiced the idea that color would be ideal in photographing large sets--it would enhance their beauty and dramatic effect and it would not matter that the people would be only incidental, faces scarcely visible at all. He was producing *Robin Hood* at the time, and perhaps its enormous scenes influenced his thinking.

I argued that the purpose of most motion pictures is to tell a story and that people are the means of telling that story and that faces and expression are of greatest importance in the telling. I felt that it was precisely there, in the beauty and expression of human faces, that Technicolor did its most useful work.

We had many such discussions, and finally Doug asked me how he could settle once and for all the charge that color on the screen hurt the eyes. I told him that if I were about to put a great deal of money into a film, I would have the point scientifically tested.

Two noted ophthalmologists tested the theory on Doug's behalf, using black-and-white film and film taken by the new Technicolor process and testing 150 students and other volunteers. The results were published in the Journal of the American Medical Association in 1926. The conclusions were that more fatigue is evident after 45 minutes of reading magazines than after viewing black-and-white or colored film for 1 1/2 hours, that the viewing of colored pictures of the Technicolor process is not more fatiguing to the eyes than black-and-white pictures (on the contrary it seems to cause less fatigue), and that those who suffer eyestrain from motion pictures are those who are unable to accomplish other ocular work without similar eye fatigue.

This report removed Doug's last doubts, and he proceeded with plans to film *The Black Pirate*--the story of a nobleman who turns to piracy--in Technicolor.

His attorneys, knowing that the film would cost $1 million, a staggering sum for a motion picture in 1926, pressed for a guarantee that Technicolor would be able not only to deliver prints but to deliver satisfactory prints. We resolved this concern with a three-party agreement: if Technicolor's Hollywood plant had any problems with delivery, KC&W, which still had the pilot Technicolor

plant in its basement in Boston, would guarantee delivery.

There was much discussion on the color key for this picture. We made test prints for Doug at six different color levels, from a very muted palate to the most garish rendering Technicolor was capable of. He chose one that he felt would capture moods in the manner of impressionistic paintings.

Doug was meticulous in testing materials such as costumes, make-up and locations. He made test shots on Catalina Island, using a specially constructed pirate ship. We assigned four of the existing seven Technicolor cameras to him. In the end, most of the motion picture was shot on the lot, including the scenes at sea, which were done on a huge ship model floating in an artificial pool and rocked by mechanically produced waves.

I was tremendously buoyed up by this project. It had all the elements I looked for in a color motion picture--careful preparation and planning, cooperation between the various principals, and a great star whose concern for the success of color matched my own. The early rushes were remarkable. I wrote to Toland, back in Boston, that I was unable to express how really remarkable they were. In one of Doug's action sequences he descends from high in the ship's rigging by digging a knife into the sails and then ripping the sails from top to bottom as he rides them down. What a scene!

The picture was released through United Artists in 1925. It was a triumph. Audiences loved it. Reviewers praised it. The New York Times declared that it brought to mind "the paintings of the old masters."

For Technicolor, it was both a triumph and a headache. The double-coated film was still cupping, randomly and in either direction. Whenever it happened the film jumped out of focus. We sent teams of men around the country to supply new prints to replace the old ones, with orders to ship the unsatisfactory prints back to Boston for decupping. The newly decupped prints were temporarily satisfactory for use, and we were able to keep the theater owners happy, but our mechanical troubles never ended. It would be impossible to give this kind of treatment to every motion picture that came out--it would never be commercially feasible. Clearly the double-coated process was another temporary method; I knew we had to press for a true imbibition process that would allow both color component layers to run on one side of the film.

One blow followed another. Fairbanks told me he had decided not to do more Technicolor pictures for the present but to wait for a more perfect process. I knew he had been disappointed with the night scenes in *The Black Pirate*. And Jesse Lasky's office reported that they would do no more work in color-- "First, because the double-coated film scratches much more readily than black-and-white and the necessity to replace copies is an added bother to our operations, and second, the cost is out of all proportion to the added value. We paid $140,000 over our other costs for *Wanderer* prints. We understand that Technicolor needs volume to bring its costs down. Someday, at eight cents per foot, we would be interested in talking volume."

Of course, any Hollywood producer would talk to us at eight cents a foot. At the time, black-and-white prints cost about 3 1/2 cents a foot. Our average cost of production was substantially over 15 cents a foot and at times more than 25 cents a foot. We were back where we started with a multi-million dollar investment and no customers.

As before, the answer was in research and more research. Didn't I say it was all process? What we needed now was a single-coated two-color print and the capacity to do a large volume of business. And we were not the only company pursuing that goal; companies all over the world were working on a solution to the problem.

Our work on Technicolor Process Number Three was far along and very promising. My only regret was that it was not successful in time for *The Toll of the Sea* and *The Black Pirate*.

Basically, the new process worked this way. First, the cinematographer obtained a negative of the color aspects of a scene using the special Technicolor camera. The next step was to make two relief prints, one registering the components in the red half of the spectrum, another the green.

These two separate relief films were used as matrices, much in the way metallic plates or stones are used in lithographic printing. We built a machine that ran each matrix strip through a dye bath which impregnated it, one with a red dye and the other with a green dye. The red matrix was then brought into contact with a celluloid film strip bearing a single transparent layer of gelatin. By keeping this matrix in contact with the gelatin for the

right time and at the right temperature, the red dye was transferred by diffusion or imbibition into this gelatin layer. The red matrix was removed and the green one applied in the same manner. The result of these two impressions--or imbibitions--upon the original blank, one after the other in register, was a finished film, ready for theater projection. The machine could use the same matrix over and over, and the resulting film was mechanically identical with standard motion picture positive.

In early 1924 we were making definite progress. We'd had to build several machines to overcome such problems as slippage of the two films during processing, accidental inclusion of air or water between the matrix and the positive, variations in the exact superimposition of the two colors, and variations in the balance of coloring and in the sharpness of the resulting picture, but by November of that year I was able to tell Technicolor's directors that we could do it--we were able to make film of commercial quality, although we couldn't yet produce it in quantity.

There was still one difficulty--the tendency of the dyes to bleed, or spread sideways, during the transfer process. By this time our engineers had developed new dye formulas and improved control conditions and the problem was in the process of being solved.

Once we were in production, I could predict that the new film would be cheaper to manufacture. It would have other advantages, as well: with the gelatin on one side only, it had the same thickness and structure as standard black-and-white film; the size of a 1,000-foot roll was the same as that of black and white; it was less liable to be scratched in the projector; it was easier to keep in focus; there would be less cupping than in black and white; definition, registration and color values were excellent because of the absence of protracted chemical treatment in the process; and we expected prints to have a longer life than black-and-white prints because of the extra toughness of the gelatin coating. What more could anyone ask?

Interestingly, no fundamental patents came out of all this work. Much of the groundwork had been laid earlier. And here, as before, it was the ingenious overcoming of technical difficulties, business sagacity, financial stick-to-itiveness and our investment in buildings, equipment and personnel that allowed Technicolor to

offer its unique product and services to the motion picture industry.

I had to persuade producers that they could afford color if they adopted a different aesthetic right from the start. By a different choice of story, different choice of setting, different cast and production values they could have a better production for a given amount of money than would have been possible for the same amount of money in black-and-white. I insisted that it was not a question of so much a foot for the prints. The production cost question should be, "What is the additional cost for color per unit of entertainment?"--not per foot of negative. But this was a hard idea to sell. As for production costs, Schenck himself admitted that it would probably cost no more for make-up, sets, costumes and the rest for color pictures than for black-and-white if these decisions were made with color in mind from the beginning.

I sought energetically to get another commitment from Jesse Lasky, but he argued that he was not sure Technicolor could consistently produce prints as good as those we gave him for *Toll of the Sea*. Until Technicolor was better established, it was going to be necessary to photograph any important production both in color and in black-and-white as insurance. In short, he felt the industry was not ready to shift to the different demands of color.

Within Technicolor, I was facing some of the hardest battles the young corporation had yet faced.

Judge Jerome was a man of broad vision and ambition, but along with these characteristics he possessed a violent impatience. In late 1923, he was reporting to the directors of Technicolor in an optimistic vein:

"We have overcome the antagonism existing on the part of producers to motion pictures in color. . . .

"We now have the entire field of color to ourselves; we are practically without competitors. . . .

"Selling to the trade at 8 to 9 cents per foot, and acquiring 10 to 15 percent of all U.S. production--that is, 1 million feet per week--we could perhaps make a profit of $1 million a year. . . ."

Jerome was reporting in the spirit of optimism we both shared at the time. At a later date, he spoke as if all the optimism had emanated from me. "We are not able to keep up with Kalmus' promises and expectations," he told the directors in a negative

memorandum. Expectations, yes, but no promises had been made by me.

I understood the pressures the Judge was under. He had invested much of his life's savings in Technicolor and had raised large investments from personal friends. So far, we had not attained the success he had anticipated. I knew that, in his own field, he was accustomed to ruling like a czar. But I knew full well that Technicolor was in no condition to stand a rupture or even a weakening in its ranks during this period of its lowest performance. I was fortified in this stand by my deep positive feelings for the Judge. He often took steps to which, if dictated by my mind alone, my response would have been antagonistic and negative; where the Judge was concerned, I learned to put patience and moderation first. Had I taken a different course, it would almost certainly have been the end of Technicolor.

Not only was I facing a monumental task in selling Hollywood on color and using all my diplomacy to contain Judge Jerome's impatient actions, I was also feeling the rupture as Technicolor began to separate from its parent engineers.

To retrace that connection, the process upon which Technicolor stood involved a large number of patents and patent rights and the design, construction and operation of the early Boston film laboratories. This early work, from 1915 through 1924, was the creation of KC&W and was done under a contract which stated that Technicolor would receive the entire benefit of that work.

During those years, as I served as President of both companies, I had constantly in mind that Technicolor would one day become an independent entity. It could not be rushed--much of its assets were intangible, represented by the training of men in both companies and what they had in their heads. By late 1924 I had largely effected the separation of the camera and field staff and the manufacturing plants from KC&W. But we were still working on Process Number III, and this was still inseparably associated with the work of Comstock, Troland, and a key group of their assistants.

From 1920 to 1925 I spent more than half of my time on Technicolor business, receiving remuneration under the contract with KC&W. I reminded the directors of Technicolor that this contract would soon expire. They were free, of course, to renew or not, and free to find a new President if they wished. As I wanted

them to see exactly how things stood, I spent a lot of time with individual members of the board, particularly the executive committee. I gave them good news on the progress of the new process. I sounded them out about producing another film. And I never failed to encourage them to view Technicolor in a broad, long-range, courageous way.

I was hampered by a critical memorandum--a "candid report," he termed it--sent to board members Erickson and Childs by Judge Jerome in March, 1924. It contained much misleading and even erroneous information. In a 45 page letter of response, I tried to correct this and other statements by the Judge, and in April, 1924, at a meeting of the board of directors and the executive committee I offered to resign before any situation could arise in which there might be a conflict of interest between Technicolor and KC&W.

The next few months were, in my mind, perhaps the lowest in the struggle for Technicolor's survival. Finally the directors referred matters to the executive committee, which made a thorough investigation and approved practically all the recommendations I had made in my earlier report to the board. They confirmed me in the position of President. Most importantly, they ordered the settlement of the KC&W accounts on a basis satisfactory to that company. In October, 1924, the engineers of KC&W turned over to Technicolor the newly completed California plant, marking the end of the weaning process of the Technicolor child from its parent. I wonder if Comstock and Wescott had a premonition on that day in Boston when they first saw me off on the train to California that this would be the result: Hollywood was the natural home of Technicolor.

My overwhelming concern now was Technicolor Process Number Three which, while still a two-component process, would prove to be the first really practical means for the production of color motion pictures in large quantities at a cost at which they could be sold. Some forty feature pictures would be made using this process, including *The Vagabond King, On with the Show, Whoopee*, with Eddie Cantor, and others. A boom period was about to begin in Hollywood.

To be sure that Technicolor shared in it, I urged the directors to consider again producing a picture to demonstrate both the

quality and costs of the new process and to keep our new plant busy while producers were still hanging around at the starting gate. To my surprise they instructed me to make it.

"What do you know about producing a motion picture?" they asked me.

"Frankly, nothing," I replied.

CHAPTER SIX

Farewell to Silents

About this time there occurred a break in my life I could never have foreseen. There was a rupture between myself and Daniel Comstock.

Dan and I had been the closest of friends. His mother was nearest to a mother I had known since childhood. We shared many interests, from abrasives to motion picture cameras, from poetry to philosophy. Dan and I owned practically all the stock of KC&W, the company we had started at MIT, in equal amounts. We were filled with enthusiasm for our work and for one another--I always regarded him the brightest scientific mind I had ever encountered, and he held me in equal regard in the ability to organize a business and maintain its financial support. Almost everything we touched had prospered. The firm boasted an enviable life history from 1912 to 1925. How could there be a rift between two such rare companions, with only success to look back on?

I was working long hours in Hollywood. Comstock was in Boston, and Ernest Wescott, brother of Burton Wescott who had retired from the original KC&W, was in charge of the Buffalo laboratory. At that distance, feeling the responsibility of pleasing clients and customers and of keeping profits up on behalf of our stockholders, I exercised the authority corresponding to that responsibility to point out how KC&W could perform better and ways in which it was failing to do so. I may have criticized Comstock and Wescott in a manner which they thought severe; I, at the time, felt that emphasis was necessary for the words to be effective. I know my language should have been such to convince them that it was not important to me to be their "boss," but to have our projects succeed. Everyone wants to be significant and so did Comstock and Wescott and so did I. If I had been able to make them feel that I wanted them to succeed so much that I would gladly have brought it about at the expense of my own significance it might have meant the continued existence of the company.

Unfortunately I did not convey this. Wescott could not toler-

ate the criticisms I found it necessary to make of his work at Niagara Falls, and Daniel was uncommonly sensitive to my remarks arising from clients' complaints. In my absence, they sympathized with one another and together challenged my authority with no alternative plan for any relief from that responsibility. Instead of speaking directly to me about their feelings, they created an impossible situation. The day I learned how the two of them had handled their grievances I was stunned silent; it is one of the dates burned into memory.

I hope the trauma was a lesson to me in the art of criticism and the management of others. I was encouraged to think so in later years when I heard our employees happily refer to the "Technicolor family" and speak with pride of the history of the company and affectionately of their association with the writer.

The outcome of this was that Dan and I divided the assets of Kalmus, Comstock & Wescott as nearly as could be on the procedure of two boys dividing an apple pie, namely, one boy cuts the pie in halves and the other boy takes his choice.

Until the break with Dan actually happened, I never thought that I would be going it alone. But I did know this: From the moment I gave Technicolor its name, I knew I was going to put natural color on the screen and I knew that somehow it would become my sole responsibility.

Judge Jerome insisted that I bring with me to Technicolor whatever KC&W men I chose who wished to come, and Technicolor would manage without the others. Comstock, Weaver and Whitney, among others, discontinued their work for Technicolor, while Troland, Ball, Cave, Riley, Conant and I remained with it.

Up until about this time, over two and a half million dollars had been spent on Technicolor. I had never concealed from the directors what a technically difficult undertaking the whole thing was, and how much business sagacity and financial endurance it would demand to see it succeed. I went before them again, not to ask for money for cameras or printers or imbibition machines but for money to go into production. For the first time, I was going to be a producer. As I told the board, my lack of experience might be a disadvantage, but at least I could start from scratch without some of the fixed ideas and prejudices concerning color that some of the Hollywood producers seemed to have accumulated.

I chose the title *Great Events* for a series of short subjects that could be shown along with feature films. The prime object was not to bring in income but to demonstrate that there was nothing mysterious about the operation of Technicolor cameras, that the transition from what the eye saw to what the emulsion recorded could be mastered with experience, that black and white cameramen could easily adapt to color, that rush prints could be delivered promptly, and that the job could be done efficiently and economically.

Dr. Troland argued for a light-hearted product, a single feature capitalizing on broad public taste for comedy and romance, but I had in mind a historical series. In the first, *The Flag*, I thought that George M. Cohan never produced anything more certain of applause than when Washington unfurls the first American Flag in glowing Technicolor. Another short was based on the divorce of Napoleon and Josephine. Producing these two-reelers was an experience that established the fundamentals of our studio service in both camera and color control departments. We had to have this background in production--in my opinion Technicolor would not have survived without it. Now we were ready to supply the industry with total advisory and technical services.

So far we had made our first film, the 1917 one-reeler *The Gulf Between*, to no great acclaim. In 1922, *The Toll of the Sea* was our first full-length Technicolor film. In the following year, Cecil B. DeMille filmed the prologue to *The Ten Commandments* in color. In 1924, we had sequences in two movies, *Cytherea* and *The Uninvited Guest*, and Jesse Lasky made the second full-length Technicolor film, *Wanderer of the Wasteland*. In 1925, Technicolor sequences were used in several motion pictures, and in 1926 Douglas Fairbanks made the third Technicolor film, *The Black Pirate*. Using our new process, we produced twelve *Great Events*. They were well-received in Hollywood and New York.

But still the rush to color did not materialize. It was Joseph Schenck who finally decided that the industry was ready for Technicolor, telling us that if we would produce a feature-length film, Metro would distribute it.

I already had an idea of the motion picture I wanted to make. I had been impressed by an earlier epic, a touching love story combined with the conquest of a continent called *The Covered*

Wagon. Why not use the same ingredients in a tale about Vikings, who combat mutinies and storms to conquer an ocean? I hired Jack Cunningham, who wrote *The Covered Wagon*, to write *The Viking*.

Judge Jerome and Eversley Childs decided that the financial committee (they happened to comprise two thirds of that committee) would fund the production, and we hired popular actor Donald Crisp, who had played General Grant in *Birth of a Nation*, to play Leif Ericsson.

In the course of shooting *The Viking* a dreadful premonition came to me: We were in danger of producing a historical film--the last motion picture without sound.

Edison had conceived his original motion picture camera, patented in 1891 as the Kinetoscope, as a visual complement to his successful talking machine. And actually the screen had never been totally silent; the "silent era" films were accompanied by piano or organ music or even, in major movie theaters, by a full orchestra. *The Viking*, while not a "talkie," was the first feature to be synchronized with music and sound effects. However, experiments with synchronized talking pictures had been going on for decades, and several organizations were close to a breakthrough. As usual, commercial producers were dragging their feet. How often I had heard their plaintive cries! "No one will look at a picture for longer than one reel!" "Color distracts the audience and hurts the eyes!" "Sound is a temporary novelty!" Now they knew that their world markets would collapse if they could no longer use titles, which were easily translated, to explain dialogue and narrative. In spite of their hostility, the era of sound was fast approaching.

It was during this period of change that a terrible battle took place inside Technicolor--this time between a fine old soldier who was growing too tired to fight and a man who had trained himself to always come up fighting when they knocked him down. The very life of Technicolor was at stake.

The accomplishment of Technicolor Process Number three, workable as it was, was still only a two-component process. Only approximate reproductions of all shades of all colors can be obtained by recombining red and green, while all shades of all the colors of the rainbow can be obtained by recombining red, green and blue. I had believed for so long that somewhere in the future

we would perfect a full three-component system and put full natural color on the screen that I could not stop the research process that would take us there. And now I had a new spur: We must not only bring into existence the final three-component Technicolor process, we must do it in tandem with the best and most commercially viable form of sound. And we must do it before producers and public become so wedded to black-and-white sound motion pictures that we would be right back where we started, selling a well-established industry the idea of color. I was so convinced that sound and color motion pictures were the future of the industry that even if I had been the only man in the world to believe it, I would still have upheld my conviction.

While I was busy on the set of *The Viking* in Hollywood, Jerome and Erickson were growing irritable in New York. They were hearing criticism of the films made in Process Number Three, and with good reason. Producers still did not realize that a color film is not just a black-and-white film shot in color. If a script has been conceived, planned and written for black-and-white, it should not be done in color at all. The story should be chosen and the scenario written with color in mind from the start, so that by its use specific effects are obtained, moods are created, beauty and personalities are emphasized, and the drama is enhanced. Color should flow from sequence to sequence, supporting and giving impulse to the drama, becoming an integral part of it and not something super-added, a novelty. The use of color demands an aesthetic, just as any other form of creative endeavor. Producers, anxious to hurry their products to market, were not worried about quality, but we at Technicolor were hurt by criticisms on color.

Jerome and Erickson did not agree with my views on the nature of our problems. Basically, they did not understand the significance of the arrival of sound, or the necessity of keeping our production department alive, or the urgency to fund research to complete our work on three-color cameras. A controversy arose on whether or not the income from production was to be used to make further productions. And most important at the time, we were of two different minds on which sound system to back.

A series of letters went back and forth between us. I have decided to publish this correspondence at length because it spells out so clearly the position of both protagonists, as well as giving,

without hindsight, a picture of our understanding of the technology of the moment and, in addition, conveys some of the flavor of both personalities, each fighting for his own point of view. I believe it was a time when Technicolor came closest to going under.

On August 15, 1928, Judge Jerome wrote a letter to me in which he described a meeting with representatives of the Radio Corporation of America.

My Dear Herbert,

Yesterday Troland and I met with Sarnoff and Bucher for about an hour. I told them that we had started out with the idea of being simply a manufacturing corporation with no intention of going into production, but that we came to realize that in order to make considerable money as a manufacturing concern we would have to have a very large volume of business, and we found that we were not yet able to secure such a large volume from motion-picture producers. We then saw that we would either have to be producers ourselves or obtain in some way a cut on the profits of production. Our business had brought us into close touch with Hollywood and we reached the conclusion that there was no mystery about successful production, that it required only the application of sound business methods. To make sure we were not mistaken in our conclusion, we went into production in a small way and produced short subjects and found an immediate sale for these at a profitable price, and encouraged by our success in this direction entered upon the production of a feature film, which, if successful, may lead us into production on a large scale.

Sarnoff said that our position was the same as theirs, that RCA was not interested in so small a business as the simple manufacture of talking apparatus for the motion picture business. He asked me what kind of a hook-up we could make, suggesting that we go in together and make a $100,000 picture with talk synchro-nized by their Phototone method. My reply was, Why put $100,000 into a picture when there are great difficulties that have not been overcome in the talking moving picture--why not make a short subject like the ones we had been making at Technicolor to demonstrate the possibilities at an expenditure of less money? He assented, and I then said that we ought to first test whether or not the Phototone process

was practical in a typical movie application. To have a singer singing directly at a microphone from an unvarying distance is no fair test of the process because in moving pictures the actors are in rapid motion, turning at all sorts of angles, moving to all sorts of distances. Perhaps what should be done is that their man, Dr. Goldsmith, and our man, Troland, should get together and stage a simple and short test under conditions similar to those occurring in a motion picture scene. He agreed, and said that if we were successful we could make a talking feature together.

Later, Troland, Erickson and I talked it over and had the idea that we should have a well-dressed, good-looking woman walking about, as she might in an opera, singing. We could film a couple of hundred feet of this. This scene would be followed by a man and a woman with good speaking voices--trained actors--who would talk and laugh and move about as they would on the stage in a vaudeville skit or drama for about three minutes. We'd follow this with about three minutes of orchestral music. Technicolor would bear the expenses of the photographic work and RCA would pay for the rest. Wire me at once on this subject.

As to the theaters that will be equipped by January, 1929, with talking apparatus, I believe the number has been exaggerated. I am told that there will not be more than 800 and perhaps no more than 600. The idea that it will be impossible to get into first-run theaters without sound is nonsense. I hear that Joe Schenck will have nothing to do with sound and is going ahead without it. The Fox man here says that most of the stuff put out is awful and practically useless for their European business.

Erickson and I both believe that there will be some place in the movie game for the talking movie. At present, the industry is in a hysterical state on the subject, with each producer so fearful that the other producers will get a jump on him that his judgment is impaired. In newsreels, in something like Mussolini's address or a speech of acceptance by a political candidate, sound may have an immediate value, but it is too early to determine what place it will occupy in the dramatic moving picture. We do not, by the way, think the dramatic moving picture is going to be permanently helped by little dabs of sound thrown in as a stunt. For music accompanying a production, it may have a quick and growing appeal.

In short, we should make tests with RCA and any other con-

cerns involved in the talking process, but practically at their expense. We should do nothing in the direction of talking movies that would involve us in expenditures of any considerable sums; you will see the reason for this when I address your request for more money to pour into the three-color process.

I realize that three-color work is something very much to be desired, but the financial situation renders the expenditure of money for research impossible. We feel that we have got to go on the best we can with what we have got, and when we have been for some time in the black--even if only a very little in the black--then we may consider the question again.

I gather from your last letter that you are under the impression that the money subscribed to produce the Viking picture is to be a revolving fund and that the profits from this production are to be used for another large production. In this you are in error. The funds were for this picture alone, and the profits from it should be returned to the syndicate members. I have no authority to say different.

As I have already written you, I know of no way in which we can get additional money except from Erickson, and we cannot at present look for additional funds from him. We have got to confront the situation. Our present indebtedness is $788,312; our interest on money owed individuals and the bank is $40,450 a year. We owe Erickson $122,500 on personal loans, and when our note for $500,000 at Bankers Trust became due last Tuesday, I had to borrow from Erickson against 3,000 shares of Technicolor.

From this you will see that we have got to be over $3,000 a month in the black to take care of our interest alone. My conclusion is that however much we may want to undertake new research, and however beneficial it may be in the long run, we are absolutely up against it. I know of no way of getting more money. It has been very hard for me to write much of the above because I am so fully appreciative of the great difficulties you have been grappling with. Erickson and I both feel the utmost confidence in you and share the highest degree of optimism for the future, but for the present we must move along the road we are now traveling.

Don't think that either Erickson or myself, the only two of the group available for conference at this end of the line, are depressed or disappointed. We are most sanguine, perhaps too sanguine, and

tremendously understanding of the very hard work that you are doing and the constant strain you are under. My own faith in our ultimate success has always been great and Erickson's optimism is just as high. Go to it, old man, and do the best you can under existing conditions. We are backing you one hundred percent.

As ever, sincerely yours, Wm. Travers Jerome

In reply, I wrote to both:

Your sources say there will be "only" six or eight hundred theaters equipped to show talking pictures this year. That number seems phenomenal to me, because these are the largest and most important theaters and generate a tremendous revenue. They are the first-run theaters in the big cities, with the longest runs and highest prices. Only yesterday Mannix told me that Metro is spending huge sums preparing to produce talking pictures and that while he considers present quality very crude he feels sure that talkies are here to stay--in fact, the crude pictures with voice are the ones now doing the biggest business. Oddly enough, it was Joseph Kennedy, the very man your source told me knew most about the situation, who said that a picture would have to have at least five or six spots of dialogue to get into the big houses this fall. I don't agree with him, but I do believe that short subjects with voice are coming in rapidly and the first person to come out with color and voice will clean up. Orchestration and sound effects are already so common that they have begun to lose their novelty. The big question is whether a new type of motion picture story, designed to take advantage of dialog, will have the effect of making this new form of entertainment permanent. Practically everybody of importance in Hollywood believes that this will be the case, and every big studio is building or planning to build soundproof stages. Joseph Schenck's studio, United Artists, has a large soundproof stage under construction and is spending at least $300,000, which doesn't jibe with your information that Joe Schenck "will have nothing to do with sound."

I believe color is never missed as much as it is in talking pictures. The producer who puts out the first good talking Technicolor production will make history. Fox made a test with us and, although it was preliminary and crude, they thought so well of it

they wanted to make a short subject for release. I couldn't do business with them because they wanted to limit us to being solely the laboratory for the project. All my recent endeavors have been in the opposite direction: namely, not to take business which seems to directly conflict with what we might ourselves produce in the near future. When we are ready, I think we will produce sound and color pictures as well as anyone, for within a year it will be possible to rent soundproof stages in Hollywood just as we now rent regular stages. Why then jeopardize our position of being producers by making such an unprofitable deal with Fox?

I was tremendously interested in your account of the conference with Sarnoff at RCA. It seems to me the test you discussed is not practical because it does not do either of two things a test should do: obtain a product good enough to show the public and good enough to encourage everybody to go ahead in the field, or, simply as a piece of research, teach us something about synchronization.

We have already made enough tests to know that--using Movietone and Vitaphone (and RCA if it works as well)--we can get results under temporary conditions, that is, we must have a special soundproof portable booth for our camera until the day we invest in building a silent camera, and we must use one of our most experienced cameramen to do the work, because such new considerations as simultaneous photography of long shots and close-ups with proper lighting of both are involved. We made such a test out here on the Lasky soundproof stage under these conditions which was technically satisfactory but was not fit to release because it entirely lacked showmanship. A film, however short, if it is going to convince those who count most in the industry, must be of such a character that both color and dialogue are seen to enhance its entertainment value. This is something for all of us to keep in mind, our production department as well as our technical staff. If we make these tests with RCA they should, in my opinion, have the same purpose that our first Technicolor short subjects had; namely, to produce something that makes better entertainment than the same thing in black-and-white.

Most of the difficulties you hope to resolve in your test are difficulties not special to Technicolor but equally applicable to black-and-white synchronization. The question of the actor's freedom of motion is the same in color as it is in black-and-white. It will

gradually improve as the sound people develop their art and is just the thing on which we should not spend money. We have held the bag for the development of a color process--let someone else hold the bag to develop the sound process.

One of our difficulties has been in arranging an optical system and lighting our sets to produce color. This is the job of the cameraman and it has become a fine art. The sound technician must learn the art of placing the microphones and of mixing the several microphone currents. He must keep the high treble voice of the woman and the deep bass voice of the man and other loud and soft tones all within the range of his equipment. The development of this art is going on at a terrific rate here in Hollywood and no doubt also in New York, but the RCA people are way behind the procession. They lack the showmanship which has characterized Fox' Movietone and other systems. Many people out here think that is why they lost out in negotiations with Paramount. Your test, it seems to me, would only demonstrate a point of technique which needs no demonstration, because it either depends upon the skill of the modulator or it will snag on a point of development that black-and-white motion pictures have not been able to solve either.

Our real problem is how to get aboard at this early stage, when everything doesn't have to be perfect--as it will later have to be. I don't think we can do it without some expenditure on our part. Meanwhile, we are keeping our options open. To go in for sound and three-color production ourselves, we need to become licensed, which is easy; we need a few silent cameras, which we could build if we had the money; and we need a soundproof stage, which will soon be available for rent.

I understand that we lack money, and for that reason want RCA to join us. If such a test is made, it should be done here in our own production department, where our cameras, cameramen, rush print unit and other facilities are located. But I must tell you that although every big producer is equipped or becoming equipped for production with Movietone or Vitaphone or both, there is not a single piece of RCA equipment here ready to use. Frankly, I don't see why we need them if they won't put up the money, or most of it. And if they don't want to do something new and superior--that is, put out the first color synchronized picture--I don't think their attitude is optimistic enough to have any chance of success.

To bring you up to date on The Viking, *despite the unseasonable cloudy weather, the sickness in the cast, reception of poor stock from Eastman, Ball's departure for the East, and other difficulties, some of the rushes have created much enthusiasm. This leads me to think of what our situation will be when production is completed.*

It is impossible for us to make a lot of money as a laboratory unless we have several times the capacity of our existing plants. I believe it will be impossible to get that volume of business from the industry if we do not have something spectacular, like three-color work, or something with tremendous novelty value like talking pictures, or if we are not ourselves in production.

If we are making pictures ourselves, we have a triple advantage. First, we have a knowledge of the capacities and limitations of our own process and an interest in accommodating ourselves which other producers are too busy or too unwilling to master. Second, we have a production department thinking solely in Technicolor terms, which means more value per dollar on the screen than other producers can get. And third, if we regularly put out good features, it encourages other producers to do the same. Without our example, they would soon convince themselves that many of the necessary steps are too expensive or too difficult, and give up color.

We can keep our present plants busy if our production department can make two or three features a year and a series of shorts. Without these, we are in danger of moving back into the rut we were in before we became producers. You said that syndicate money put into The Viking *is not pledged beyond this picture, but you must remember that it was definitely held out to me when you and Eric were here that if this picture is successful we would go into production on a larger scale. In fact, a very substantial scale was indicated.*

If The Viking *is not successful, I shall have nothing to say except to take the blame as a rotten producer. But if it does get good distribution, I can only say that to break up the combination of good men I have had on the set with me would destroy one of Technicolor's corner posts. These men left important jobs on the theory that if "Leif" was a success, we would go on in production. We literally cannot afford to disband this unit, for I cannot agree that "successful production requires only the application of sound business methods." It requires a combination of sound business methods,*

specialized technical knowledge, and showmanship. It would be heartbreaking to lose this talented group.

You may be sure that I am not unmindful of our finances, but we could clear up the whole situation with the first few successful full-length pictures. Meanwhile, the rushes look great, and I am very optimistic about the outcome of everything.

As always, affectionately, Herbert

In the following weeks, Fox approached me in Hollywood to suggest that we provide them with color cameras to make a series of short synchronized Technicolor pictures. I turned them down. They became insistent, asking if they might see a rough cut of the Viking picture with a view to distributing it. What they really wanted was to use color in some of their talking pictures. They offered us the use of a soundproof stage and sound recording apparatus in exchange for letting them use color. I could see that it would not be long before anyone could operate on a soundproof stage, but I believed it would be many years, if ever, before anyone had color like ours. Instead of cooperating with Fox, I turned my interest to MGM.

Irving Thalberg, the son of a German immigrant lace importer, was a delicate and studious boy who at the age of 19 became private secretary in New York to Carl Laemmle, head of Universal. Thalberg came to Hollywood and, only 20, became Universal's studio manager. From there he went to MGM, and everything that came out of MGM from 1924 to 1933 passed under his eye. He was Hollywood's bright young man, with his charm, ambition and power.

I wrote to Judge Jerome:

Thalberg asked if he might see our Viking picture in its present 12-reel form in order that he might make constructive criticism. We ran it in his private projection room late at night. In the middle of the film he leaned over to tell me that it was "very interesting," and at the end he said, "You have a fine story and it is well told. You got a splendid performance from all the cast except one. In spite of the lateness of the evening and the fact that I am tired, the picture held my interest to the very end."

Schenck had promised that if we produced a film, MGM would release it; Thalberg liked the result so much that he persuaded the company to buy it. Therefore we were reimbursed the entire cost of production of $225,000.

The Judge, having come around to agreeing with most of the points in my correspondence over the past months, wrote me from New York that he was raising $1 million for a Technicolor production syndicate, and sent me news of *The Viking's* fate in New York:

The Embassy was a very bad theater for the premiere. The throw was only 95 feet, and they had arcs in the projector of sufficient intensity to have shown the picture at the Capitol, where the throw is 135 feet. The screen at the Embassy was only 17 feet square. Moreover, instead of leaving the screen where it usually is, they advanced it to the very edge of the orchestra in order to place behind it additional magnifiers for two or three wretched talking things that they showed before they ran The Viking. *The screen was too near the audience and was too brilliantly illuminated. Anyone sitting in a seat that wasn't at least halfway back in the theater could only reach the conclusion that the picture was a poor piece of photography.*

About half the criticism in the New York papers was favorable, some very favorable. The older critics like Mordaunt Hall in the Times *were negative, but you must recollect that these critics have in the past committed themselves violently against the use of color in the movies. Hall, however, opened his review with the words, "There is something compelling about* The Viking. *The story holds the attention of the audience, and that is the acid test.*

Major Bowes was at the opening with his wife. He said to me afterward, "That is a very fine picture." I replied, "Major, it cost us less than $300,000, and I do not believe there's a Hollywood producer who could do it for twice that amount." His reply: "They could not do it for three times that amount." The horrible talkies they put in ahead of the picture did it injury. They got the audience in a mood not at all proper for a fair appreciation of our picture. I'm glad they are taking it out of that theater and putting it in the Capitol, with its big screen.

While the talkies seem to have stirred up the leaders in the industry, the general sentiment in the East is that they are a flop;

that the tide of public opinion is setting against them; that they have not yet found their place and have got to be much improved. Practically everyone agrees that orchestral music in a movie--with no asinine talk--is the best step.

We are all agreed that we must get into three-color work as quickly as possible; how quickly depends of course on our capacity to raise money, which is not proving easy after the recent flurry in Wall Street. Keep your health and don't worry and inside of a year we will all wear diamonds!

> *As ever,*
> *Wm. Travers Jerome*

The Viking opened in New York City in 1928, the first feature in the new Technicolor Process Number Three, and on the color side it was a huge success--the strong reds and browns of the Viking costumes and the blue-green of the sea and sky were particularly good. But due to over zealous historical research, our adventurers were burdened with such long and healthy mustaches that to some critics the entire screen seemed filled with Viking hair. Americans were to prefer their heroes clean-shaven until Mr. Gable's day. And as I had feared, it was a milestone, one of the last silent movies.

As a successful color film, it did have some effect in Hollywood. Warner Brothers and MGM began projects using the new process, and Paramount contracted for a feature film, *Redskin*. Jack Warner became Technicolor's best booster when he decided to make 20 color features. The rush to color had begun.

Mr. Technicolor

CHAPTER SEVEN

"What Goes Up Must Come Down"

One day in 1929, I was waiting in Jack Warner's office to discuss the use of color in one of his new pictures when I glanced through the window down to the street where a large and exceptionally red Cadillac limousine was parked almost under the window of Jack's office. Inside, Jack pressed the button to summon his secretary. "Whose car is that?" I heard him ask.

"That's Al Jolson's new car, Mr. Warner."

"Get me the Cadillac sales department on the phone."

A moment later Jack was talking to the salesman who had sold Jolson the Cadillac. "Well, I want one exactly like it, only redder. How soon can you send it over?"

I was amused at this evidence of rivalry between two men who had revolutionized film history. In the first publicly performed sound film, *The Jazz Singer*, Jolson sang on-screen and uttered two prophetic lines of dialogue: "Hey, Ma, listen to this" and "You ain't heard nothing yet!" Opening in New York in October, 1927, it threw Hollywood into total confusion.

On the other hand, *The Jazz Singer* stabilized the financially insecure Warner Brothers, whose gamble on the talking picture and the Vitaphone process was paying off. The brothers--Harry, Jack, Albert and Sam--had set up a film distribution company in New York in 1917, the year Dan Comstock and I were projecting our first crude color scenes in Boston. The Warners then expanded into production on the West Coast, acquiring the old Vitagraph company, but failed to make it big until Sam Warner worked with Western Electric and Bell to develop the sound-on-disc system they named Vitaphone. Sam was to see nothing of the far-reaching effects of his invention--he died at 39, just twenty-four hours before the premiere of *The Jazz Singer*.

Warner Brothers went from a company that made $30,000 in 1927 to one that would earn over $17 million two years later. It may have been the success with sound and dialogue that made Jack wonder if he could acquire a corresponding advantage in the field of color. If so, he must have come to realize that it would be a

difficult challenge, if not impossible. Technicolor had too many years of experience, and owned its own laboratories, machinery, equipment, and cameras as well as standing on a strong patent position. Upon reflection, Jack may have considered that the best hope for him and Warner Brothers to dominate in sound and color would be to contract with Technicolor such a volume of business that it would, in effect, absorb our entire capacity for the next couple of years. At least, that is what I think he was thinking that day, when he discussed his plans to make twenty feature films with Technicolor. I know what I was thinking. I had not announced it publicly yet, but I intended to double the Hollywood plant capacity by August.

Jack and I agreed to do business. I explained our usual policy: A deposit of $25,000 must be made with the execution of a contract for a feature-length picture. This payment would be forfeited if the picture was not made or, if made, would be returned to the producer as a credit against his payment for prints. This ensured that the commitment for a picture would be met and provided money for Technicolor to operate and to add plant capacity.

I knew that Jack had the authority to make all decisions having to do with studio operations, but that his brother, Harry, took care of matters of policy and finance. Shortly after our discussion, Harry returned from a trip to Europe and was interviewed by the press as soon as his ship docked in New York. He seemed to take a very dim view of the whole color business and displayed no enthusiasm for Jack's plunge into color with sound.

Nevertheless, the day came to close the contracts and collect the deposits, and Andrew Callaghan, who was assisting me in Technicolor's sales department, accompanied me to the appointment. Warner Brothers required three signed or initialed copies of each contract, as did Technicolor: for twenty contracts, 120 copies would have to be handled. It occurred to Andy that twenty times $25,000 was to be paid as deposit--$500,000. "Do they realize that?" he asked me several times. It had been made plain in the negotiations, but Andy feared that it might prove a stumbling block in closing and that this great life-saving volume of business might evaporate before his eyes. When we reached the curb opposite the entrance of the Warner office, Andy was too tense to go in with me and remained in the car, filled with visions of failure.

I had never beheld a happier man when I returned to the car an hour later with two brief cases bulging with the signed contracts, deposit check in hand.

I was convinced that sound was no more "just a novelty" than color, and I found myself in agreement with an individual relatively new to the motion picture industry, Joseph P. Kennedy.

Hollywood was always in awe of the Eastern "money" men, the bankers and investors whose infusion of new funds were a lifeline. Kennedy, a bold and energetic young Boston lawyer, had recently managed a series of mergers that put him in a position to enter film production. First he bought a small chain of New England theaters and obtained controlling interest in FBO, a film producer. He then merged with Pathe-DeMille pictures, a company which already controlled the huge Keith-Albee-Orpheum circuit of theaters. His relations with a few of the people in control of Paramount and MGM were such that I had no doubt his combined production and distributing power would soon be second to nobody's in the industry.

He then moved to acquire a capacity for producing talking pictures. Warner Brothers' Vitaphone system had brought them great success, but there was another system, Photophone, which RCA was working on with General Electric and Western. Kennedy linked up with RCA, the first combination between the rival industries of radio and pictures. The new company, Radio-Keith-Orpheum (RKO), with assets of $80 million, was one of the largest mergers in the history of film.

I invited Mr. Kennedy to 1006 North Cole, our Hollywood plant, to view some of our "Great Events" short features. Kennedy was delighted with the films and asked if I could find time to take charge of some of his major black-and-white productions.

"I am one hundred percent Technicolor," I responded. "Technicolor consumes all my time."

He wanted to know if I would produce a similar series of color shorts for him, and I discussed the possibility. I sent a memorandum to the Executive Committee (Jerome, Childs, Erickson) reporting that the work of our production department was a great sales argument for Technicolor, and that I had developed a close, active and very pleasant working acquaintance with Joseph P. Kennedy. "He thoroughly agrees," I added, "that the picture of

the future will be a color picture with tone synchronization." I made it clear that I would rather join forces with Kennedy than with some of the others who were pursuing us.

Later we talked about an all-color feature of his story "Silk" (he even proposed taking it away from DeMille and turning it over to me for production), of possibly filming a color insert for a movie Gloria Swanson was making, and arranged to shoot about 850 feet of color for DeMille's big production, *King of Kings*.

Did you envy him, in that he had his own great star?" my lovely wife asks me when we talk about those days.

Some Hollywood producers possessed an added dimension in their control of a star of great beauty and film presence, as in the case of Irving Thalberg and Norma Shearer, Joseph Schenck and Norma Talmadge, David Selznick and Jennifer Jones, and Joseph Kennedy and Gloria Swanson. But my words to Kennedy were accurate: I was one hundred percent involved in Technicolor, and it was my only key to Hollywood.

It was interesting later to realize that the dates of my most important and concentrated dealings with him were in the spring and early summer of 1928, the time when he must have been tremendously concerned with the great advance in prices of securities in the New York stock market. I have no specific knowledge about his activities in the market during 1928 and 1929, but I have reason to believe that the profit I made during that panic period was but a drop in the bucket compared to the immense profits Kennedy realized. His huge philanthropies and the part he played in financing the campaign of Franklin D. Roosevelt in 1932 are evidence that he did not suffer in the crash.

Kennedy agreed to let me and Technicolor technicians operate alongside the General Electric tone engineers, as a result of which we worked out our method of combining sound with our imbibition prints.

An obvious procedure would have been to print the sound track in one of the dyes. But this was not practical because the photoelectric cells used in projection equipment in theaters would not function with a dye track as they did with a silver track.

We solved the problem by starting with a strip of positive stock on which the sound track was printed and developed in silver while leaving the picture area blank. We had to learn how to

prepare this blank so as to eliminate its original silver content and permit imbibition without bleeding or diffusion. A transfer machine had to be designed and built capable of handling film in long lengths and in quantity and in such a manner that the blank and the matrix could be brought into registered contact and held there for a precise length of time while the dyes transferred. Our labor was considerably increased, since the blank had to be given a complete black-and-white processing for the sound track before it went onto the transfer machine for printing the picture in color.

Our operation gave us a sound track identical with that used in black-and-white, except that we had one distinct advantage. With black-and-white, both sound track and picture were processed together, so that development had to be a compromise between the optimum conditions for each. But in the Technicolor process the sound track was developed separately to its own best specifications.

The first customer to use our process was Ted Reed, in charge of Goldwyn's sound department on the production of "Whoopee." When that picture was shown in Hollywood, the sound quality was praised by producers and technicians.

The early sound discs were soon completely dropped, replaced by optical sound on the film itself, where synchronization with the picture could not be lost. Competing sound systems existed, mainly the variable area process of RCA and the variable density process of AT&T. A variable area sound track appears along the edge of the celluloid strip as a single or double white line with serrations corresponding the variations of the sound signal. A variable density track appears along the edge of the celluloid strip as a narrow band striped with bright and dark bands corresponding to the variations in the sound signal.

Technicolor had to be able to work with either one, since some of our customers used one and some the other. I had forecast in a letter to Judge Jerome that the variable density of AT&T would come to prevail, and indeed it did.

As our two-component imbibition Technicolor process and the new sound system became commercial almost side-by-side, progress rapidly became easier. To my surprise, sound actually helped to sell color. I can only explain this by looking at the role of the producer, who had for many years employed familiar and

efficient techniques in the studio and in the laboratory to produce his pictures, and who resisted change to the bitter end. When sound swept the country, it became absolutely necessary for every producer to make radical changes, both in photography and in the laboratory. This conditioned the producer to see that change was inevitable, and it became easier to sell sound and color together than it had ever been to sell color alone.

In the year 1930, Technicolor closed contracts for 36 future feature-length productions, calling for some 12 million linear feet of negative to be sensitized, photographed and developed, and approximately 60 million feet of prints to be delivered. Our cameras never cooled off--they operated day and night. Laboratory crews worked three eight-hour shifts. Hundreds of new men were hastily trained by our older craftsmen.

The Boston plants were shut down and all manufacturing operations consolidated in Hollywood, a logical step. Some two hundred men and their families moved to Hollywood from Boston, many of them then and later the backbone of the company: Mr. Riley in sales, Mr. Fassnacht, plant manager, Mr. Pohl, technical consultant, Mr. Howse and Mr. Ames in the engineering department, and too many others to name.

In these boom years of 1929, 1930 and 1931, Technicolor released twenty-eight feature films. Some of these were delightful. *On with the Show*, from Warner, was the first all-talking, all-color motion picture. Maurice Chevalier and a bevy of showgirls starred in *Paramount on Parade*. Joe E. Brown, to my mind a delightful screen comedian, played in three of these twenty-eight pictures, and Michael Curtiz directed four of them.

Mike was an outstanding director whose special talent for comprehending anything new and finding a way to employ it made him a great favorite with Technicolor technicians in spite of his autocratic European temperament.

It was a joy to hear Mike tell the story, in his acute Hungarian accent, of his arrival in New York City. A successful director in Berlin, he had been cajoled by Harry Warner to give up his career there and come to Hollywood to direct for Warner Brothers. Harry painted a glowing, inviting picture of all that awaited him: What a hero he would be, what a great welcome he would receive in the new world!

On the steamer on the way over, Mike spent hours in his cabin working on his speech so that when the time came he would have "a thoroughly prepared spontaneous response" to the eloquent speeches of welcome that would greet him. It was a little disappointing when, within sight of the Statue of Liberty, the usual government officials boarded the ship from a small tug and proceeded with the routine of customs and quarantine. Ah, well, perhaps he should not have expected a representative of Warner Brothers to come aboard in the outer harbor. Leaning on the railing of the deck, Mike was suddenly aware of great bursts of light overhead. The shore came alive with bonfires. Rockets burst over the harbor into dazzling flame. "This was a welcome!" he remembered. "Far greater than I had expected. I was overwhelmed!"

He disembarked in New York City on that Fourth of July, still wondering when the Warner bigwigs were going to appear, and a week later found his way west alone. There he had a long and successful career, working on many Technicolor pictures, directing two Warner stars to their only Oscars--James Cagney in *Yankee Doodle Dandy* and Joan Crawford in *Mildred Pierce*--and leaving us *Casablanca*, which, while not in Technicolor, is certainly an American classic.

The early pictures gave the public a chance to see their favorite stars in color: Jeanette MacDonald in *The Vagabond King*, Paul Whiteman in *King of Jazz*, and Eddie Cantor in *Whoopee*. Eddie's success in this film reinforced my feeling that color properly used enhanced the dramatic and entertainment value of a film and accentuated personality. In Goldwyn's *Whoopee* and in Warner's *Wax Museum* the Technicolor two-component process reached the ultimate that is possible with two components. A serious dilemma overtook Hollywood in the latter part of 1929.

Movie attendance showed a marked decline. The novelty of sound and color was wearing off, and producers were not taking steps to improve quality. It seemed to me many producers chose to film in the gaudiest colors, simply proclaiming that their product was in color instead of black-and-white, but doing little to explore the aesthetic capacities of color.

Finding good stories was always the most difficult problem. Broadway has a terrible struggle each season to find stories good enough for a dozen successes. Hollywood was trying to find several

hundred. They simply didn't exist! There is no prospect of a weak story or a story badly cast or directed being made satisfactory to the public through the use of sound, color, or any other embellishment. And yet producers were putting out second-rate films with poor stories, monotonous "formula" musicals with little story at all, and these mediocre films were not doing Technicolor any good.

We were doing everything possible to consult with and advise directors, scriptwriters, art directors, wardrobe heads, paint departments and other studio technicians. Our color control department was expanding as fast as practicable. Its services ranged from the color composition of sets and choice of materials and costumes and makeup to the broad planning and preparation of a picture by "scoring" it for color, in much the same way the musical score is written.

All of this was far more difficult with the two-component process than it would be with a three-component system, which would be more faithful to the true colors of nature. We were still working hard to perfect a three-component Technicolor camera; I wrote to Judge Jerome that wherever our preliminary three-color hand tests were shown they created tremendous interest, and answered every criticism of our two-component system.

Companies which were trying to work out their contracts with us were suddenly confronted with the necessity for drastic curtailment of their budgets because of the sharp drop in movie attendance. Paramount and Warner, who had contracts with us for multiple pictures, were postponing production, asking if we would permit their advance payments to carry over to the following year. We agreed, although it was an extremely difficult decision to make; these payments totalled more than one and a half million dollars, and we needed to fund our own expansion in order to meet future commitments. Even though technically this money was forfeited if the pictures were not made reasonably on time, we returned the payments as credit for future print orders.

At the peak of the rush, Technicolor had 1200 employees and a payroll of $250,000 a month; by the middle of 1931, this had dropped to 230 men and approximately $70,000. Picture production in Hollywood was at low ebb, and the last week in July was the worst for theater receipts in fifteen years.

During all this, Judge Jerome was becoming increasingly

impatient. It was difficult for him to understand why the industry didn't cooperate more fully with our existing two-component process in light of our very diligent work toward a three-component camera and a complete three-component process.

His impatience was expressed in visits he made to Hollywood producers, during which he gave them what he considered a straightforward lecture on what they should do and how it should be done, and what kind of men they should employ to do it, embellished by his opinion of what Technicolor had done on their behalf. One very dramatic such interview was with Sydney Kent, President of Paramount.

That interview in particular was a cause of great concern to me. The three-component process was just around the corner, and there would be no way to reap a reward from this technical breakthrough unless we maintained good relations with the producers-- our customers, after all. I could not let Mr. Kent believe that the Judge's remarks really represented the attitude of the whole board of directors of Technicolor; I did what I could to smooth his ruffled feathers. And then at a meeting of the board I knowingly and reluctantly precipitated a crisis by acknowledging the growing friction between myself and my old friend.

"If I am to continue as president of the company, with my present duties which include direct charge of sales activities, I must insist that no one else be allowed to interview customers except under my direction and approval."

There was an uncomprehending silence in the boardroom. I then described the recent scene at Paramount that had brought things to a head.

Judge Jerome rushed from the room, with several directors running after him attempting to pacify him. Erickson and others remained to talk to me at length. I was entirely correct, they said, and it would not happen again--they would talk to the Judge.

After he had time to think about the position he had put me in, and the consequences to the company of his high-handed approach in Hollywood, Judge Jerome wrote me a magnificent letter, confirming once again his fundamentally sterling character. We never referred to that day in the boardroom; it had been far more violent than either of our natures could bear.

85

People have a mistaken idea about Hollywood during the Depression. The public did not throng to theaters to forget their economic woes. Movie attendance dropped. By 1932, the average U.S. weekly wage had fallen to $17, and many people did not have the price of admission. My personal survival through the period of the stock market crash was in part due to A.W. "Eric" Erickson, who had become Chairman of the Executive Committee of Technicolor. Emigrating to America as a small boy, he had worked his way up in the advertising business from the bottom to the top. Eventually his company consolidated with Harrison McCann's to form McCann-Erickson, one of the largest agencies in the country. Erickson possessed a tremendous flair for business--including the stock market, in which he was deeply involved--but was in person modest in behavior and appearance, with a quiet but highly developed taste for the finer things of life.

In 1929 Erickson offered me a five-year contract with Technicolor at a salary of $200,000 a year, half in cash and half in Technicolor stock, if I would divest myself of other responsibilities and devote most of my time to Technicolor. I knew that Technicolor might not earn enough over the next five years to pay my salary, and I believed that the stock would only be worth what I made it worth. But I had great faith in the future of Technicolor, so I accepted his offer and signed a contract.

As I had anticipated, we soon faced a period when my salary could not be met and Technicolor stock, like the rest of the market, dropped greatly in value from 1929 to 1932.

Erickson did not intend me to suffer from my decision to cut off my other activities in favor of Technicolor, and he early on began to advise me about investments and encourage me to accumulate a sound portfolio. Occasionally he would wire me from New York that he had "put me into" a block of stock, for example, 1,000 shares of Anaconda. I would decide it was more than was wise for me to keep, so I would promptly place a sell order to offset it. By the time my sell order had been executed, Anaconda had risen nearly five points, so active was the pre-crash bull market.

As the year 1927 progressed I became uneasy about the economy, despite Erickson's buoyant optimism. It troubled me

that the total accumulated debts of the nation as well as states, counties, cities and individuals were so enormous that the whole country might be said to be in bankruptcy. A close look at financial statements put out by the larger companies tracked the preceding boom period, a boom stimulated by high-powered salesmanship when homes, automobiles, and everything else were bought on the partial payment plan. In addition, as the Wall Street Journal often reported, loans on stock exchange collateral had mounted and mounted until they reached the staggering sum of $5 billion ("That isn't very much," stated President Coolidge). In the spring of 1927 the New York Federal Reserve Bank cut its rediscount rate, making available even larger sums of money for financing stock speculation, spurring the boom in stocks and frightening me into the opinion that the quotations of stock market prices were too high-- if not fictitious.

My rule was that the price of a security should be measured by its present and potential earning power and dividends payable, not by what it had done under previous abnormal conditions. In short, I felt that during late 1928 and early 1929 the price/earnings ratio--the current price of the stock divided by its current earnings--was too high for most stocks to be considered other than dangerous to purchase or to hold.

The stocks I did accumulate in that period (Technicolor, Congoleum, Warner, General Motors, New York Central, Union Carbide, U.S. Rubber and others) account for about $1,250,000.

Published opinion was "Take advantage of inflation and load up with stocks." But as a physicist I knew that whatever went up must come down. Toward the close of 1928 I began to fear that the drop would come soon, and told myself to get out of securities, get out of debt, get into good real estate and sound bonds, and be particularly long in cash.

In late 1928 and 1929 I sold stocks to a total of some $1,400,000. As a result of my sell-off, when I set sail in November, 1929, about two weeks after "Black Thursday," on the S.S. Conte Biancamano for Italy en route to Paris and London, I had completely sold out my portfolio of securities and in its place had some Los Angeles real estate but mostly cash, which I deposited in Massachusetts savings banks. Massachusetts law would not permit banks to accept more than $4,000 from a single depositor, I was stuck with more than 80

savings-bank books, which I left in my safe-deposit box in Boston when I sailed for Europe.

As a survivor of the crash, I have at times been asked "What happened? Whose fault was it?"

Political leadership was partly to blame, particularly for high tariffs. The unwise policies of the Federal Reserve Board and the neglect of agriculture contributed to the situation. The encouragement of both private and public debt and the indiscriminate lending of money abroad were detrimental. But mostly, it seemed to me, the boom and crash were due to the madness of people. With no experience or training in market procedure, much less any study of the basic economic values involved, everybody seemed to be trying to get something for nothing by gambling in the stock market.

Of course, the worst was yet to come. The collapse of stock prices in the last months of 1929 was a prelude to a disastrous and prolonged Depression. I did not know--nobody knew--how deep it would be or how long it would last. The day came when I read newspaper headlines saying that 15 million people were unemployed.

During 1930, the market rose from its low of 198 to approximately 294, only to plummet by December to 158. It is possible that more people were hurt by buying in the rally of 1930 than were hurt by the bust of 1929.

I had sold a block of Technicolor stock at around $90 a share, very near the top, in September 1929. In 1931 I bought a block of Technicolor stock at $1.50 a share. And then I waited for the bad times to be over.

For ten years, from 1925 to 1935, I enjoyed Erickson's friendship. I often joined him at lunch or dinner at the Union League Club in New York, after which we would stroll along Fifth Avenue, talking, or walk over to his residence on East 44th Street where he housed his art collection. He was not a man to talk much about his acquisitions, whether from the stock market, a big account for his agency, or his numerous side ventures such as Congoleum or Technicolor. In the same way, he said very little about his wonder-

ful collection of old masters, although he did tell me something of the history of his superb Rembrandt, "Aristotle Contemplating the Bust of Homer." The painting was originally ordered by an Italian nobleman in 1653. It was bought by the Ruffo family, in whose possession it remained for some 150 years--the reason, Erickson said, it survived undamaged. Joseph Duveen, the most famous dealer in fine arts in his time, bought the painting in 1907. Erickson acquired the painting from him for $750,000.

Something in Eric's character led him to acquire, love, live with and enjoy his masterpieces. I believe that Eric's paintings played a part in his life closest to the ecstasy of grace experienced by those who seek meaning in spiritual values and a religious life. It was a sign to me how much he had been hurt by the stock market crash that in 1929, desperate for cash, he sold the Rembrandt back to Duveen for $500,000 until he could partly recover and reacquire it for the sum of $590,000. From that time until the time of his death it hung in his gallery, there to console him whenever he had time to spend with it.

But Eric never really recovered from the crash. While he had helped me to make and save about a million during the period from 1925-1929, he had made a much larger fortune, probably $25 to $30 million, much of which he could not save. The shock was a severe strain on his health. In 1929, on a trip from New York to California, Eric suffered a stroke and was taken off the train in Pasadena. After a long illness, he passed away. Technicolor lost a staunch friend that day, and so did I. For years afterward, I had an uncontrollable antipathy for the town where he suffered so much, and avoided Pasadena whenever it was possible to do so.

After his death, the Rembrandt was auctioned for the estate by Parke-Bernet. Dr. Alfred Frankfurter, editor of Art News, said that it was the most important single painting offered for sale in America or Europe during his long career. The painting was purchased by the Metropolitan Museum of Art for $2,300,000, a record at the time and the first painting to sell for seven figures.

I understand something of what Eric gained by living with his paintings, for although I never owned a Rembrandt nor a Hals, I have lived with a collection of 15th and 16th century masterpieces which have profoundly influenced my life.

In Berlin, in 1929, I met two brothers, Heinrich and Ernst

Remak, who were anxious to sell the well-known Remak collection. These paintings were mostly of religious subjects, the work of Italian masters. After our transaction, the Remak brothers were able to leave Germany, where a Nazi government was coming to power, and make new lives in New York and Buenos Aires, and I was able to see these powerful and meaningful paintings hung on the walls of my homes in Bel-Air and Cape Cod.

CHAPTER EIGHT

Selling Hollywood on Technicolor

"What WERE you two laughing about?" Eleanore asks me. We are reminiscing about old friends and the Bel-Air dinner parties that always ended in a stroll through the gallery where our favorite paintings hung to the theater at the end of the hall, where we concluded the evening with a movie.

"Remember the timetable?" she reminds me. "Forty-five minutes for cocktails, one hour for dinner--always a hot soup, an entree, salad and cheese and dessert. Vintage wines with each course, and an after-dinner drink to carry with us because the film had to go on at 8:30 precisely since our beloved projectionist, Lester Cobb, was a union man. And whenever Lily and Walt Disney were among our guests, after the movie was over and the others had gone home, you and Walt would sit in the large empty projection room and rerun *Flowers and Trees* and *The Three Little Pigs* and *Silly Symphonies*. You'd sit here and he'd sit over there, and you'd both be roaring with laughter and calling out, 'Remember when...?' "Herbert, will you ever forget...?"

It was Walt's great gift as an innovator and his single-minded perfectionism and meticulous attention to detail that brought us together in Hollywood, I remind her. "He was still a perfectionist years after," she replies. "Before the party celebrating the opening of Disneyland and the Disney's thirtieth wedding anniversary, I was in the powder room combing my hair when Walt walked through and methodically flushed every toilet--all sixty of them. I caught his eye and laughed until he laughed too, but he was determined that everything should work, down to the smallest detail."

By May 1932 Technicolor had completed its first three-component camera and had one unit of the Hollywood plant equipped to handle a moderate amount of three-color printing. The difference between this three-component process and the previous two-component process was truly extraordinary. Not only was the accuracy of tone and color reproduction there for the eye to see, but definition was markedly better too. For the first time, all the colors

of the rainbow, in true and realistic hues, could be reproduced on the screen. It had taken many years--actually, it had been twenty years since the day I named the process "Technicolor"--but it had been worth the effort.

Success was due in no small part to the years of financial support from Judge Jerome, William Childs, A.W. Erickson, Eversley Childs, James Colgate and Alfred Fritzsche. Arthur Ball's work on the new three-component camera was a true breakthrough, and Dr. Leonard Troland, George Cave, Robert Riley, Russell Conant, and Ray Rennahan, who had been with me at Technicolor since its earliest days, all played important roles in readying our revolutionary new color process for general use.

Basically, we had perfected a way of marrying together negatives individually sensitive to red, green and blue--each of these "colors" actually a complex band of shades comprising about one third of the spectrum's length.

The "red" color separation negative is really "minus green and blue," because it is obtained by causing light to pass through a red color filter which absorbs the green and blue light to create an image on the red negative.

Similarly, the "green" negative is in reality "minus red and blue," because that image is caused by light passing through a filter which absorbs the red and blue light, allowing green light to register.

The "blue" negative is really "minus red and green" because the blue filter through which that light passes absorbs the red and green colors.

By suitable combination of the proper proportions of these components, red, green and blue, all shades of all colors can be reproduced.

The exposed film from the Technicolor three-strip camera, when developed, produces silver-colored negatives; held up to the light, they appear the same as black and white negatives. The next step is to run these negatives through a matrix printer, making a relief image from which any number of copies can be made.

The "hills and valleys" of these relief images, consisting of hardened gelatin, are microscopic in depth but adequate to use like a matrix in other forms of reproduction--the plates in a lithographic process or type in printing. Because multiple copies are

made from this matrix, the original negatives are seldom used and can be preserved in almost perfect condition.

The matrix positive, a special gelatin coated film, is capable of absorbing, or imbibing, and printing dyes. Each matrix is supplied with dyes complimentary to the colors that created the negatives-- that is, the red matrix is brought into contact with its complementary, or opposite, color, blue-green; green with magenta dye, and blue with its complementary color, yellow.

The dyes from each of these matrices are transferred separately onto a blank (clear gelatin). Superimposing these three transfers from the matrices one on top of the other in register, we obtain the final print.

Two dilemmas faced us. When a motion picture company undertakes the photography of a feature-length picture, a sizable investment rests entirely in some ten reels of negative film. Anywhere along the line this investment is dependent upon the photographic quality and the safety of this film. Naturally, a producer hesitates before entrusting a production to the new process until he knows that process has been commercially tried and proven. With Technicolor Process Number Four, we were at a familiar starting gate: we had a new product to promote to the usual customers--Hollywood's cost-conscious producers.

On the other hand, we could not offer the new three-component product to one film producer without offering it to all--and to do that, we'd need many more cameras and the conversion of almost the entire plant. My idea was to first try out the new process in the cartoon field. That would allow us time to expand, while producing films for the public that would prove the process beyond any doubt.

But we ran into opposition. We were told that cartoons were "good enough" in black and white. Of all departments in a film company, the budget of the cartoon division could least afford the added expense of color.

I invited Walt Disney to come by for a private view of the new process. He had been intrigued with the idea of adding color to his cartoons for years, but his technicians had not advanced any further than the use of blue film stock for night scenes, green for underwater, and red for fire. He was enchanted with the effects we were getting, and decided to scrap a cartoon he was making for his

Silly Symphony series and remake it in full color.

Brother Roy was not so happy. Roy Disney had supervised the finances of the Disney studio since he and Walt left Kansas City to seek their fortune in Hollywood. They had just signed a contract with United Artists for twelve *Silly Symphonies*, of which *Flowers and Trees* was to be the first. "You'll ruin us," Roy said when he heard Walt's decision. "We'd be crazy to take on color now. United Artists won't advance us any more money to cover the additional expense of color."

Walt came back to me with a proposition. If Disney pioneered with the new process, would we give them exclusive rights to the process in cartoons for two years? I agreed; Walt's cartoons would showcase the process, and our real goal was feature film production.

In late 1932, *Flowers and Trees* premiered at Grauman's Chinese Theater in Hollywood, along with Irving Thalberg's production of *Strange Interlude* with Norma Shearer and Clark Gable. I was told that the cartoon got a more enthusiastic response than the feature; at any rate, it was obvious to me--and to Walt--that color was the future of cartoons.

Flowers and Trees became the first Disney film to win an Academy Award. At Christmas time 1932 came *Santa's Workshop*; the following Easter brought *Funny Bunnies*; and in May 1933 Disney's wonderful *Three Little Pigs* sang "Who's Afraid of the Big Bad Wolf?" in full color. Mickey Mouse too joined the color parade. Just ahead was Disney's lovely full-length feature cartoon, *Snow White and the Seven Dwarfs*. Walt and I never lost our joy in this early work; the slightest *Silly Symphony* could leave us laughing like boys.

Producers were willing to admit they had been wrong about color in cartoons now that the color cartoons were being held over for weeks or even months and earning several times their cost, but they still began every conversation about color in feature films with the question of cost.

I liked to confound them with the following reply. "Do you remember the huge rainbow in Disney's *Funny Bunnies*? Do you remember the bunnies drawing the colors of the rainbow into their pails and splashing their paints on the Easter eggs? Don't you agree that it was marvelous entertainment? Now I will ask you

this: How much more did it cost Mr. Disney to produce that entertainment in color than it would have in black-and-white?" The answer, of course, was that it could not have been done in black-and-white at any cost.

The same was true of feature films, if only I could make them see it.

I wanted to find someone to prove for full-length productions what Disney had proved for cartoons. It was about this time that I met John Hay Whitney.

Jock Whitney was a financier with wide business connections. He represented the third generation in a prominent family whose original wealth had been made from New York's street railway system by his grandfather, William Collins Whitney. Old W.C. made several fortunes and married another--Flora Payne, daughter of Ohio's Senator and sister of the treasurer of Standard Oil. When Jock's father, Payne Whitney, died on a tennis court, he left an estate of almost $200 million, the largest estate ever appraised in the country at that time.

Jock reflected the financial, political and social standing of his family (he was later to serve as our Ambassador to the Court of St. James and to own the New York Herald Tribune) and was a daring pilot and sportsman as well. He invested his money in whatever interested him, and at the time I met him was Chairman of Freeport Sulphur, a company in which he'd sunk $500,000. I passionately shared his interest in horses--his Easter Hero was one of the country's great steeplechasers, and Jock was captain of his own polo team.

I was introduced to Jock by Merian C. Cooper in New York. Cooper, after service as a pilot in World War I, had become a journalist and an explorer before turning to directing and producing films, and was about to make his archetypal Hollywood horror film, *King Kong*.

Even at that first meeting with Whitney, and at our second meeting at his palatial residence in Saratoga Springs, the subject was how and when Jock's entrance into the world of motion pictures was to be effected.

Technicolor was just on the verge of perfecting the three-component process, and I suggested that Jock's debut might be made wisely and soundly through the medium of full color. He was

as enthusiastic as I could have wished, and declared that nothing less than the most perfect color represented by a full three-component process would be good enough to distribute to the theaters of the world. I told him that the scientific and technical problems had been largely solved on an experimental basis, but that, as usual, we needed money to go into production. A large block of Technicolor stock was purchased by Jock Whitney and his wealthy cousin Cornelius ("Sonny") Vanderbilt Whitney, yielding Technicolor $180,000 in cash for further expansion and working capital.

Sonny was also interested in horses and in aviation, starting an airline which grew to be Pan American, and had wide interests in the mining field, eventually becoming president of Hudson Bay Mining and Smelting.

Early in 1933 Cooper and the Whitneys made a thorough investigation of the technical and business aspects of Technicolor. As a result, they and their associates formed a production company, Pioneer Pictures, Inc., and in August, 1934, were ready to sign a contract for the production of eight pictures in Technicolor's new three-component imbibition process. But first...a few doubts and questions remained.

They were thinking of filming a jungle story. Would the process reproduce the various shades of green in the heavy undergrowth of a jungle? They were considering a dark-haired actress with olive complexion as a leading lady. Would she photograph attractively against light backgrounds? They wanted a blonde in another leading role. Would she look washed out--would she virtually disappear against stronger colors? What about makeup? What about the visibility of extremely small figures in the distance?

"Let's make a short subject before we launch into a feature," Jock suggested, and I agreed. While he and Cooper began the hunt for literary properties for use in their feature films, Pioneer made a very practical and complete test of the process by producing a short, *La Cucaracha*.

La Cucaracha was the first non-cartoon picture to reach theater screens that had been photographed in studio conditions with the new Technicolor three-strip camera and with prints made by the new Technicolor three-color imbibition process. This picture brought human figures in full color to the general public for

the first time. As we expected, the critics paid little attention to the actors or the story. They were looking at the color.

One reviewer said, "There are now rich, deep blues, and it is no longer necessary to ignore the existence of blue skies, blue water and blue costumes. The colors are clear and true."

The entire industry agreed, and in 1934 *La Cucaracha* won an Oscar for best Comedy Short Subject. While we were waiting for Whitney and Cooper to choose their first full-length production we were not standing still. During the year 1934 nearly 60 percent of Technicolor production was made by the new three-component process, and the rest in the old two-component process.

I was in New York City when Andrew Callaghan reached me and asked if I could take the next train back to Hollywood. Andy, who had been assisting me with customer contacts for years, was a Hollywood favorite, loved by all, and I valued his assessments of the film community. "What's the trouble?" I asked.

"Sam Goldwyn is screaming about the Technicolor prints for *Kid Millions*. He's complaining that they're so bad they're ruining the picture. Can you leave immediately?"

"No, I can't, but I'll be back in a few days." I thought about the situation. We were doing an important three-component insert for Goldwyn's feature, which starred Eddie Cantor. If things were really bad, there was not much I could do about it. The choices were to do the prints over and over again at great expense until, hopefully, we got a good print, or make no charge for the prints or make a substantial reduction in price. Andy had no authority to offer any of these, so we left it that he would suffer it out until I could reach Hollywood a few days later.

On the morning I arrived at my office there came an invitation to lunch with Goldwyn. "How does the print look?" I asked Andy, holding my hand over the receiver.

"It looks just fine to me," he said.

I accepted the luncheon invitation, feeling unprepared and fearing the worst. The last time I had tried to argue an important point with Goldwyn--we were drawing up the contract for *Whoopee*--he had dismissed the problem with a wave of his hand and the

extraordinary phrase, "To me, that's primarily secondary"!

Ever since *Whoopee*, which had been filmed in the two-component process in 1930, Sam Goldwyn and I had talked several times a year about making another Technicolor picture. I generally ran into Eddie Cantor in Goldwyn's waiting room, and the two of us were in agreement that in a conversation with Mr. Goldwyn, meaning was almost completely independent of words.

Upon arriving for the luncheon, I was escorted to Goldwyn's private dining room where to my surprise I was introduced to Dr. Giannini, President of the Bank of America and supervisor of its Department of Motion Picture Loans. I had met Giannini casually several times at the Los Angeles Country Club, but in deference to our host, we both accepted our introductions without comment.

The three of us dined, and from caviar to brandy I heard not a word about terrible prints or the imminent ruin of the Samuel Goldwyn Studio. Instead, Sam kept dropping broad "hints" such as "Dr. Kalmus is coming along very rapidly with a growing business and should do his banking with you, Dr. Giannini." We were a little embarrassed at having our business affairs unexpectedly discussed, and after coffee I found myself being dismissed without ever finding out why I had been summoned. As the two men were bidding me good-bye, Giannini turned to Goldwyn and said, "Sam, I'm anxious to see our picture--you've been talking so much about it." Sam had almost ushered me out the door when Giannini added, "Won't you stay, Dr. Kalmus, and see the picture with us? I understand it's great." Mystified, I joined them in the projection room and saw the first print of *Kid Millions*, with its closing sequence set in an ice-cream factory in full color--wonderful entertainment, excellent color--and at the end of it Goldwyn turned to Giannini, obviously an investor, and exclaimed, "I tell you, that picture is the sensation of all sensations!" I never heard another word about any problem with the prints.

Goldwyn's fracturing of the English language was a favorite subject of conversation in Hollywood, and some of his phrases-- "Include me out," for example--have passed into common usage. Some of them have been pure fabrications, but I know of one incident when Sam had been persuaded to make up a golf foursome and had appeared on the green in natty white flannel trousers ready to play. Turning to his caddie, he asked, "Are you good at

finding balls?''

"Yes, sir, very good," replied the caddie.

"Then suppose you run out and find me a couple and we start."

Later in the game Sam had a ball with a rather close lie on the fairway. He took a healthy swing at it with a three-iron and missed it entirely. "You know," he remarked to his partner, "where I usually play the ground is higher."

Kid Millions was a huge success at a private preview in San Diego. The audience started applauding with the opening of the color sequence and continued until the end of the movie. Sam got in the last word. He said to Andrew Callaghan, "They were applauding the production as well as the color; the print quality might have been better."

<p style="text-align:center">***</p>

Meanwhile, Jock Whitney and Merian Cooper were hunting for a story to film as their first feature, and finally--after considering more than two hundred--settled on William Thackery's classic novel "Vanity Fair," the story of a poor girl with expensive tastes who lives by her wits. They decided to call the picture *Becky Sharp*, and cast as Becky the clever and beautiful Miriam Hopkins.

Becky Sharp was a champion movie for hard luck. It was planned as the first of several Pioneer motion pictures, but it was delayed at first because of Cooper's illness--he was in charge of production--and then by the death of the original director, Lowell Sherman. He was ably replaced by Rouben Mamoulian, a director with a wonderful understanding of light and color. But more trouble developed: Whitney encountered great difficulty in the technical work of sound recording, so that he was in the anomalous position of producing the first full-color Technicolor feature in which he surmounted all the hazards of color yet found himself in grave difficulty in the area he had naturally taken for granted, sound.

As a laboratory for the new process, *Becky* turned out to be an expensive proving-ground. The crowd scenes, the costumes, the period sets, the battleground scenes were all expensive to film. By the time it was completed, on March 20, 1935, it had cost almost $1

million. This was a huge budget for that period. At a time when the average price of a movie ticket was twenty-four cents, a movie had to have a tremendous draw to recoup its costs.

In the 1930s and 40s, nothing of greater importance could happen to a picture than to be engaged to play Radio City Music Hall in New York. *Becky Sharp* was to open there in early June. I was concerned that the prints we sent from Hollywood be of the proper density and color for the long throw in that theater. I asked the general manager for permission to run a print late one night after the close of the final show of the day, and Mr. Van Schmus not only agreed but invited me to bring the directors of Technicolor and other interested friends and join him after the show at his apartment on the roof of the Music Hall.

I was delighted with the print, which was to my eye startlingly beautiful on the large screen, and I accepted warm congratulations from Jock Whitney and his wife and others at the party afterward. I was sad that Judge Jerome was no longer with us; what a pity that he did not live to see this beautiful result of the work into which he put so much of his heart.

All at once Eversley Childs, in his usual outspoken way, broke in to the chorus of praise. "Just a minute, now, just a minute. I've been saying right along that this Technicolor hurts my eyes, and by thunder it hurt my eyes tonight!"

God bless him! He had a small fortune invested in Technicolor; had been an active director for many years; frequently helped me raise money; was a very able businessman, and knew what was riding on this picture--such a time to complain about his eyes!

The others stood by their opinion--the color was magnificent and the picture certain to be a great success. The New York Times, in its review on June 14, said, "As an experiment, it is a momentous event, and it may be that in a few years it will be regarded as the equal in historical importance of the first crude talking pictures. It is probably the most significant event of the 1935 cinema...it possesses an extraordinary variety of tints, ranging from placid and lovely grays to hues which are vibrant with warmth and richness...a vividly pigmented dream world of artistic imagination."

The dramatic elements of the picture did not receive match-

ing acclaim; story, characters and actors got short shrift from the reviewers. It should have proved to the feature field what Disney had shown for the cartoon field--that increased box office returns accompany good pictures, economically made with the additional appeal of color--but it didn't. Its production extravagance was a demonstration of how not to make a picture for profit.

But Technicolor had little reason to be downcast. The new process was on a solid footing. We had four new cameras, with four more nearly completed. We could manufacture two million feet of positive prints a month, which meant we were ready to operate in the feature field. And such samples of color as the public was getting in sequences in *The Little Colonel* and *The House of Rothschild* and *The Cat and the Fiddle* were whetting the appetite for more.

After *La Cucaracha* and *Becky Sharp*, Pioneer Pictures filmed *The Dancing Pirate*, a rather standard musical which turned out to be Pioneer's last production, as the studio was dissolved when Jock Whitney joined forces with David Selznick. However, Jock took with him not only his original enthusiasm for color, he also determined to continue his contractual commitments with Technicolor.

In October of 1935 I reviewed the color situation with Darryl Zanuck, after which he announced to the press that 20th Century-Fox would produce *Ramona*, with Loretta Young and Don Ameche, entirely in Technicolor. Meanwhile, we were working with Walter Wanger on a Paramount film which would be largely shot outdoors at Big Bear Lake and the surrounding mountains about one hundred miles from Hollywood. The negatives arrived daily at the plant in Hollywood for development. Everybody, including Wanger, was thrilled at the extraordinarily fine quality of the rush prints. In fact, Wanger showed many of his rushes to the Fox people and to Cecil B. DeMille. He not only ran the film for them--he showed his cost sheets around Hollywood, too. On balance, these were encouraging to producers.

In the early stages of every technical project, some trouble is bound to arise, and in this case we had plenty. We spoiled two days

101

of Wanger's photography, one on account of static electricity in the camera and the other on account of a scratched negative. We worked out a friendly and reasonable measure of relief for him, although we had no legal liability under the terms of the contract. We simply always tried to do our best for our customers while being ourselves good businessmen. Wanger's film, *The Trail of the Lonesome Pine*, directed by Henry Hathaway and starring Sylvia Sydney, Henry Fonda, and Fred MacMurray, had a splendid reception from the public. Here, color was neither a gimmick nor the main focus of the film. It simply enriched the story.

David Selznick was producing a major film, *The Garden of Allah*, staring Marlene Deitrich, Charles Boyer and Basil Rathbone. This was the fifth of what I think of as the first fifteen color features to prove the new process beyond a shadow of a doubt, and it was, again, one of Jock Whitney's Pioneer series, this time made for them by the Selznick studio. The budget was $1.2 million. I viewed the rushes along with Selznick and Whitney; much of the picture was in a subdued, exotic mood, and the scenes exceeded in beauty and effectiveness anything I had previously seen on the screen. Most of the early Technicolor films had featured unknown actors or young stars at the beginning of their careers. Established stars were not willing to risk themselves in the medium of color, having been frightened, I suppose, at the number of stars whose careers were ended by the coming of sound. But *The Garden of Allah* starred major international stars, and revealed the beauty of Marlene Deitrich more strikingly than ever. Selznick expressed his readiness to undertake another Technicolor picture as soon as that one was completed.

Box office figures were excellent. At Radio City Music Hall, the figures for the first week ran far ahead of the preceding weeks, when Katharine Hepburn's *A Woman Rebels*, *As You Like It*, starring Elizabeth Bergner, and Irene Dunne's *Theodora Goes Wild* were running. Jack Warner, who had been one of the first to commit to color when it was a two-color process, decided once again to move with the times and chose a fast-moving romantic outdoor story with extraordinary settings in the North Country and a memorable log-jam sequence for three-color production. *God's Country and the Woman* was based on the novel by James Oliver Curwood and starred George Brent and Beverly Roberts.

Early in December, 1936, the seventh picture, *A Star Is Born*, was nearing completion. It was another lavish Selznick-Cooper-Whitney production, an inside-Hollywood story starring Frederic March and Janet Gaynor as the couple whose marriage is destroyed by the changing fortunes of their show-business careers. William Wellman, the director ran into several unique difficulties in this film, one being that Miss Gaynor's contract limited the number hours she could work on the set each day. As she appeared in most of the scenes, this slowed production. Too, there were about seventy-five different sets in the picture--twice the usual number. Setting up and taking down scaffolding and light units and changing camera set-ups added overtime.

Wellman, one of the most dynamic of directors as well as the fastest shooter, was not backward in bringing his criticisms to me. "Technicolor cameras are more cumbersome than black and white; they are hard to handle, and slow down the work. The camera requires three strips of negative instead of one, and takes longer to thread between takes. It demands more light, which means more arc lamps, more carpenters, more electricians, more current, and more time--not to mention all the problems of color composition, lighting, and makeup."

I granted him his points and told him we were working on these problems. In fact, I already knew that our next step was almost certain to be the elimination of the three-strip negative Technicolor camera we had worked so hard to perfect, and the employment of a single negative which would go through any black-and-white camera. Toward the end of the picture, he praised the Technicolor crew for its hard work, its progress, its speed, and its photography, and said he was moving along almost as fast as with black-and-white. This news was a boon for Technicolor--it was also good for Bill Wellman as a director in the new medium and good for the people for whom he was making the movie, with their stock interest in Technicolor. In its run at Radio City Music Hall in the middle of 1937, it was drawing $100,000 a week. It was the first picture to be held over a fourth week in the four years since the theater had opened. It was an unqualified success.

Wellman directed the next Technicolor feature, *Nothing Sacred*, starring Carole Lombard and Frederic March. It opened at Radio City Music Hall Thanksgiving week and grossed $110,000 in

the first week, despite rainy weather. David Selznick called to tell me that when his black-and-white feature *The Prisoner of Zenda* grossed as well as his Technicolor *A Star Is Born*, his distributors argued that it was not worth doing pictures in color. "Now that *Sacred* is topping both of them, they have nothing more to say on that subject," he assured me.

James Hogan, who was directing *Ebb Tide* for Paramount, told Paramount's president, Adolph Zukor, that the picture had been photographed as fast as any black-and-white picture he had ever directed. Lucien Hubbard, the producer, was particularly pleased with several scenes of projection backgrounds we had been able to photograph, which he said were the best process scenes he had ever seen--but then every film in this series produced new techniques and innovations or solved earlier problems. Ray Milland, Frances Farmer and Barry Fitzgerald starred in this sea-going adventure.

Walter Wanger's *Vogues of 1938* for United Artists starred Joan Bennett and Warner Baxter--and the artistry of Max Factor, whose make-up effects were to be very important to color photography. Wanger was quick to notice the wonderful sharpness, texture and quality in our prints. The improvement was due to another revision of the Technicolor matrix developer.

Tom Sawyer was completed during 1937 to be released in early 1938. It was another Pioneer film, and Selznick told me he thought it was the most charming yet, the one that color had done most for.

Warner's second Three-color production, *Gold Is Where You Find It*, finished photography late in 1937. It was a gorgeous outdoor story with George Brent, Olivia de Haviland, and Claude Rains.

But it was Jack Warner's third production that walked off with the prizes. *The Adventures of Robin Hood* probably cost $1.5 million to produce, and boasted one of the most elaborate stage sets I have ever seen--a huge castle that alone occupied an entire stage. Errol Flynn, Olivia de Haviland and Basil Rathbone were the stars, but so was Technicolor; the general opinion of audience and experts was that it was the most pleasing and appealing color yet seen on the screen. *Robin Hood* won three Academy Awards--more than any other picture that year.

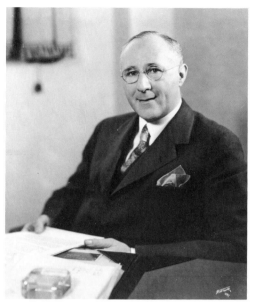

Dr. Herbert T. Kalmus

Eleanore King Kalmus

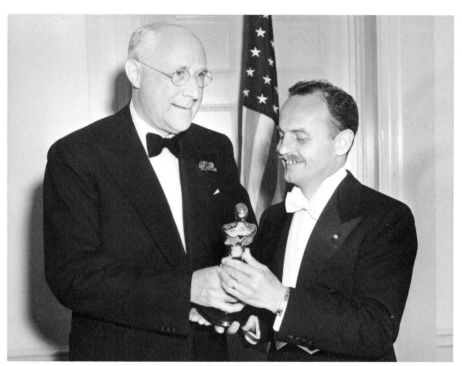

Dr. Herbert Kalmus after receiving Academy Award from Darryl F. Zanuck on February 29, 1940. The special "Oscar" was presented for Technicolor's "...contributions in successfully bringing three-color feature production to the screen."

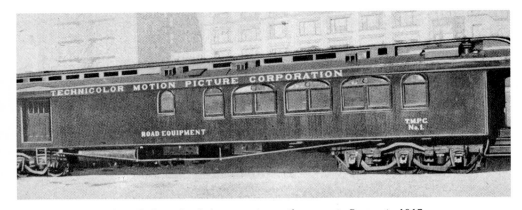

First Technicolor Laboratory in a railway car in Boston in 1917

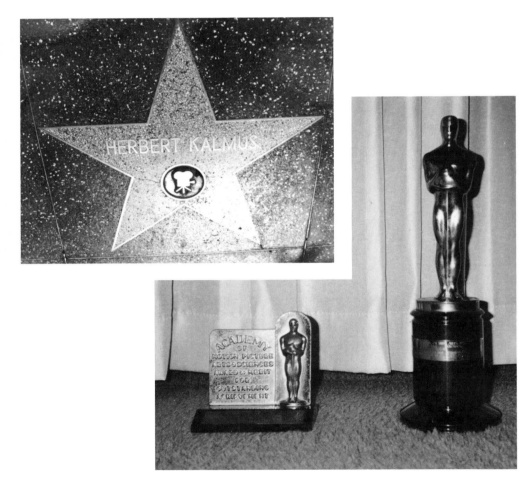

Above left Dr. Herbert Kalmus' "Star" on Hollywood Boulevard, Below right Technicolor's Academy of Motion Picture Arts and Sciences Award of Merit and "Oscar"

Technicolor Hollywood plant during construction in 1929

Technicolor 3-strip camera. Only 24 existed, two were lost during production. A few still remain today at the American Society of Cinematographers.

Technicolor plant after construction

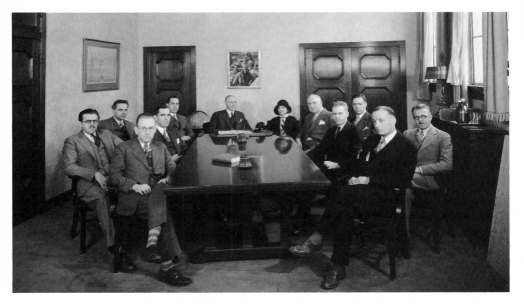

At the conference table in the Hollywood plant are (beginning from the right foreground)
A.. G. Jacobs, C. L. Brohammer, L. W. Corbett, J .E. D. Meador, Andrew J. Callaghan,
Natalie Kalmus, Dr. Herbert Kalmus, President and General Manager, J. A. Ball,
George A. Cave, John M. Nalle, E. T. Estabrook and J. F. Keinninger

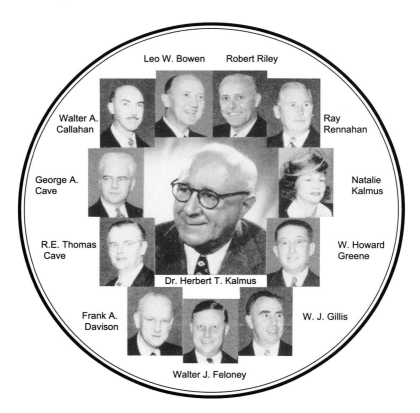

Technicolor personnel honored for 25 or more years of service at the
Beverly Hills Hotel on November 1, 1947

Carmen Miranda gets a Technicolor camera lesson from Leon Shamroy ASC, Director of Photography during the 20th Century Fox filming of That Night in Rio *1941.*

Tank target practice in Warner Bros. Technicolor short, The Tanks are Coming *1941*

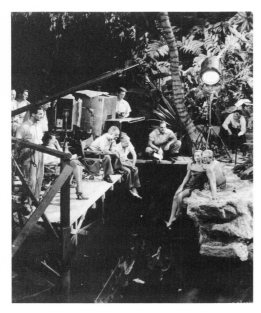
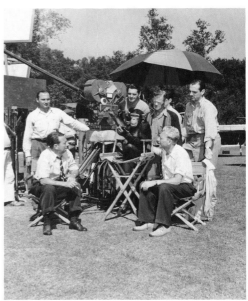

Filming on the set of Paramont Pictures' Beyond the Blue Horizon *1942. Above left, seated in the director's chair (center) Alfred Santell sets the scene for actors, Dorothy Lamour and Richard Denning. Above right is William T. Mellor, ASC - Director of Photography (standing next to camera - left).*

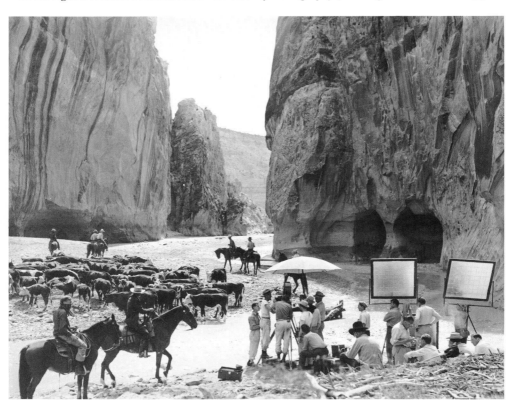

On location in Kanab, Utah for the 20th Century Fox film, Western Union *1941*

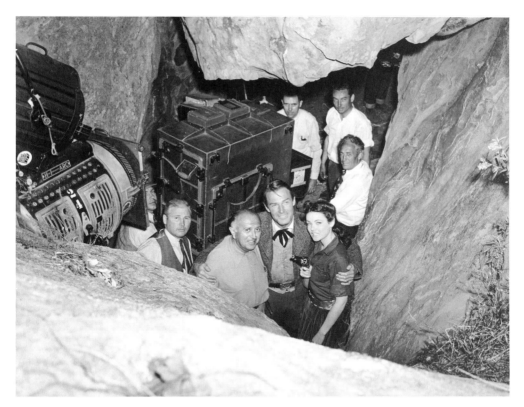

Belle Starr, *20th Century Fox studio set 1941. The 3-strip Technicolor Camera in the background is encased in a ''blimp'' - a lead lined container which reduced a high noise level created when more than one camera was employed at a time. It weighed in excess of 700 lbs. Front row left to right are Ray Rennahan ASC, director of photography for Technicolor, Irving Cummings, Director, actors Randolf Scott and Gene Tierney and behind her, Ernest Palmer, ASC 20th Century Fox's Director of Photography.*

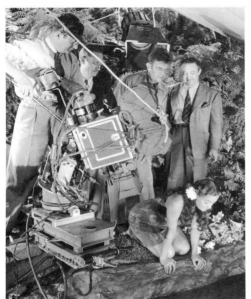
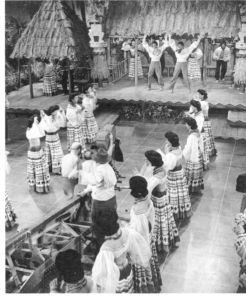

Above left Aloma of the South Seas, *Paramont Pictures 1941 - directed by Alfred Santell (standing right) and featuring Dorothy Lamour (kneeling).* Above right Moon over Miami, *20th Century Fox 1941.*

Eleanore King Kalmus

Dr. Herbert T. Kalmus

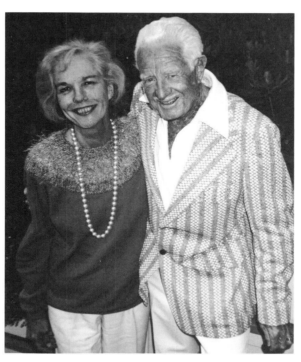

The Kalmus' daughter, Cammie King Conlon with
Technicolor cameraman, Arthur Ayling, during a
1990 Gone with the Wind *reunion*

Sam Goldwyn put $2 million and an all-star cast (Kenny Baker, Vera Zorina, Edgar Bergen and Charlie McCarthy) into *The Goldwyn Follies*. With typical aplomb, he told me that he expected it to be his all-time greatest production and at the same time complained about the high cost of Technicolor prints.

Dorothy Lamour played Hollywood's idea of a South Seas beauty, a role she was to repeat many times, in *Her Jungle Love*, co-starring Ray Milland. Paramount released the picture in 1938, and I was particularly pleased with the lush, exotic color.

These, then, were the first fifteen important feature-length pictures produced in three-color Technicolor. They were key films in that they demonstrated that the Technicolor three-strip negative with its three-component imbibition process was as successful for features as it had been for cartoons and short subjects. These fifteen films were acclaimed by the public. But more than that, they were of special importance to the industry because for the first time a large number of producers and directors and actors and film technicians gained actual experience with the three-color camera. We had done it. We had sold Hollywood on Technicolor.

Mr. Technicolor

CHAPTER NINE

The International Technicolor Family

About the time that *Becky Sharp* had its premiere in New York City, I was packing a few selected reels of the film and leaving for London. It would be folly to delay; a number of color processes, most of them still experimental, were putting out feelers around London. We had competition at home--Kodachrome, Cinecolor, Magnacolor, Vericolor, Fin-a-color were a few companies offering their processes to anybody who was interested--and I felt there was no reason to allow new foreign processes to take root.

When I had accepted Eric Erickson's proposition to sever my connections with other technical and business enterprises and devote my time exclusively to Technicolor, I realized that I had never intended to make pictures only for the United States. There were tremendous possibilities everywhere; it was inevitable that the time would come when I would look at Britain and the continent of Europe and think, "Why not put Technicolor on the screens of thousands of theaters all over the world?"

Soon I was operating from my favorite headquarters in London, a suite in the Savoy overlooking the Thames, and running *Becky* in a rented theater as often as I could assemble a group of interested viewers.

One of my audience, a German technician I knew casually, asked if he could bring Mr. Kay Harrison around to meet me.

Harrison, an ambitious and far-seeing young man, was Chairman and General Manager of Gerrard Industries, financed by Prudential Assurance, a company with extensive investments in the British film industry. He had already formed the opinion that a two-color process was not enough for the permanent enterprise he had in mind--an opinion that I shared, of course--and by the time I met him had already bought or was thinking of acquiring an interest in a number of processes, some already producing commercial films. Among those that interested Harrison--Hillman Color Process, Gasparcolor, Dufaycolor, and the Keller-Dorian

107

process--I was most intrigued in Bela Gaspar's invention, a subtractive method and in general theory similar to Technicolor. In fact, I negotiated with Dr. Gaspar and his associates for a period of months on the subject of merging their interests and ours, but was never able to settle on a plan. Once, after a long siege of conversations in London, I thought we had reached a definite understanding only to receive a cablegram on the ship as I sailed from Southampton modifying the understanding to a degree that practically wiped it out.

I was not the only one attracted by Gaspar's genius; he made many trips to Rochester, where Dr. Mees and other Kodak staff were encouraged to think that something would come of his work, but somehow nothing did.

When Kay Harrison first heard that I was in London showing a new Technicolor film, he brushed the news aside saying he was not interested in a two-color process. But when he was told that I had reels of a three-component motion picture--one that was currently running at Radio City Music Hall--his interest was kindled. He promptly arranged to have it screened, and the effect was electrifying. "My financial people at Prudential have to see this," he said. "And of course Alexander Korda must see it as soon as possible."

Korda was born in Hungary and educated in Budapest, where he wrote and directed his first films. By 1917 he was known as Hungary's boy-genius, with twenty films to his credit. During the political upheavals of 1919 he left Hungary to work in other European capitals and arrived in Hollywood at the time when sound tracks were being added to films. There he was associated with Warner and then with Fox, and although his Hollywood output was not distinguished, in one film he hit on a formula that was to serve him well in the future. *The Private Life of Helen of Troy* gave him a blueprint for historical pomp, rich costumes, and bravura acting that he used over and over with great success.

Korda went to England in 1931 to make a film for British Paramount, and remained there to try to recreate Hollywood-on-Thames with his London Film Productions, backed by Prudential. In 1933 he released *The Private Life of Henry VIII*, which was an immediate international success, and not only solidified his position but launched the careers of Charles Laughton, Robert Donat,

Wendy Barrie, and the beautiful and glamorous Merle Oberon.

Korda and I were not strangers. We had met in Hollywood, at a time when Technicolor was beginning to prove itself, a time when the producers and I were involved in our peculiar balancing act. Aware that Technicolor had made great strides in ten years of unremitting effort, Schenck, Goldwyn, Zanuck, Selznick, Wanger, Goetz and a few others of that handful of powerful men saw clearly that while color was inevitable, its adoption could be hastened tremendously--or slowed disastrously--by the degree of cooperation they offered. If they fed the public a dozen or so outstanding color features in rapid succession there might be no turning back. So, unless they could gain control of Technicolor or find another process as good or better...why hasten the day?

Meanwhile, they hoped to secure their position by obtaining options on Technicolor stock in large blocks at low prices.

Alexander Korda, in Hollywood to acquire one of the five participating interests in United Artists for London Films, got very close to Sam Goldwyn. Korda and his entourage, Sir Connope Guthrie of Prudential and Stephen Pallos, who managed the distribution of London Films, visited the Technicolor plant and we spent hours discussing pictures and options. Goldwyn was present at some of these meetings, and one day said to me, "Well, I've kept my word. I told you I wouldn't make the Cantor picture in Technicolor unless you gave me some inducement, and I didn't." I, too, had kept my word; I had refused to make Technicolor cameras available for the Cantor picture if, to get it, we had to give Sam options at the price per share he demanded.

Sam asked me to call on him the next day. He and Korda had obviously put their heads together, figuring that if they each agreed to give Technicolor several pictures over a period of a few years they would be entitled to their "inducement," large blocks of options at a low price. Sam, dangling the carrot before me of a further color picture, *Goldwyn Follies*, in a new development in his inducement strategy, said he was ready to shoot the Cantor picture--photography could start next week--if I'd give him the options he'd been asking for. He also reminded me that he was a leader in the industry. His choice of Technicolor would influence others. "If I make a picture about mosquitoes all of Hollywood will follow," he claimed. I replied that if options were given they would

be at, but not below, the market price of the stock.

"Not my idea of an inducement," he declared. But when *Goldwyn Follies* was produced in 1937, the contract carried options on the standard basis we had adopted for all producers.

I was not rigid on the point, however. Anything that strengthened Technicolor's financial position was worth considering.

At that time, I divided feature productions into two classes. Of the five hundred to six hundred pictures a year being made in Hollywood, I classed 80 percent as mass-produced; that is, for these productions the aim was to create the maximum amount of entertainment on the screen for a given cost, generally a budget of $200,000 to $500,000 a picture. The added cost of color (including three million feet of prints for distribution at our charge at the time of 5 1/5 cents per foot) was $150,000. For that class of production, the added cost was large and in my view not warranted by increased box office receipts.

The other 20 percent comprised the more ambitious productions with budgets from $500,000 to $1.5 million or more. In these, producers aimed to make the best possible product, to create the maximum entertainment, almost irrespective of cost. For such pictures the added cost of $150,000 for color was not excessive and could expect abundant rewards at the box office.

I focussed on this top 20 percent, with the object of obtaining at least half of all the big productions for Technicolor, which, with our short subjects and cartoons, would amount to 125 million feet of prints a year. Suitable options, properly placed, might help greatly!

As I was coming to this conclusion, several things happened in the industry. Top executives were playing musical chairs: Selznick left UA for MGM; Mervyn LeRoy left Warner for the same company; Goldwyn and Korda were angling for a controlling interest in United Artists.

At the same time, box office returns were diminishing. Budgets were being cut and productions canceled.

The options Technicolor had granted some producers at prices from $16 to $28.50 a share (most above $21.50 a share) when our stock was skyrocketing from $2 a share to $92 were no longer attractive in the late thirties, when Technicolor stock was quoted at around $12. Therefore some (Merian Cooper, Walt Disney, Sam

Goldwyn, Loew's, Inc., London Films-Korda-Prudential, E.J. Mannix, Paramount, Pioneer, David Selznick, 20th Century-Fox, Walter Wanger, and Warner Brothers) held options which had been granted at substantially higher prices than current market quotations.

Nevertheless, Korda and his associates requested extensions on their options before the expiration date. Their request was followed by similar requests from everyone on the list. It was my opinion that we should say yes to Korda, and to deal similarly with our other option-holders as they approached their expiration dates.

So when Korda brought his associates, Percy Crump, V.P. in charge of investments for Prudential, Sir Adrian Baillie and Col. P.W. Pitt to see *Becky Sharp* in London, he was already involved, to some extent, with Technicolor, Inc. Baillie and Pitt I had also met before, through Jock Whitney (Baillie was married to a relative of his). Jock had sent the two men to me when we first began to talk about a British division of Technicolor.

As things crystallized, it became apparent that we all wanted to raise a substantial sum of money, build a laboratory, and organize a British-based Technicolor company. The principals would be the Prudential Assurance Company, London Film Productions, Ltd., and Gerrard Industries. The opportunity for a small degree of participation would be offered to Sir Adrian and Colonel Pitt.

Kay Harrison threw his considerable energy and ability into helping me deal with all the others. The principals of Allen & Overy, solicitors for Sir Adrian (and for the British Royal family), were drawn into the conferences, which thereafter took place in their offices. I pulled in Robert Cushman, senior member of our patent attorneys in Boston, who was touring Europe with his family. I also employed a London solicitor, John St. George Syms, who remained by my side through all the discussions and became one of the first directors of the British company.

Technicolor, Ltd. was formed in 1935. Under contract with Technicolor Motion Picture Corp., it was licensed to carry on an enterprise in the British Empire similar to that of American Technicolor in the rest of the world. The entire original stock was issued to the parent company. Approximately $750,000 was raised through sales of shares of Technicolor, Ltd., to Prudential, London Films, Gerrard, the Industrial Agency Co., and Sir Edgar Hornebart.

This provided funds to run the company and to build a laboratory.

When the British shares were sold, the capital of the company was increased from 160,000 shares at £1 each to 320,000 shares at £1 each--159,996 shares to the British group and 159,996 shares to Technicolor Motion Picture Corp., with one share each to the eight directors. The Articles of Association provided that the chairman, so long as I held that position, would have an extra casting or deciding vote in case of a tie between the British and American directors, but during all the following years no dissension arose in which it was necessary to use this vote.

I was appointed Chairman of the Board and Harrison became Managing Director. Allen & Overy were appointed solicitors of the company. Kay and I immediately faced several problems: Should we follow Korda's advice and build the new laboratory at Denham Studios, which Korda intended to be the Hollywood of Europe? Prudential was providing the capital for this project--almost £1 million. Should we prepare to take on black-and-white laboratory work in conjunction with color? Should we build the equipment and machinery in Hollywood and ship it to England? Which key men could we move from Hollywood to London? We had to keep in mind that design and operation of both labs must be identical so that an interchange of matrices and other facilities could become the practice.

Kay and I spent several weeks looking at locations and finally settled on a plot of land on Bath Road, Harmondsworth, West Drayton, about a half hour from Trafalgar Square.

We brought cameras over and filmed the first Technicolor feature to be made in England, *Wings of the Morning*, starring Henry Fonda in his second Technicolor role and the young French actress Annabella, but the celluloid reels had to be shipped back to Hollywood for processing and printing. By July 1937 we were established in England, ready to enter into a contract with Korda's production company for six feature length films to be filmed and processed by British Technicolor.

The first of this series was *The Drum*, which starred the Indian boy Sabu, who had been discovered by documentary film-maker Robert Flaherty in *Elephant Boy*. The second, *The Divorce of Lady X*, starred Merle Oberon, whom Korda married in the same year the film was completed. He had found her working in London

as a film extra and dance hostess and made her a star overnight when he cast her as Anne Boleyn in *The Private Life of Henry VIII.*

Technicolor, Ltd. was alive and well.

In the years to come, Kay Harrison never failed to be an engaging companion, a highly energetic, intellectual, and artistic individual--and a complete enigma to me.

In appearance, he was not unlike the stereotyped cartoon depiction of John Bull. Australian-born, he had lived in India, China, Peru, and in almost every European country before adopting the United States as his home. He married a charming girl from Alaska and had a large family of appealing, delightful children. His interests seemed to be unbounded, and he freely shared them--I am thinking of an occasion when he whisked us--Eleanore and myself and the Disneys--from London to Glyndebourne for a walk in the gardens and a concert, a magical evening. In his list of enthusiasms--music, painting, philosophy--he had room for everything from the ballet to the Derby at Epsom Downs.

And yet through it all there was never any mention of his personal life or relationships or his deepest feelings. It seems remarkable that in a friendship that lasted for so many years, I was never taken into Kay's confidence to any degree. Perhaps he felt the same--we were both reticent men.

"His wife and children were a joy," says Eleanore, "but he was not well-liked by his associates."

"Why was that?"

"I can only cite small incidents. The first time I met him, he talked at length of 'his' production of *The Red Shoes.* That was an absurd claim to anyone who knew anything about films. And when we were in France for the inauguration of French Technicolor, I think the wives of the executives were not amused when Kay showed up with a different woman at each event, introducing each one as his 'translator.'"

"Why didn't you tell me?"

"My dear, you had three thousand employees to worry about, and that left you no time for gossip. At any rate, I could see why he was an asset to the company. He had qualities that no other top executive at Technicolor had. He was a promoter with vision, an urbane man, probably the world's most restrained supersalesman. I was impressed by the amount of energy and research he put into

the Indian project.''

A few months before his early death, I spent an evening with Kay. He had just returned from India where he talked with political people, particularly the Minister of Education. Kay believed that Technicolor's new developments in visual education had much to offer India with its 440 million people and 500,000 schoolrooms.

Chatting quietly in the Bel-Air sitting room, we touched again and again on that desperate nightmare of doom that hangs over all humanity and which cannot be dispelled by increasingly powerful weapons, whether offensive or defensive, nor by physical walls, nor by hatred, but only by mutual understanding, confidence and good will. And that led us back to education--and ever more education. Could Technicolor, with its new devices as well as its old and time-honored one of illuminating the theatre screen with the full representation of reality, create a greater understanding in the world?

Kay's sudden death from stroke made it impossible to reply to the last letter I have from him, just one of the great number of letters, documents, financial reports, newspaper clippings and other material I have assembled to prompt memory as I write these chapters. I had told him tentatively of my intention to write a book on the business, financing and scientific research of Technicolor, and he generously replied from Paris:

Dear Doctor,

You have created a new art form and I acclaim it so and reject any accusation of vanity. You have created a new and fascinating world of colour that can be used in the arts and sciences to reveal the texture of life, to teach, to educate and to inform. But most important is its adaptation to an art form. You, more than any man living, have accomplished that. For tens of millions of people you have held a mirror up to nature and brought colour into their lives and into their world.

Colour had been limited to the privileged few. Artists sought their patrons from the church, the court and the merchant princes. You gave colour to the multitudes. Your modesty might seek to avoid the issue. But what is Technicolor and what has its effect been upon the world since you first struggled with its potentialities?

Technicolor is more than the outgrowth of an idea, of development and constant research. It is the anatomy of Herbert T. Kalmus; say what you will, it has been your life. Tonight in Afghanistan or in Abyssinia, in Greece or New Zealand, some romantic youth may be experiencing his first inspiration in the discovery of colour on a motion picture screen, a thing that is alive with movement and light, a thing to stimulate the mind and engage the heart.

But your diffidence in proclaiming the value of your work may be arrested by self-imposed restraint. Nevertheless I do feel that your story is Technicolor's story; how it developed in your hands and what impelled you to defend its purpose and persist in seeking its perfection. Yes, the material reward was in itself a form of recognition--it need not be denied that you have enjoyed the fruits of your successful labours. But the important thing that overwhelms other considerations is that you perfected and were chief steward of an idea that has captured the imagination of the entire world.

The title "Mr. Technicolor" is just about right. Give your heart the fluid of your thoughts and let your intellect drive your pen. Open the doors to intimacy. Tell us what influenced your thoughts and actions, what created your lust for life. Why did you seek and embrace the world of business and finance and leave to Comstock and others the research and investigation into phenomena? Was it the fascination of material power? Was it the passion to solve a proposition and then to reap the rewards of its solution? I suspect your material success was tempered with a will not to submit to a problem unsolved...that your joy or pleasure came from the solution itself. Tell us these things.

> *Yours, as ever,*
> *Kay*

Kay Harrison was one of the men who made Technicolor the great corporation it became. There are two theories or principles that may guide a man in managing or directing a sizable business: He may undertake to learn all about things, including all the machinery and equipment employed in his business and, as far as possible, aim to do something with the physical objects and processes himself; or, without altogether neglecting to learn about

things or to become reasonably capable of doing a job with his hands, a man's greater effort and interest may be to know and to understand people, and to gather a talented and reliable staff to manage the things for him.

My choice has been the latter. Some of these people have already been given attention in this book, but there are others who have performed so splendidly as to merit special appreciation and consideration.

First, there is J. Arthur Ball, whose contribution was inventing and building the first three-component Technicolor camera. Starting about 1920 with the idea of adopting a Bell and Howell camera as the best and simplest type, Arthur evolved a movement which was more compact and capable of giving a longer period of rest to the film, that is, giving it more exposure time per frame. Our patent attorneys found that this new development did not infringe on the Bell and Howell patent, and a rough model of Ball's camera movement was made and tested. Arthur did the difficult precision work under great pressure which I confess to having put on him, along with some of his other associates, because of the active competition from Eastman Kodak and other companies.

There had to be a process for making three-component prints from the three-component negative which came from Ball's camera. The Technicolor imbibition process was due to the splendid work of Wadsworth Pohl and his staff.

George F. Lewis, who had been one of the junior partners in Judge Jerome's firm of attorneys, was elected secretary of the company at one of its earliest meetings and for nearly forty years served Technicolor in the most loyal and able way. He was a very active director, serving as Eastern counsel for all the divisions. I was in constant contact with him, and he advised me in personal matters as well; I always counted on him as a very dear and dependable friend. His son, George Lewis Jr., was elected to succeed his father as secretary of the company, and proved just as energetic and helpful as his father had been.

It was Erickson who introduced Harrison K. McCann to Technicolor with the suggestion that he would make a good director, and indeed he became an extremely active member with a record of constant attendance and invaluable service on many committees. Harry had a charming manner which radiated good

nature and affection.

McCann introduced me to James Bruce, who had been U.S. Minister to the Argentine, who also accepted a directorship, along with another friend of McCann's, William G. Rabe, director of Manufacturers Trust.

Murray D. Welch, always available to give assistance and advice, served as a director. David S. Shattuck, the able treasurer of Technicolor Motion Picture Corp., was elected to the board in 1946. Dave had been one of the attorneys in the law offices of Loeb, Walker & Loeb of Los Angeles, one of the largest motion picture company law practices in the country. I had observed for some time his dedicated sincerity to whatever he undertook, and considered it a piece of good fortune when he joined us.

Robert Cushman, from the distinguished firm of patent attorneys in Boston which has represented Technicolor since its organization, was elected a member of the board. He is remembered warmly for his keen sense of humor and his inherent modesty as well as for his power and resourcefulness as one of the leaders of the patent bar in the United States. A partner, Charles S. Grover, was elected to succeed him after his death.

George Cave, for twenty-six years a member of the operations division in various capacities as cameraman, head of the camera department, plant manager and vice president of Technicolor Motion Picture Corp. in charge of Hollywood sales, was appointed to the board in the same year that Kay Harrison, managing director of Technicolor Ltd., was elected a director of Technicolor, Inc.

Robert Riley joined Technicolor in 1922, starting as an operator in the Boston laboratory and was through the years promoted to the position of vice president in charge of sales. He was made a director in 1956.

Eleanore confers another title on him. "He was also our best man," she says.

Another valuable employee was Samuel Corekin, who served as secretary and treasurer in the early years. He had been introduced by Judge Jerome who, in a sense, he represented through those years. Louis Sallet deserves mention, serving as comptroller with efficiency and success.

Members of the Technicolor organization with forty years or more to their credit are Arthur Ball, Walter Allahan, Thomas

Cave, Walter Felone, Stanley Gillis, Wallace Gillis, John Kienninge, Robert Riley, and Jack Clark. And, of course, myself, serving for more than forty-five years in a job I never ceased to find both demanding and rewarding.

It was not until 1939 that cumulative profits overtook the cumulative losses so that the company began to reward its "financial angels" or stockholders with net earnings. In the very early days "angels" seemed a more appropriate term because not only did the company have no net earnings but its assets consisted largely of the nerve and appetite of those having made the largest investment and of those of us who were responsible for the invention of the process and for its commercial performance.

At first, we had no representative or establishment in California that could be called an organization. In April 1922 I sent a group from Boston with Willat in charge, Ball as technical director, Cave as assistant technical director and Ray Rennahan as cameraman. Their first assignment was to photograph color inserts for a film called *Scaramouche*. They gradually established a base in Hollywood, but still each day's work had to be shipped to Boston where the prints were made and shipped back for the director and producer to view.

Another memory of 1922: Kodak announced that it was prepared to make, by a newly developed process, color prints suitable for projection in any projector which could be used for close-ups and special scenes in motion picture production. We were afraid this meant that ANYBODY could make color motion pictures!

The year 1934 shows a loss of some $283,000 before taxes--another profitless year, and the year Judge Jerome died. The entire Technicolor family loved and honored the Judge and suffered the most heartfelt sorrow at his death. We were especially grieved that he did not see the company grow to become a strong and profitable enterprise, nor see the results of its work in the outstanding motion pictures that were soon to come.

Technicolor closed the year 1948 in a strong position: over $6,000,000 in cash, no bank loans, no preferred stock, no mortgages, no options on its stock. The year 1952 saw a new record of 97 feature-length pictures in a single year. In the same year, the number of employees increased from 1837 the previous year to 2215.

In 1950, Technicolor began its program of changing over from nitrate base film, which was highly inflammable, to safety, or acetate, base for both positive and negative film.

In 1953 the American Stock Exchange issued a bulletin titled "Dividends for More than a Decade." Under the classification of "Motion Pictures," Technicolor alone was listed as having paid dividends for seventeen consecutive years, up to the end of 1952.

Those seventeen years take us back to the year 1936. It is plain that Technicolor practiced a very liberal dividend policy toward its stockholders.

In December of 1953, RCA demonstrated the results of its research in electronic photography, which led to television. As the number of television sets increased in homes across the country, the number of movie houses began to decline.

In 1955-56, the decline of profit can be traced to the introduction of Kodak color positive film, among other factors.

Back in 1929-30, during the early rush to color after the Technicolor two-component system had proved economical, the company made a profit before income taxes of some $1,700,000 and its stock shot from $2 a share to $92 a share.

I recall that, watching that rise, Erickson and I felt we were at a point to consider financing of a more permanent character. At the time reputable brokers might have been interested in underwriting, say, 100,000 shares of stock at $40 a share, providing us with $4 million.

A sum like that would have enabled us to accept only desirable projects, limited to what we had the laboratory capacity to handle well; it would have supported our research and development departments so that our three-component process could have come a year or more earlier; it could have strengthened our position in the very important Monopack developments to come; we would have been able to trade more advantageously in establishing foreign subsidiaries; and, of special importance, it would have enabled us to participate in the financing of exceptionally promising productions so as to enjoy not only a consistent large volume of laboratory business but also a share in the profits of production and distribution.

But we never found this $4 million nest egg. And the policy of Technicolor never moved in the direction of taking part payment

for services and prints in the form of an interest in the returns from a picture, or of making a cash investment in the picture, or by financing motion pictures through the sale of a substantial block of Technicolor stock through a brokerage service. Otherwise, Technicolor might have participated in the huge box office returns of the great Technicolor films to come and its financial history would have been that of a company blazing a trail in the color laboratory business and at the same time establishing itself in the business of production. But we never did; the general feeling of the board of directors was that a half-dozen powerful Hollywood directors were our only customers, and that we should not compete with them in their own field.

Looking again at the chart, I remember what a great year 1939 was for Hollywood and for Technicolor. It had taken us fourteen years of effort to turn the corner and show a profit. It was the year of *Gone With the Wind*.

CHAPTER TEN

Gone With the Wind

On the night of February 29, 1940, 1,200 members of the Academy of Motion Picture Arts and Sciences and their guests gathered at the Coconut Grove in Hollywood's Ambassador Hotel. It was the big night--Oscar Night. Nineteen thirty-eight had been a year of outstanding films, and tonight we would see which achievements had been chosen to receive recognition from the motion-picture community.

I watched Vivien Leigh, wrapped in an ermine robe, arrive on the arm of David Selznick. For David, tonight was the culmination of years of labor--it had taken him three years to prepare and shoot *Gone With the Wind*. For three years, the main topic of Hollywood was whether he could do it--or was it an impossible task to turn the Civil War epic into a motion picture? The newspapers and the trade publications had been full of details about the problems during production and the seemingly endless search for an actress to play the role of Scarlett O'Hara. Production costs had risen astronomically, and still the producer would not compromise with his ambitions for this film. And now it had garnered an unprecedented thirteen nominations.

From the start of the year, with the release in January of *Gunga Din*, we had seen a greater number of films destined to become classics than in any similar period in moviemaking annals. *The Wizard of Oz, Dark Victory, Good-bye Mr. Chips, Mr. Smith Goes to Washington, Wuthering Heights, Of Mice and Men, Stagecoach* and *Ninotchka* were just a few of the year's productions. And there were at least as many outstanding performances by actors and actresses as there were good films. There was a certain tension in the audience, despite the fact that the Los Angeles Times had "leaked" the names of the winners in its final edition, and some late arrivals had been able to pick up a copy of the newspaper on the way to the Ambassador Hotel. The tension was somewhat relieved by the relaxed humor of Bob Hope, making his debut as Master of Ceremonies, and we all forgot our problems as 17-year-old Judy Garland sang "Over the Rainbow," winner of Best Song.

But we were all waiting for best picture--would it be *Gone With the Wind*?

Margaret Mitchell's Civil War novel was published in 1936. It was an overnight sensation, but it had elicited a great amount of excitement even before it was published.

Selznick's New York editor, whose job it was to scout for new literary properties, read the book in galley form and decided it had the makings of a spectacular motion picture. She urged Selznick to drop everything and buy the rights. Selznick too read the book before it came out and immediately offered $50,000 for screen rights. A month after the book was published, he was turning down offers of $350,000 from people who wanted to buy the rights from him.

Ten thousand copies of the novel were initially printed, far short of public demand. Within three weeks, 176,000 copies were in circulation, and within six months one million copies had been sold. It went on to sell millions of copies and win a Pulitzer Prize for its author.

Gone With the Wind was the only book Margaret Mitchell ever wrote. It is the story of Scarlett O'Hara, a fiery Southern belle, who is disappointed when the man she loves, the refined planter Ashley Wilkes, marries gentle Melanie. After being widowed twice, Scarlett marries dashing Rhett Butler, who proves more than a match for her. Their personal lives are portrayed against the background of the Civil War and Reconstruction. The story was simply made to become an epic motion picture--and certainly to my mind it should be made in Technicolor.

Among the Technicolor pictures produced in the years from 1935 to 1937, five (*Becky Sharp*, *Dancing Pirate*, *Garden of Allah*, *Nothing Sacred* and *A Star Is Born*) were Pioneer Pictures produced for Jock Whitney and his associates by Selznick International. That left three of eight pictures still to be produced under the Pioneer-Technicolor contract.

Whitney and Cooper, representing Pioneer, along with Selznick asked Technicolor for permission to substitute one superproduction in place of two regular features under this contract. *Gone With the Wind* was to be that superproduction. Our stipulations--and our way of assuring that the production would do justice to the project-- was to ask that the picture would cost not less than $2 million with

prints and a guarantee that the picture would run not less than 15,000 feet in length, with penalties in options if the picture cost less than that amount or ran less than that footage.

We need not have worried. In the end, the actual production cost was almost $4 million, an unprecedented sum, and we shot 449,512 feet of color film, totaling 88 hours. One hundred and sixty thousand feet of film were printed, resulting in 20,300 feet of edited film--a movie totaling three hours and forty-five minutes. It was the first motion picture to have--and need--an intermission.

In spite of its army of technicians and extras, its experts giving advice on every subject from military history to regional accents, its battery of stars, writers and directors, *Gone With the Wind* was essentially a one-man movie, and that man was David O. Selznick.

David was a second-generation producer, starting as office boy in his father's New York studio. Lewis Selznick, a pioneer in the days of silent films, went bankrupt in 1923. It was said that the Hollywood money-changers ruined him.

Instead of shunning the industry that left them penniless, David and his brother Myron went to California, Myron to become Hollywood's biggest talent agent and David to become himself one of the men who had brought down his father--a movie mogul.

He started modestly enough, being hired, reluctantly, in 1926 by his father's former partner, Louis B. Mayer, as assistant story editor and later promoted to associate producer of MGM's B movies. Two years later he married the still-reluctant Mayer's daughter, Irene.

In 1935, with the backing of Jock Whitney, he established his own independent filmmaking company, Selznick International, which released its movies through RKO and United Artists and later through its own distribution branch.

There were many Hollywood stories about Selznick--his meticulous attention to detail, his ability to do everyone's job including his own, the steady stream of memos that issued from his desk to every corner of the studio--but my favorite anecdote is a feat he pulled off on his first production assignment. Sent on location to make a Western, David took one set of technicians, one supporting cast, and two sets of stars--and made two movies for little more than the cost of one.

It was true that he could do most jobs on the set as well as a

professional. He had a strong sense of how to photograph an actor, how to use sets and music and how to construct the developing action of a movie. And I believe he wound up rewriting almost every script he ever produced. He was never reluctant to demonstrate his expertise, which drove some writers and directors to the limits of their patience. Two years before, when William Wellman received the Academy Award for Best Director for the Selznick production *A Star Is Born*, Bill strode across the podium and handed the gold statue to David, saying, "Take it. You had more to do with it than I did!"

The American public took a great interest in the making of *Gone With the Wind*, and millions of readers thought that no one could play Rhett Butler better than Clark Gable. The problem was, he was under contract to MGM. In the days of the studio system, most stars were tied to their production company by contracts, and could only be "lent out" to other studios in situations advantageous to the original producer. Selznick considered other actors-- Gary Cooper, Ronald Colman, Errol Flynn--but somehow never signed any of them; perhaps he secretly suspected that no one but Gable could carry the role.

Selznick finally got him--but he paid a terrible price. Knowing that Gable was secretly in love with Carole Lombard and that Gable's wife was demanding a large divorce settlement, MGM's Louis B. Mayer offered Gable a one-film release from his contract and a $100,000 bonus to make *GWTW*. Clark reluctantly agreed although he himself was not convinced that he was destined to play a blockade-running rogue in costume.

This put David Selznick in an unenviable position when he went to Mayer's office to bargain for Gable--the cards were all in his father-in-law's hands. The price? MGM would lend their top star and put up half the film's budget; in return, MGM would get half the profits and full rights of distribution.

This caused another delay. Production had to be postponed until Selznick's distribution contract with United Artists had expired.

These elaborate machinations took care of the casting of only one of the major roles. Lesley Howard had to be persuaded to play Ashley against his better judgment. The actor felt he was too old for the role, and had played the same kind of weary intellectual too

many times before. And when David asked Warner Brothers for the services of Olivia de Havilland to play Melanie, Jack Warner answered with a simple "No." She, too, was a contract player, and her price was high. Warner finally agreed to lend de Havilland in exchange for the services of newcomer Jimmy Stewart--a swap.

The search for an actress to play Scarlett O'Hara had a twofold purpose. On the one hand, it maintained public interest in the project during the two-year wait while Selznick's distribution contract ran out, and on the other hand, it really was a search for a little-known actress--the budget could not stand the cost of another major star.

Established Hollywood actresses read for the role of Scarlett as well as hopeful young unknowns around the country. The cost of screen-testing possible Scarletts rose to $92,000. The names of Bette Davis, Katharine Hepburn, Paulette Goddard, Tallulah Bankhead, Carole Lombard and dozens of others had been entered as candidates; young women from Boston to Atlanta to San Francisco read for the part. David Selznick watched every screen test.

Finally, there could be no further delay. Under the terms of his contract with MGM, Selznick had the service of Clark Gable for an allotted time--he had to put him to work by mid-February 1939. Production had to begin--but there was still no Scarlett.

In England, a beautiful young actress comparatively new to films read Margaret Mitchell's book and decided to seek the role with all the determination she could muster.

One would suppose that a British actress in the role of a Southern belle was the farthest thing from Selznick's mind, but actually he had been secretly screening her English movies in his projection room at home. He became convinced that the green-eyed beauty with her fiery film presence would make the ideal Scarlett, and he began to barter with Alexander Korda for her services. Finally the obstacles were worked through, and Vivien Leigh was Scarlett.

Several writers had a hand in reducing the 1,037 page manuscript to a manageable script. Sidney Howard, a Pulitzer Prize winning playwright, was the first to try. Three writers later, the novelist F. Scott Fitzgerald worked on it. By the time shooting began, nearly every scene had been rewritten by Selznick himself. David decided that one more rewrite was called for, and brought in

Ben Hecht. Hecht went back to Sidney Howard's original script and edited it down to a workable length.

The directors were caught in the same revolving door. The original director, George Cukor, who had worked for two years on pre-production planning, was replaced two weeks into the film by Victor Fleming, who was driven to physical and mental exhaustion and turned the reins over to Sam Wood. All along, of course, the directing was as much in Selznick's hands as any other part of the production.

Gone With the Wind was the first motion picture to be photographed with the new, faster Technicolor film, which made a huge difference in the lighting methods and color values of the final film.

One evening in late 1939 during the cutting and editing process I saw *Gone With the Wind* screened in twenty-two reels (its final length would be twenty reels), still in a crude state and with some parts missing. Nevertheless, it was the greatest thrill I had ever experienced in viewing a motion picture. Unlike most epics, where every other consideration is subordinated to imposing sets, lavish costumes, thousands of extras and scenes with huge sweep, the characters of the actors came through. Vivien Leigh gave a remarkable performance, and her beauty and high spirits fit the role perfectly. Clark Gable, Leslie Howard, Thomas Mitchell and Hattie McDaniel were superb, and Olivia de Havilland, in a role that could have been mousy, gave Melanie a warmth and honesty that was most moving. I predicted then that although the cost of the film had been enormous, it would be a great money-maker, probably the most popular movie of all time.

The only worry at the moment was the fact that war clouds in Europe would deprive Selznick and his investors of much of their European market. I had this in mind when their attorney approached me with a request.

Pioneer Pictures had options on a substantial number of shares of stock of Technicolor exercisable for a period of ten days beginning on the day the cut negative and print order of *Gone With the Wind* was delivered. Now they requested an additional ten-day extension on that period. Considering that we had come through this project with everybody treating each other in a fair manner and with everybody so pleased with the results, I recommended that it was fair, proper and good business for us to extend the

options for a period of six months without further consideration and at the same price.

David did quite well out of this. He had agreed to shoot *Gone With the Wind* in Technicolor partly because he had already made Technicolor movies and had faith in the process. Another reason was the obligation, inherited from the Jock Whitney-Pioneer agreement with Technicolor, to produce a number of movies in the new process, an agreement that included an option on Technicolor stock at a specially discounted rate. As we had agreed to count *GWTW* as two movies because of its great length, he would be entitled to double the number of shares under option. When *Gone with the Wind* was completed, Selznick was able to collect 15,000 Technicolor stock options at $3 a share--when the over-the-counter rate was $11.

Selznick and I were not always so agreeable about money matters. When his expenses had reached over $3.5 million, David began to fear that it was a dangerous sum to spend on the negative of a movie since no production had ever grossed enough at the box office to make such an investment profitable. From time to time Selznick, quite understandably, would appeal to me to reduce Technicolor studio and laboratory charges. As much as I wanted David to be able to stay within his budget, and as much as I held Jock Whitney to be a firm friend, I was obliged every time to say that Technicolor had one scale of prices which, once broken for anybody, would mark the beginning of an endless appeal from everybody for reductions for one reason or another. Jock understood my position, and when I explained the reason for my refusal always promptly said, "Go ahead as you are."

The initial order of prints numbered 350. Over the next several years, subsequent print orders totaled 1,666 prints from the Hollywood plant and 329 prints from the British plant. Then came an order for one hundred prints.

In billing for prints, it was always true that the price per foot depended on the number of prints ordered at one time. Naturally, an order for one hundred prints would cost more per foot than an order of 350 prints. This particular reorder came just when MGM had taken over the total distribution of *Gone With the Wind*. That fact was not generally known and I doubt that David knew I was aware of it.

David argued with me long and hard that the price per foot for this order should be the same as his original order. "I think the matter should be arbitrated," he said.

"I'm always anxious to be reasonable," I replied. "It's a matter of finding the proper arbitrator."

To my surprise, David named Eddie Mannix, a burly Irishman who had been a fairground barker and was now L.B. Mayer's right-hand man. Mannix was general business manager at MGM and was therefore an employee of the distributor which was going to have to pay the bill in question. But I had known Mannix for half a lifetime, and would have trusted him with anything.

"He's acceptable, on the following conditions: that you, David, make an appointment with Mannix and tell him your side of the story without my presence. Then I'll make an appointment and tell him my side of the story and you will not be present. That way we'll avoid a loud argument." After David's session with Mannix, Eddie telephoned to say I need not bother to make my case. He understood perfectly why Technicolor had to stick to its guns, even though the sum involved was only about $20,000.

And when the last piece of film was swept from the cutting room floor, hadn't David produced the most important motion picture of all time? It took great genius to bring together all the elements of that great screen entertainment.

I have probably seen it a dozen times or more since its first release. As late as 1962 I couldn't resist the temptation to see it once more.

The picture had lost none of its charm. And most interesting of all, from my point of view, the print showed the same breathtaking beauty and naturalness of color that had enthralled us all from the beginning, although more than a thousand prints had been made from this negative. The accuracy of color was there, both in the long shots and the close-ups of the actors' faces. All the hours of consultation and planning, the problems of lighting, of color control, of special effects had paid off, from the delicate white flounces of Scarlett's dress to the burning of Atlanta.

And so many people share the credit. Ray Rennahan, Technicolor's cinematographer, who had shot some of the earliest productions using Technicolor's new three-color system, including the ground-breaking short *La Cucaracha* in 1934, shared the

Academy Award with Ernest Haller for Best Color Cinematography for *Gone With the Wind*.

And behind the scenes I felt the fine hand of Ted Curtis with the great power of the Eastman Kodak Company behind him, and the equally fine hand of Merian Cooper, whose experience in the film world was second to none. The two of them brought us together--Whitney, Selznick and myself. Without any one of the three, there would have been no *Gone With the Wind*.

Finally, I must not overlook the fact that David's genius stretched out to give the part of Bonnie Blue Butler to a little four-year-old girl named Cammie King. Her mother was a well-known journalist, Eleanore King. It is the same Eleanore, my dear bride and constant companion, who now and then while I am writing this manuscript comes into the study to see if there is anything I need or to remind me of an appointment I must keep.

Eleanore tells me that it was her older daughter, Diane, who was first considered for the role.

"Mr. Selznick and his casting director were delighted with Diane--'Gable could not have a daughter more like her; her eyes are the same size and shape,' they decided. I was only concerned that she not be spoiled by attention and that the arrangements would suit a four-year-old's schedule.

"Selznick walked us to his office door just as an extremely tall and distinguished-looking man was chatting to the secretary. 'Doctor,' said Selznick, 'this is our lucky day. We've found her. Please meet Bonnie Blue Butler and her mother, Mrs. King. Doesn't the child resemble Gable?' Dr. Herbert Kalmus greeted us in a courtly, distant manner, but it was clear that he agreed with Selznick's enthusiasm. I looked up at him, thinking to myself, 'I didn't realize anyone could make David Selznick seem less impressive.'

"The problem was, by the time production started Diane was almost eight. Then one day early in 1937 I was surprised to receive a call from the casting director. 'We have tested thirteen hundred little girls, Mrs. King, but Mr. Selznick cannot get Diane out of his mind. Is there any other little girl in your family?'

"'Why, yes,' I said, 'Diane has a little sister.'

"'How old is she?'

"'Four....'

"'Can the two of you be ready in twenty minutes for the studio limousine?'

"'Yes...but...Mr.--' 'Twenty minutes,' he said, and hung up. I was about to tell him that Cammie's eyes were not blue but brown.

"Cammie was an enthusiastic child, full of sunshine, and it was evident to me almost from the beginning that she was wanted in this production. But what would they do about her brown eyes?

"'We're going to have your picture taken, Cammie. Would you like that?'

"'Oh, yeth, Mr. Thelthnick,' was the answer.

"Mr. Selznick gave the orders to take some shots of her straight on. 'The whites of her eyes are very blue, and she'll be wearing blue costumes and blue ribbons in her hair,' he told me. 'We think we may have found her.'

"Three days later we were called back to Selznick's office. I could see that the past four years of pressure and decisions had been hard ones. He sat for a moment, breathing audibly as though in anguish. Then he slammed his hand down on the top of his desk and faced me.

"'Mrs. King, we have found our Bonnie Blue Butler at last.' I smiled at him as he continued. 'I believe she has brought me luck already. You have probably read in the press that this is the most expensive picture ever made, and I needed still more money.' He sat back and the tension that had held him in a vise relaxed somewhat. 'It came through today.'

"Dear, it was only later, reading your manuscript, that I realized that Jock Whitney must have given him the go-ahead sum that day. He asked what part of it I intended to ask for, and I said, 'Mr. Selznick, I am going to find out what four years at Stanford will cost, double that amount, and that will be Cammie's price. She is only going to make one picture, and I'd like for it to pay for her education.'"

David had raised the last block of money from the Whitneys, but not without travail. First he had tried MGM again, but MGM saw clearly that there was no need to put up any more; if David failed to complete the picture, MGM would be able to take over the production on its own terms and complete it in order to recover its investment.

He approached the Bank of America's Motion Picture Loans

Department, where Dr. Giannini still played financial godfather to the cinema industry, but the bank wanted MGM to back the loan. MGM sat and waited. David's company was almost literally down to its last dollar; he had borrowed money from his brother Myron to meet the last two weekly payrolls.

David needed $1 million to finish the picture. His backers were reluctant to come up with another million dollars, but if the picture wasn't completed, their investment to date would be jeopardized. Finally, the Whitneys and their associates--including myself--raised $400,000 and the Bank of America came through with the rest.

Eleanore recalls the scene. "Mr. Selznick seemed buoyed up by the last-minute funding, and he agreed to my terms. 'We'll want Cammie on Wednesday,' he told me. 'There won't be a script, but she will be working with Gable and the director, who will meet her alone before you go on the set.'

"When we met Victor Fleming, the first thing he said to me was, 'Well, he's given me a 40 year old Ashley Wilkes, a British Scarlett O'Hara, and now a brown-eyed Bonnie Blue Butler,' which made us all laugh.

"Fleming explained the first scene to her carefully. She would be in a bedroom in London, wearing an old-fashioned nightgown, hiding under the covers, crying, and her daddy would come home to comfort her. 'Action!' he called. Lights went on, and Clark Gable rushed in, tossing off his top hat and pushing back his opera cape.

"'Daddy, Daddy, I want to go home. I want to go home. I want my Mommy. Mommy, Mommy, where are you?' Cammie did her lines very convincingly.

"Rhett soothed her and rocked her in his arms as she fell asleep. They made a beautiful picture. The scene continued as Rhett admonished the English nurse, 'Haven't I told you never, NEVER to leave Bonnie in the dark?'

"'But Mr. Butler, it is not good for a child to sleep with a light in her eyes.'

"'Don't you tell me what's good for my child. Pack immediately. We're sailing for America on the first boat.'

"Gable continued to sit and rock, singing and talking to the sleeping Bonnie, as the scene ended. Later he turned to me and asked, 'Do I handle a child as though I'm accustomed to it?' I

assured him that indeed he did.

"The set of *Gone With the Wind* was a happy place to be. I was hardly aware of the army of technicians and workers who surrounded us. It was an extraordinary experience for everyone connected with it.

"And then years later--remember?--after we were married, and Cammie was graduating from high school, we took her on a European trip as a graduation present. We ran into Clark Gable in the lobby of the Dorchester in London. He said he simply couldn't believe his little Bonnie Blue had grown up on him. 'It's the first time I've ever felt old,' he said to you, and you replied, 'Nonsense, Clark, you don't know anything about the word.'

"And when he said, of Cammie, 'She's still a beauty!' she answered right back, 'Mr. Rhett, you're more handsome than ever!'"

<p style="text-align:center">***</p>

Eleanore's memories are full of detail. *Gone With the Wind* seems to bring back more than its share of memories to everyone who was ever connected with it. Eversley Childs claimed to the end of his life that it was his favorite motion picture. In spite of its tremendous cost at the time, it was calculated that it would have cost $40 million to make the film only twenty years later. And as I predicted, it has been a box office winner. By the end of 1940, it had been seen by 25 million people in the United States and had grossed over $14 million, more than earning back its production costs. By 1956, one hundred million people had seen the film somewhere in the world. In wartime England, the picture ran almost the entire length of the war; in East Berlin in the 1950s it ran for two and a half years. The picture continues to be seen. Unlike most motion pictures, which have a life of a few weeks, this one went on and on.*

* By 1967, it had earned $75 million for MGM; in that same year it was overtaken in box office gross by *The Sound Of Music*; because of greatly increased admission prices, other blockbusters exceeded *GWTW*. The seventh time MGM released *Gone With the Wind*, it was in a widescreen version with stereophonic sound. When CBS paid $35 million for twenty years of television rights, it meant that an enormous new audience would continue to enjoy the film, and eventually it was released as a videocassette for home viewing. --E.K.K.

At the Awards Ceremony that night in February, 1940, the roll call of awards went on and on, as well. *Gone With the Wind* swept the board with ten Academy Awards: the film won Oscars for the best picture; best actress, Vivien Leigh; best supporting actress, Hattie McDaniel; best director, Victor Fleming; best photography, Ernest Haller and Ray Rennahan; best screenplay, Sidney Howard; and a special award to William Cameron Menzies, art director, for "outstanding achievement in the use of color for the enhancement of dramatic mood in the production of *Gone With the Wind*."

Technicolor, too, received a coveted Oscar "for its contributions in successfully bringing three-color feature production to the screen." It was a high moment in Technicolor's history. As I received the award from the hand of David O. Selznick, I could only think of all the years that had led to this moment.

With the remark that it was a long deserved recognition, I was asked how I felt about it, after clinging so tenaciously "through the dark ages, when color motion pictures were not so well appreciated."

I replied, "It was all marvelously interesting, it was great fun. We couldn't let anybody down, neither customers, employees, stockholders nor directors. But there was something else, too. There was always something just ahead, a plan for tomorrow, something exciting to be finished--yes, and something more to be finished after that. And I am willing to predict that it won't be finished for many years...."

CHAPTER ELEVEN

The War Years

In 1939 there began the worldwide conflict that eventually engulfed every major power in the world. World War II was the result of the rise of totalitarian, militaristic rules in Germany, Italy and Japan, encouraged in part by the Great Depression that swept over the world in the early thirties and in part by the unsatisfactory peace settlements after World War I. In 1941, as the United States and the Soviet Union entered the battle, American correspondent Quentin Reynolds, who had just returned from Russia and England, declared, "Motion pictures are as important as planes, guns, tanks and factories in winning the war."

I agreed completely. Not only were motion pictures a source of morale and information for the general public, films were an important educational and training medium for members of the armed forces. Motion pictures could educate in the causes of war and the reasons for America's participation, and newsreels could inform us directly of world events.

While Hollywood fare had previously aimed at themes that were not offensive to any market, with the closing of foreign markets due to Hitler's advances and the effects of war, the studios began to make movies that alerted Americans to the threat of totalitarianism and brought us closer to our allies. Some of these were black-and-white (*Mrs. Miniver*, *Mission to Moscow*, *The Mortal Storm*, and Chaplin's *The Great Dictator*) and many were in Technicolor (*Crash Dive*, *Salute to the Marines*, *To the Shores of Tripoli*, *Dive Bomber*, *Victory Through Air Power*, and others).

Movie stars became an essential commodity in the war effort. Several stars enlisted--James Stewart and Robert Montgomery among them--and others, such as Bing Crosby, Frank Sinatra and Marlene Dietrich, devoted their efforts to the USO and to War Bond drives.

Scientists and technicians at Kalmus, Comstock & Wescott and those at Technicolor had invented and manufactured various optical instruments and mechanical equipment used in photographing, processing and making prints of motion pictures. This

very fine mechanical and optical work was called upon by the government. During the years 1939 to 1946, we were particularly engaged in the manufacture of theodolites--a surveying instrument used to measure horizontal and vertical angles--and other precision instruments for the war effort.

Entertainment was of great importance to the nation at war. Technicolor was justly proud of the many outstanding pictures made available to the Army and Navy. As well as pictures for entertainment, we were involved in the photography and printing of films which the government used in connection with defense and training, such as *The New Spirit* and *Any Bonds Today*, made for the Treasury Department. In the first of these, made with the Disney organization, Donald Duck amusingly and convincingly explained the new wartime income-tax laws, adding numbers of new taxpayers to the rolls and increasing the government's income for the war effort. The Treasury Department ordered 1100 prints to show all over the country and *The New Spirit* was seen by some 26 million people. At the height of the war, some 50 percent of screen time available for shorts went to the government war effort.

In England, British Technicolor was at work on inventions the technical staff had devised that resulted in special domes where battle-simulation techniques were used in the training of anti-aircraft gunners.

We were part of an industry which needed the very material the government required to wage war. An uninterrupted supply of raw film, chemicals, electric power and other utilities were necessary to the practical operation of the Technicolor plants and service departments. Some of these products were under direct government control and a considerable number of them required a priority rating before delivery could be obtained.

In the motion picture industry as a whole, the War Production Board held the power of life and death over Hollywood through control of raw film supply. The shortage of other materials took a toll, as well. Lumber was particularly in short supply for building sets; paints, shellacs, lacquers and thinners were also hard to obtain. The studios voluntarily limited the cost for set construction to $5,000 per production. In prewar years, the cost of a set could exceed $50,000.

Late in 1942 demands of the Army and Navy for 35 millimeter

motion picture negative and positive film were increasing by leaps and bounds and had become nearly equal to the total print capacity of all manufacturers of raw stock in the United States.

I was told that Washington was taking a serious view of the fact that Technicolor used three times as much negative for a Technicolor film as a corresponding production in black-and-white would employ. I immediately contacted Harold C. Hopper, Chief of the Motion Picture and Photographic Section of the War Production Board.

Hopper verified that the demands for raw film totaled more than the existing capacity of the manufacturers. He wanted to curtail the motion picture use of film by about a third, but he wanted to do this without changing the position of importance of the various companies.

"I have been in this business for many years," he told me. "Your name and Technicolor frequently come up in my conferences with the distributors. You're a man of wide experience. I would like to hear your views."

My first position was that the theaters of America should be kept open, and Hopper agreed unqualifiedly.

Second, I stated that it was most important to preserve the best pictures, and I named several important Technicolor pictures which were in production. Hopper agreed; the government did not wish to censor pictures, and it was not their intention to cut short or destroy the best work.

Third, the curtailment he proposed should concentrate on positive film and not on negative film, because negative was used in relatively small footage. To back this up, I related an experience Technicolor had just been through. Francis Harmon of the War Activities Committee of the Motion Picture Industry telephoned me from New York to say they had viewed and cut the working print of *The Battle of Midway*, and that at the request of the Secretary of the Navy he was placing an order with Technicolor for 500 prints, which were needed on the most rapid schedule possible. "You can consider that the pressure for this comes from the President's office on down," he told me. In addition to these 35mm prints, 16mm prints were needed for schools, associations, institutions and for all branches of the service in order that all the young men in uniform might see how their comrades conducted them-

selves and what they accomplished in the Battle of Midway, one of the decisive Allied victories of World War II. Hopper saw my point and agreed with me that if they saved the entire amount of negative Technicolor used the year before, 12 million feet, it would be insignificant compared with the loss of pictures it would entail.

My fourth point was that Technicolor was not only a laboratory but a research organization which had developed important processes and manufactured fine mechanical and optical equipment for the Navy, the Signal Corps, for Fort Monmouth and Wright Field and other government departments, and for the British Admiralty. I told him about British Technicolor's domes for teaching anti-aircraft gunnery, and said that the Technicolor plant in England could not run without the basic support of the Hollywood plant. Hopper agreed overall that Washington should take into account that Technicolor was performing a number of direct war tasks which, to pay for these tasks, required a substantial underlying volume of other regular business.

Two weeks later, Hopper called an emergency meeting of the Motion Picture Producers and Distributors Association in Hollywood and declared that all users of 35mm film must apply to the War Production Board to acquire film or even to use film already in their possession. Hopper advised Technicolor to make immediate application for its requirements. We did, and those requirements were granted.

The War Manpower Commission considered the production of motion pictures essential to the war effort. No one wanted theaters to go dark, either in the military sector or the civilian. I certainly thought the motion picture industry was indispensable to the morale of our men and women--those in the service, those doing war work in industry, and the families at home.

One of the most difficult problems for Technicolor during the years from 1939 to 1946 was the abnormally high turnover of skilled labor due to enrollment in the armed forces and to attraction by the aviation and other direct war industries in California. But I felt that the workers--many of whom were classified as doing essential war work--who remained with us, producing films for the American public and doing a substantial volume of direct work for the government, could well feel pride and satisfaction in the labor in which they were engaged.

I am very proud of a certificate that lies here among my papers. It reads:

Washington, D.C.
March 1, 1945

This is to certify that Dr. Herbert T. Kalmus has participated in work organized under the office of Scientific Research and Development through the National Defense Research Committee contributing to the successful prosecution of the Second World War. On behalf of the Government of the United States of America this certificate is awarded in appreciation of effective service.

James B. Conant, Chairman
Vannevar Bush, Director
National Defense Research Committee

After the enormous effort of the war and the return of peace, we found it was time to turn our attention once more to the demands of labor. The severe economic crisis of the 1930s had given rise to unionism in industries all over the nation, and the motion-picture industry was not exempt. The studio craftsmen were the first to organize--carpenters, painters, plumbers and others whose skills were not strictly limited to film work. As early as 1918 these craftsmen called a successful strike to achieve a wage increase.

The major producers of the motion picture industry, including those with their own printing and developing laboratories, had contracts covering their employees, in some cases with the international unions alone and in other cases supplemented by contracts with the locals. Under these agreements, which called for the closed shop, the unions were recognized as the collective bargaining agencies of the employees.

Technicolor, on the other hand, had many types of employees who did not follow the pattern of the industry in general. The nature of the Technicolor process introduced inherent departures from the set-up of the rest of the industry so that Technicolor management was constantly engaged in special negotiations with

unions, of which we had contracts with as many as nine.

Generally, management's dealings with representatives of the unions have been satisfactory. This is not to deny that the increase in wages and other restrictions imposed by the unions sharply increased operating costs. Negotiations have at times been extremely difficult, and at times have threatened to blow up into a strike. In the worst labor disputes, we were only secondarily involved.

Hollywood producers managed to maintain open shop until 1935, when the right of workers to bargain collectively with management through unions was firmly established. One of the unions competing for the support of the movie industry's craftsmen was the IATSE (International Alliance of Theatrical and Stage Employees); one of the leaders of this union was William Bioff.

It was generally acknowledged that Bioff counted among his acquaintances some of Chicago's most notorious gangsters. In an early demonstration of strength, IATSE called a projectionists' strike in Chicago, darkening hundreds of theaters. This forced the major producers to recognize it as the sole bargaining agent for certain jobs, including sound men, cameramen, projectionists and laboratory workers. The closed shop came to Hollywood--membership in the union became a first condition for employment. Overnight IATSE's membership went from one hundred to 12,000 members.

The heads of these various crafts called upon us at Technicolor. They demanded their standard labor contract providing a closed shop. I knew that the situation with color was different in some respects from the situation with black-and-white laboratories, so that while in a sense we were being asked only to do what the laboratories of all the studios were doing, in practice it was not the same. Technicolor found the stipulations too exacting, and we expressed this.

Mr. Bioff sent word that if Technicolor delayed further in falling into line with studios and other laboratories he would notify all theater projectionists to refuse to project Technicolor films.

I went to confront him. I had faced sharp money-men and powerful producers through the years, but Bioff was more threatening than anyone I had ever known. He sat behind a large, shielded desk, and I was struck by the conviction that there were

guns within reach on his side of the desk. Nevertheless, I told him flatly that I doubted he would carry out his threat because it would work a great hardship on the producers, who had millions invested in Technicolor pictures, and he could hardly afford to offend the producers at this point.

His rough, blunt manner of negotiating bothered me greatly, but my last remark gave him something to think about and avoided an open break. Eventually we reached an agreement with his union which was reasonably satisfactory to Technicolor.

My feelings about Bioff were proved right. Later, he was indicted and tried for extortion. Under threat of strike action, the major studios had been paying large sums of money to him and other union racketeers for years. Bioff was convicted and sentenced.

The most serious altercation between Technicolor and labor took place in 1945. It began in a small way, over the jurisdiction of a group of set designers. By the middle of the year it had grown into a confrontation involving IATSE and other groups--machinists, electricians, carpenters and janitors--under contract with the motion picture industry and Technicolor. Basically, it became a conflict between IATSE and groups within the American Federation of Labor on who would represent which divisions of studio craftsmen.

When D.P. Wayne of the Studio Machinists Union ordered the machinists at Technicolor plant to shut down, it threw 1250 men out of work, including 750 technicians who were members of IATSE. The fate of five Technicolor productions at major studios hung in the balance.

I called a meeting with Wayne and several other labor people, including Herbert Sorrell, President of the Conference of Studio Unions.

"This is Technicolor's position," I told them. "We will operate as long as we can, but we are approaching a point where the volume will be too low to make it technically possible to continue. Such a cessation will stop the work being done for the armed forces, which alone is not sufficient to enable us to operate the plant. We may simply have to close."

The labor leaders saw in this an advantage for their side. "Except for "B" movies, black-and-white production is almost at

the vanishing point," responded Mr. Sorrell thoughtfully. "The big studios are depending on Technicolor for a product to sell to the public. If we can stop the producers through Technicolor, we can win."

At six o'clock the next morning, April 27, 1945, a picket line was thrown around the Technicolor plant. Machinists, auxiliary operators, electricians and janitors refused to cross the picket line. We kept the plant running by pulling men from the research department and supervisors, foremen, superintendents and men of rank from all departments and throwing them into all sorts of jobs as a temporary stopgap.

Technicolor was the heart of the industry for the duration of the strike. Eddie Mannix of MGM wanted Technicolor to file an injunction under the hot cargo act. Our executives and attorneys met on April 30 with Mannix and representatives from MGM, Paramount and other producers to consider the chances of success if we took this step. My feeling was that if we obtained such an injunction and forced those men back to work, we faced sabotage, scratched negatives, customers suing for damages, broken pipes, and worst of all, arson. For film, fire is the greatest possible threat. We might well have worse than a strike on our hands.

"I think everybody will be behind you if you try for the injunction. If you don't, the strike could last many months," Mannix said.

"What do you mean by 'many months'?"

"Possibly eight or nine months." I was startled by this remark, but found that others were of the same opinion. Mary Pickford, who always had her finger on the pulse of Hollywood, agreed with Mannix. George Bagnall, Vice President of United Artists, estimated a strike could last six months to a year.

Nevertheless, I told Mannix that Technicolor was going to do its best to keep the plant going, to service customers, to give employment to the 1200 men who were not involved in the strike, and for the benefit of its stockholders.

Sunday night, April 30, the Technicolor plant in Hollywood was started up despite the picket line. Almost all our men were roughed up by the strikers as they entered the workplace, but the plant got started and eventually the unions ironed out their disagreements.

142

Jurisdictional differences of long standing, which caused the 1945 strike, continued to divide labor into two camps and led to two strikes at Technicolor in 1946. The first lasted only two days, but the second, which began on September 26 at the major studios and on October 11 at Technicolor, continued until September of the following year, and involved two thirds of Technicolor's employees. Serious disturbances accompanied this strike.

The motion picture industry differs from most industries. If a strike shuts down theaters throughout the country for a considerable period, the admissions that would have been paid for that time period are irrevocably lost and can never be recovered. In contrast, in the case of an automobile factory strike, for example, there may well be an increase in business after the strike. Those consumers who were not able to buy a car will now buy one, and the automobile manufacturer will make up partially or even entirely the losses he sustained during the strike. This doesn't happen in the case of movies; consequently, most producers and distributors feel very strongly that they have to avoid a strike at all costs.

I was very proud of the way Technicolor stood up to threats during the labor battles of the 1940s. Dealing with unions was perhaps the aspect of my years at Technicolor that I liked least. I asked Norman Pottle, who had a long and successful career at Technicolor and who played a very active and loyal part in the 1945-1946 strike activities, to write a succinct account for my files of his memories of that time, and I include them here.

"The first labor problems of any significance started in February 1945 and were precipitated by an arbitration award involving set decorators who worked for the producers' studios. Technicolor, a film processing laboratory, was not directly involved in the dispute as we did not employ any members of this craft. When difficulties arose from this arbitration award, a strike was called against the studios. Some other unions, in sympathy, recognized the picket line, so that carpenters, electricians, machinists and painters refused to report to work. Technicolor was not affected at this time, but in March we were advised to stop the mechanical servicing of our cameras at the struck studios. A picket line was

thrown up on April 27 in an attempt to enforce this demand.

"While we had no dispute with the striking unions, we were now involved because of secondary pressures on our camera service workers. Our machinists, electricians, carpenters and janitors refused to cross the picket lines placed at Technicolor. Our administrative staff filled in for the absent workers while we trained new employees in these jobs.

"On July 27, two thirds of our office employees, with whom we also had no dispute, began respecting the picket line. Difficulties continued through the summer months, but Technicolor managed to fulfill its commitments.

"In September, the Conference of Studio Unions struck. Mass picketing started at Warner Brothers and MGM. Once again, Technicolor had no dispute with any of the unions involved, but on October 13 members of the Film Technicians' Union voted to respect the picket line. These employees constituted the largest craft employed by Technicolor. Of some 900 workers, only thirty-five crossed the picket line. Production was halted.

"There were outbreaks of violence on the picket line. Police intervention was required to maintain order. There were attacks on laboratory workers--roving squads waylaid employees, some were severely beaten, and homes were bombed. There was great stress both on management and workers.

"It soon became apparent that it would be necessary to replace those employees who felt compelled to remain away from their jobs. An extensive program of hiring and training began. By November 1946 we were almost at a normal production level, and as the disturbance gradually abated, many employees returned to work. It was not until September of 1947 that labor unrest ceased, leaving in its wake the inevitable personal tragedies of violence."

Relieved as I was to see the time of labor troubles recede, I must recall--with humor--a personal triumph from those days.

During a series of meetings between representatives of the producers and representatives of the labor unions, I attended one that was held a short distance from my office at Technicolor. George Hoover, who had been my driver for many years, took me

over and waited for me.

By now, George had driven me in New York City, Boston, Cape Cod and Los Angeles. He was quite a character. In Boston, I found him at 9:30 every morning, leaning against the side of the limousine, waiting to take me to the office. One morning I came out to find that the car had been stolen. I teased George for years about it, maintaining that the thief had driven the car right out from under him. George was a great favorite with the Technicolor men who rode with me, and a great chauffeur.

On this particular day, I listened to the arguments for the producers and the arguments for the union until I was exhausted. One speaker in particular delivered an impassioned speech at a crucial time in the negotiations--and almost every sentence was punctuated with an oath.

At the close of the meeting I found George waiting for me. I jumped into the back seat and asked to be driven to my office. The first thing I did when I got into the car was to light a Berlinder, a heavy Havana cigar. I was in the habit of smoking eight or ten a day.

On the way, I wondered why the speaker at the meeting swore so incessantly during his remarks, a habit which, from my point of view, got him nothing--on the contrary, it put his listeners off. I came to the conclusion that he swore to cover up a deficiency in his vocabulary. As I puffed away, the same question occurred to me regarding my smoking. Why did I puff away at this object from morning till bedtime? Perhaps for a similar reason--to cover up a deficiency in my poise.

When George delivered me to the office, I decided to test it out. Instead of pacing back and forth across the office, smoking a cigar while dictating letters and reports, I sat quietly at my desk with my two feet squarely on the ground and dictated without a cigar. I felt comfortable, and decided to take the experiment further.

I didn't smoke for several days. These few days grew into weeks, and after that I was so entirely pleased with myself for not smoking that nothing was likely to make me start again. There was a feeling of victory about it--I no longer wanted to smoke. Labor negotiations might continue until eternity, but tobacco had ceased to exist for me.

Mr. Technicolor

CHAPTER TWELVE

Who Invented Technicolor?

After struggling for many years to establish the position of Technicolor, we found ourselves part of the establishment. We had a superb process, refined over many years, which could bring living color to the screen. We had received awards, tributes, recognition. We had plants in Boston, Hollywood, London, Paris and Rome. The name "Technicolor" had become synonymous with color motion pictures.

And still I was asked the question I had been asked from the beginning: Who invented Technicolor?

The scientific research and the resulting patents on which Technicolor was founded were not the work of one man or even a handful of men. And although our early work took place in the infancy of motion-picture history, much scientific work had preceded it.

James Clerk Maxwell, the great 19th-century Scottish physicist, was only sixteen when he met the elderly scientist Nicol, who had invented the Nicol prism. As a result, young Maxwell grew interested in the subject of light and the theory of color perception. As early as 1855, he published a paper explaining how three negatives could be made through red, green and violet colored glasses, and how positives from these negatives could be projected in register through filters of the same colors to reproduce the original colors.

In 1869 L. Ducos de Hauron published his ideas on the development of the subtractive process. In 1880, Frederick Eugene Ives made his first color separation negatives from three-color photography, in 1888 presenting a demonstration of additive tricolor photography at the Franklin Institute in Philadelphia. Ives actually invented a process for presenting moving pictures in natural colors. In 1889, William Friese Greene, a renowned English inventor, devised what is recognized as the first commercial cinematographic process.

In 1905, a German experimenter, A. Schinzel, described the details of an integral tripack for color photography. Although de

Hauron had suggested the idea as early as 1862, Schinzel went much further by putting together a multilayer composite emulsion coating, with each emulsion sensitive to a certain part of the spectrum and the emulsions, colored yellow, cyan and magenta, suitable for a subtractive process.

In 1909, Charles Urban and G.A. Smith in England introduced Kinemacolor, the first viable color process to be commercialized. In it, alternate frames were photographed at double speed through a rotating red and green filter on black-and-white stock and projected in the same way. Because the pictures were not photographed at exactly the same time, the images on the screen were blurred by color fringes, and the process could not really capture moving objects.

In 1912 R. Rischer patented a monopack process covering chemical substances called couplers which he placed in each of the emulsion layers of a multilayer color film. These substances combined in the development process to form cyan, magenta and yellow dyes, but the process failed when sensitizers wandered from one layer to another.

In the same year, A. Hernandez-Majia produced double-coated film for two-color subtractive printing.

Each of these steps, taken separately, were important. But when the earliest Technicolor process, Process Number One, was developed in 1916, and we photographed live action using two negatives which recorded light split by a prism into red and green components, and then projected our film with a special projector with two filters, one red and one green, it was of significance to the industry primarily because we were determined to pursue the process on a commercial basis.

We were helped in our pursuit by the patents we applied for and were granted covering Technicolor products and processes. During our first twenty years we made 139 patent applications. None of the patents and no part of the processes were obtained by absorption or purchases from outsiders; all were developed by our technical staff.

Early patents laid the groundwork for the development of Technicolor Process Number One. Burton Wescott's continuous projector of 1914, was followed by six patents in 1915, one for Wescott's Double Nonadjacent Images and five for Comstock's

camera, covering the Optics of the Two-Color Camera, the Continuous Projector, the Projection of Color Pictures and Projection Arc Source.

From 1914 to 1921 Wescott applied for eighteen patents, mostly mechanical in nature, connected with the camera and the projector. From 1914 to 1925 Comstock applied for twenty-eight patents, largely covering the optics of the camera and projector and the dyes we were using. During the years 1921 to 1933, Joseph A. Ball applied for twenty-four patents dealing with the mechanism of the camera and the transferring of the dye by imbibition, culminating in the patent on the optics and mechanism of the first Technicolor three-color camera in 1929. In approximately the same period of time, Dr. Leonard Troland made applications for twenty-eight inventions having to do with development solutions, the details of film handling, film cementing, the printer, dye diffusion, and most important of all the basic Troland Monopack application of September 9, 1921. We were working toward the monopack many years before it became a commercial entity. In all, Troland's applications account for ninety-eight patents from among the men in the research division who were assigning their patent applications to Technicolor.

Each step in Technicolor's development depended upon technical and engineering work of a very high order. Not one of our patents would have survived had it not been followed with further inventions and further solutions--accompanied by business decisions and financing steps which provided the organization and the means to found Technicolor.

In the first stage, the camera invented by Comstock and Wescott was the crucial patent. We knew what we wanted it to do-- photograph two images simultaneously--and we kept at it until it worked.

In the second period, from 1922 to 1926, we operated Process Number Two, in which we basically cemented together two relief images and floated them over dye baths. The precision steps in this process were covered by a patent, Film Floating Method, applied for by Troland, Ball, and J.M. Andrews. It was used for several films, including DeMille's *Ten Commandments* and Fairbanks' *Black Pirate*, but the double-coated film was too thick for regular projectors, and it buckled and warped.

Process Number Three, really the first practical process for the production of color motion pictures in large quantities at a cost at which they could be made, was, again, not based upon fundamental patents. It succeeded by its ingenious overcoming of technical and financial difficulties and by our daring to make large investments in plants and equipment and staff. Some forty feature films were photographed in this process 1928 to 1934. Its drawback was that it was still short of full three-color photography.

A key patent was applied for on August 20, 1931 by Ball and G.F. Rackett for the Basic Three-Color Camera. It was around this camera that Technicolor perfected its three-component process, Technicolor Process Number Four, in 1935. The three-strip camera was intricate and expensive, and somewhat bulky and awkward to operate, but Technicolor built a number of them--thirty-six, to be exact--and from then until around 1945 it was the only available source of quality professional color motion picture photography.

* * *

I have among my possessions six small prints on paper and one transparency which were made by Leonard Troland in the year 1916. These were shown to me around 1919, according to a note in my files. They represent his earliest work on the project to develop a monopack, a single film with three layers of emulsion-- in contrast to the line we were following at the time of exposing each of the primary colors on different lengths of film. This work resulted in one of the earliest, most important and most ingenious Technicolor patents, applied for September 9, 1921 and issued December 6, 1932 as Reissue Patent #18680. Much research and the interruption of World War II were to prolong the development of the monopack, but I had total faith in its viability.

Before Troland became Technicolor's research director, he had been a student in Dan Comstock's physics classes and then an instructor at Harvard University in the Department of Psychology and the author of many scientific papers and books on that subject. His heart was very much in his teaching and research, and I considered it most fortunate that I was able to entice him away when we were still in the pilot stage, with everything in a state of

semi-operation. His enthusiasm and curiosity led him to cast his lot with us, and he became indefatigable in his work on behalf of Technicolor, rejoicing with us at every step forward. He was, as well, a cherished companion, able as he was to switch from a discussion of the latest phase of our laboratory work to almost any subject on a list of wide interests, and endowed with a very keen sense of humor.

In 1932, with a younger Technicolor research man, Troland went on a photographing expedition to the famous astronomical observatory near the summit of Mount Wilson. Climbing on the cliffs in an attempt to photograph the scene from exceptional angles, Troland fell from a height and was killed. Everyone in the Technicolor family considered him a friend; all mourned his loss.

The patents awarded to Technicolor were the matrix, the situation, within which Technicolor developed; they were not Technicolor itself. Other companies were working on the same product. None achieved the success of Technicolor, and many were rendered obsolete by Technicolor. Of the five eventual different Technicolor processes, none depended on basic patents; all depended on the solution of stubborn technical and engineering problems. The patents, in a way, simply marked the path of development and problem-solving over the years.

In addition to the 139 patents applied for during the period from 1914 to 1933, 170 patents were assigned to Technicolor during the years 1933 to 1961 by staff in the research department and the laboratory.*

Several elements in the Technicolor method of producing release prints (composite prints, ready for distribution to motion picture theaters) were patented. The most important of these, and the names of the responsible staff members, are Wadsworth E.

* These are, in alphabetical order, Malcolm H. Ames, John M. Andreas, Joseph A. Ball, Charles D. Bennes, Benjamin B. Burbank, Adolphe E. Carlson, Arthur B. Clark, John R. Clark, Jr., Lauriston E. Clark, Russell W. Conant, LeRoy M. Dearing, John P. Delangre, Richard J. Goldberg, Everette E. Griffith, Winton C. Hoch, S. Eric Howse, Donald H. Kelly, John F. Kienninger, Leslie W. Oliver, Leo W. Pavelle, Wadsworth E. Pohl, Leland B. Prentice, Gerald F. Rackett, William F. Schreiber, Frank W. Taylor, William B. Tucker, Alan G. Tull, Bertha Sugden Tuttle, and Lloyd E. Whittaker.

Pohl, Hardening Dye-absorptive Hydrophilic Colloidal Layer of Blank Film; Albert P. Lofquist, Pressure Roller Mechanism for Cinematographic Films and Sulfate Blank; Clarence H. Warme, Pressure Device for Cinematographic Films; John P. Delangre, Mordanting Process and Deacetylated Chitin Mordant; Harold Peasgood, Pin Inserting Machine; and Richard J. Goldberg and Leon A. Levinson, Matrix Developer.

However, the patent rights obtained in the area of producing release prints never formed the key to applying the imbibition technique to monopack processing. We can achieve quality imbibition printing from monopack positive, but it is not the result of work represented by the list of patents. It is rather by the use of techniques developed in the Technicolor research department and by Technicolor laboratory technicians, which cannot be patented. This state of affairs is reflected in the following statement of fact agreed to by the Government and by Technicolor:

"The imbibition process of color photography is generally quite old and there are no basic patents covering the film used in it."

So much for any attempt to control this area of production. Yet, because of our experience and quality controls, we could expect to do quite a large business in developing monopack film for a variety of customers.

One central problem, always the subject of intensive research at Technicolor, was the improvement of the imbibition process. There was a tendency of the dye to wander, or migrate, in the lateral direction in the release print blank. In ordinary projection, the image on the film is magnified about 350 times. Any defects-- even a small scratch or smear--become enormous on the screen. As screens grew larger, the need of greater sharpness in prints grew more acute.

We found that the control of the wandering dye during transfer from the matrices to the release print blank could be accomplished partly through the introduction in the blank of chemicals called mordants.

These dye mordants are sometimes incorporated into the raw stock emulsion by the blank manufacturer, sometimes they are added during the Technicolor processing, and sometimes both techniques are used. In any case, we have been able to get a

152

significant improvement in sharpness, even though it is not a process we can patent.

On the subject of the importance of patents relative to other aspects of Technicolor, I quote Frost and Oppenheim in "Technical History of Professional Color Motion Pictures."

"Three . . . considerations deserve emphasis in connection with the history of Technicolor. The first is the influence of Dr. Herbert T. Kalmus in the activities of the company. From the start, Kalmus was managing and promoting head of Technicolor. The continued activity of the company through ups and downs was principally due to his faith in the ultimate success of the venture, the commercial possibilities of a successful professional color motion picture process, and the scientific attainability of such a process. At one critical time, 1927, over $2.5 million had been spent by Technicolor, the welded film process had shown its unsuitability, the imbibition process had been developed but not yet used on any pictures, and motion picture producers, conscious of prior difficulties, would not use the new process. At this time Kalmus managed to finance the production of several shorts and a film, *The Viking*, based on the imbibition process. These led to the initial period of company acceptance and success. On the scientific side others had a major part in the progress of the company, but there is every indication that their work would not have been possible in the absence of the continued leadership of Dr. Kalmus.

"Secondly, the ultimate success of Technicolor rested on a high order of scientific accomplishment, but not on basically new principles. The idea of making color separation negatives of a single scene can be traced well prior to 1900. The same may be said of the idea of combining color separation positive transparencies to produce a color projected image. The imbibition idea is likewise traceable to work done long before Technicolor applied it to color cinematography. With respect to all of these techniques, however, there was a great gap between theory and practical application to still photography and practical commercial motion picture production. Until the final success of the Technicolor three-color imbibition process there was no assurance that the practical difficulties would not render the entire venture as unsuccessful as the predecessor additive process and welded print process. And the prob-

lems of moving from theory to a practical technique were exceedingly stubborn. Their solution entailed sustained research effort and the exploration of numerous false leads.

"Finally, the Technicolor process was not a color technique that could be simply adopted by motion picture producers with the expectation of successful results. In the early years especially, the producers relied heavily on the Technicolor advisory services with respect to lighting, costumes, and scenery. The experience of Technicolor in producing shorts and a feature in the late twenties, followed by experience with productions of other producers, gave the company a substantial store of knowledge. In addition, Technicolor processing services were relied upon for 'rush prints' and ultimately for the positive color projection prints. These integrated services were as necessary as a successful process. The experience of Technicolor in producing motion pictures and in processing the film made these services possible. While the major producers obtained their own color advisers as the use of color technique increased--and there is room for difference of opinion as to the extent Technicolor should have tied its advisory, filming, and other services to its processing services --it seems clear that, at least before color feature films were common, these Technicolor advisory services were of major importance."

So we see that there were no basic patents upon which the company rested, but rather a large number of patents tied to the best "know-how." Just as important was a remarkable staff of scientists, engineers, officers and directors who made possible the industrial development and financing necessary to employ these patents on a sound commercial basis.

It is doubtful that the Technicolor patents could have prevented someone else from inventing and developing a competitive process.

The Troland Reissue Patent, and the monopack agreement under which we licensed it to Eastman Kodak, is in several respects unique in the patent history of Technicolor. It brought us a large royalty income from Kodak, which inspired the confidence of investors. From the beginning, it was my job to attract the investment of substantial sums of money by outsiders. The fact that Technicolor had such a large number of patents and particularly the income-producing Troland patent were very important

talking points. So while I say that Technicolor did not depend upon basic patents, our patents were important in helping to obtain the financing necessary to keep the company going forward.

Very early in the Technicolor story, even though our operation was based on our special Technicolor cameras, one of our goals was to eliminate this special camera. Producers had always chafed at the fact that their regular cameras could not be used for color. We wanted to get rid of the bulky, inelegant, beam-splitting camera and perfect a method of commercial color photography using a single strip of film instead of three. For years I had toyed with the thought that eventually color motion pictures would be photographed on monopack type negative so that the producer could employ his standard, flexible, movable studio black-and-white motion picture camera. It is interesting to note, looking through my papers, how early in the annals of Technicolor research this idea and plan existed. But it demanded many years of research, and its development was interrupted when the Navy and the Air Force converted much of the Technicolor laboratory into a top-secret plant during the early 1940s. As it was our habit to go forward, even though progress rendered many of our own processes obsolete, I decided not to build any more three-color cameras during those years, but to function with the existing number we had on hand until the monopack was workable.

The monopack is also called multilayer integral tripack color film. Monopack film is a celluloid strip coated on one side in layers that provide the red, green and blue sensitive emulsions and their separation by optical filtering layers.

The patent on the Troland monopack type had a stormy career at the Patent Office. More than eleven years passed between the original filing date and the issuing date of Reissue Patent No. 18680. It fell into interference with another type of monopack invented by two young musicians, Mannes and Godowsky, who had taken their idea to Eastman in Rochester.

Mannes and Godowsky worked independently at first but were later employed by Eastman Kodak. After years of experi-

menting they concentrated on the idea of incorporating couplers into the developing process rather than in the film, thereby overcoming the problem of coupler diffusion. This became the basis of Kodachrome, the name given by Kodak to its amateur 16mm film and process employing the monopack idea.

The interference suit was eventually settled by agreement. Our patent, as granted, contained 239 claims, the largest number of claims of any patent granted by the United States Patent Office.

The agreement we came to was announced in 1934. Technicolor and Eastman Kodak agreed to a cross-licensing patent arrangement commonly referred to as the Monopack Agreement, giving Technicolor exclusive motion picture processing rights to the multilayer monopack film of 35mm width and larger, mostly used in commercial motion-picture film production. Kodak was granted the motion picture rights for the use of this film in less that 35mm width, which would include 16mm film, in wide use for amateur photography. The inventions, which both companies had been working toward for years, seemed important to both, and the agreement therefore provided us with a means of getting together rather than battling it out in a contest. In fact, relations with the Rochester-based firm were harmonious. Old George Eastman was no longer alive, but I couldn't help recalling the day many years ago when I stood before his desk and heard him say, "Most ingenious, young man, but not commercial!"

During those eleven years, Dr. Kenneth Mees, Vice President of Kodak in charge of its research laboratories, was often my guest in Hollywood. He spent time working with me and Technicolor research men, acquiring a thorough understanding and appreciation of the Technicolor process. As a result, we continued an active cooperation. We outlined arrangements for joint research work, both on the three-strip Technicolor process then in general use and also on the monopack process in which we enjoyed a cross license.

In their agreements Technicolor and Kodak always drew a sharp line between the professional field of motion pictures for theatrical release--which meant 35mm film--and the amateur field, employing 16mm film. The original Monopack Agreement of 1934 gave Technicolor exclusive rights for a certain length of time under certain circumstances in the 35mm professional field, but except for the royalty paid to Technicolor we obtained no rights in the

16mm amateur field. That was a sharp line! But later, in 1938, after many discussions with Kodak officials, the original contract was modified to permit Technicolor to operate a 16mm processing machine and to buy the 16mm raw monopack film. Here, the processing and sale of 16mm film was restricted to film which was printed from negative originally photographed on 35mm Technicolor negative. This gave Technicolor an opportunity to make available to the advertising field 16mm prints of material it had first photographed by its regular 35mm process. Kodak realized the difficulty of keeping track of this film but through the years no serious problems arose--another illustration of the measure of good will that existed between the two companies.

The 1934 agreement called for payment by Kodak to Technicolor of a 2 1/2 percent royalty on sales of amateur film. I amazed the board of directors at the time of closing the contract by pointing out to them that the inclusion of that item would someday be worth at least $1 million to Technicolor. At the time, there was a very thin volume of amateur color film in use, and some directors found my prediction hard to countenance. Yet, by 1948, total royalties paid by Kodak to Technicolor amounted to more than $2,500,000.

During those same years, Technicolor was, of course, a good customer of Kodak. The first sale from Kodak to Technicolor of monopack camera film was in 1939. In the next ten years, Kodak sold $500,000 worth of monopack film to Technicolor. And all the while, both companies were engaged in experiments in the use of monopack.

The armed forces were the first to use the new multilayer single-film process. The United States Army Air Force and the Navy photographed unusual and difficult scenes on all the fighting fronts. Technicolor's camera department trained a large number of service cameramen in the use of the Technicolor monopack.

The Battle of Midway, one of the first instances of photographic reporting during the war, was made with 35mm imbibition color prints from 16mm Kodachrome originals. Commander John Ford, USNR, left his work in Hollywood to become Chief of the Field Photographic Branch. He produced this first American war documentary during the actual battle.

The first commercial use of the monopack was in 1941, and in the beginning was limited to special sequences which were matched

157

and cut in with the larger part of a picture which had been photographed by the standard three-strip method. Monopack was used when greater mobility was important, to record storm scenes, fire scenes, stampedes, ships at sea and so forth. The aerial shots in *Dive Bomber* and *Captains of the Clouds* employed monopack. The more compact camera could be mounted on the wings. It was used again for the spectacular outdoor fire sequence in *The Forest Rangers* as well as for all the exterior scenes in *Lassie Come Home* (1943). We were still experimenting with interior lighting with monopack, but in 1944 we were ready for both indoor and outdoor shooting, and *Thunderhead, Son of Flicka* was shot in 1944 using monopack entirely.

Eastmancolor products were introduced in 1950. These materials included Eastman Color Negative Film, Eastman Color Print Film, and intermediate films. The color negative film was of the monopack type suitable for use in conventional motion picture cameras--similar to Kodacolor film for still camera. The color print film was also of the monopack type and was intended primarily for printing from a monopack negative intermediate film, thus providing a relatively simple optical procedure.

Eastman initially recommended that to preserve color fidelity in the usual four-step motion picture printmaking procedure, at least one step should be made using color separations. By 1953, improvements in the color negative and intermediate films led to the recommendation of an all-monopack printing sequence without use of color separations and the attendant expense and complexity.

Two main technical developments were used in the Eastmancolor materials. One was the colored coupler principle. The other was improved methods of coating the film base with emulsions possessing the required uniformity of thickness. These were significant contributing factors to the overall color quality.

By 1953, Technicolor was almost completely converted to the use of monopack camera film which, in combination with our imbibition printing, constituted Technicolor Process Number Five.

It had always been Technicolor's goal to perfect a method of commercial color photography using a single strip of film. The news that it had been done, and the introduction of Eastman Kodak single-strip color negative and printing film stock, meant a

great opening up of the industry. Smaller, more mobile cameras began appearing on Hollywood sound stages. Soon there were ten or fifteen multilayer color films on the world market--among them Ansco Color, Kodachrome, Ilford Colour, Fugicolor, Ektacolor, Ektachrome, Gervais Color, Ferrania Color, Agfacolor, Telecolor and Pakolar.

The color process and product appear under a variety of names, usually the name of the print manufacturer, as in Eastman, Ansco Color, WarnerColor, Pathecolor, Trucolor, DeLuxe Color, Metrocolor--and Technicolor. These names often reflect the name of the company or the laboratory where the film was printed and processed. In fact, after some of these other color processes were in operation, the Technicolor laboratory still did a large business in developing and printing--thus the Technicolor trademark is seen on many films during this period that were not photographed by Technicolor.

By the 1950s the Technicolor beam-splitting camera was obsolete. In fact, in the year 1954, a year in which Technicolor commemorated the four-billion feet mark of 35mm color motion-picture release prints, Technicolor cameras were used for the last time on an American-made film, which was, as I recall, Universal's "Foxfire."

Mr. Technicolor

CHAPTER THIRTEEN

The Better Mousetrap

Early in 1947, my secretary's voice came through on the interoffice telephone to announce a visitor. "This chap says he's working on a report and would feel privileged to meet you and show you his questionnaire. He promises to take only a few minutes." Although most of my appointments were set up more formally than this, I had always had an open-door policy at Technicolor.

"All right, Mrs. Harris, I'll see him--but please stress 'only a few minutes.'"

My visitor introduced himself as Joe Borkin, representing some minor bureau in the U.S. Department of Commerce. His assignment, he said, was to make a study of the motion picture industry, particularly in Hollywood, for a government report. "I have no particular ax to grind," he assured me several times. "I just want to acquire the information to write a full and accurate summary."

He had approached me, he said, because my position as head of Technicolor for so many years had put me in contact with many of the activities within the industry; I was undoubtedly knowledgeable on the subject of producers, directors, actors, writers, technicians, laboratories and even distant manufacturers of raw stock such as the Eastman Kodak Company. While another individual might have a very complete knowledge of some phase of the industry, he was not likely to have as complete a picture as mine, Borkin declared.

"Would you mind answering a few questions?"

I agreed, in the interest of accuracy, to give him some of my time, and over a period of weeks Borkin turned up, by appointment, to talk about Hollywood and the history of the motion picture industry. Then one day, without notice, he appeared at my office door with another man, whom he introduced as Fred Weller. "Mr. Weller is in charge of the case," he added.

"Case? What case?"

Borkin looked down at his shoes. "A suit is being filed in the Southern District Court of California, by the United States of

161

America against Technicolor and Eastman."

"And what in God's name is the charge?" I asked. I was dumbfounded. The man knew very well that in my talks with him there had never been any indication that lawyers or "cases" were on the horizon.

"Unlawful monopoly and conspiracy." I could get very little further information out of either of them. My anger at this man, who had appeared to be a routine sort of clerk, and his underhanded approach, was nothing to my shock that the government of my country was proceeding against me in what I felt was a totally unfounded action. "My secretary will show you out," I said shortly. I buzzed for Mrs. Harris and turned my back on them.

My first move was to inform my associates in Technicolor and find a law firm to represent us. The choice was Fulton, Walter & Halley of New York City. I had long admired Hugh Fulton's expertise and ability, and I knew that one of his partners, Joseph W. Burns, was an expert in antitrust cases.

We set to work to answer this case, and I issued the following statement.

"Technicolor is extremely proud of its history as a pioneer in the field of color cinematography. The name Technicolor stands for highest quality and the history of the company has been one of hard work and modest profits.

"Through the technical maze of optical, chemical, physical and mechanical steps there are many possibilities from which a color process may be evolved. Technicolor respects any path through this maze adopted by any other laboratory.

"It has always been Technicolor's policy to recognize that the fields of theatrical entertainment, commercial advertising and visual education are enormous and that there is room for more than one process to serve their needs.

"The Technicolor process has been evolved from more than twenty-five years of achievement and the expenditure of millions of dollars for research and not by purchase or absorption of other companies. We look forward to constant further development, improvement of service and lowering of cost."

Then we and our lawyers immersed ourselves in preparing to present the company's position before the court--a considerable task, as the material would have to cover the company's activities

for a period of more than fifteen years.

Antitrust proceedings were instituted on August 18, 1947, against Technicolor, Inc., Technicolor Motion Picture Corporation and Eastman Kodak Company. The complaint against Technicolor read, "Technicolor does over 90 percent of all the business in professional color cinematography in the United States. Since 1934 it has produced the positive film prints for all the Class A feature-length motion pictures and most of the short subject and animated cartoons produced in color by the motion-picture industry of the United States. Motion pictures filmed in color today represent from 15 to 20 percent of all feature-length pictures exhibited in theaters in this country."

An ironic charge, in view of the fact that my earliest ambition in Hollywood was to have all Class A features produced in Technicolor. We were being accused of exactly what we had tried to accomplish.

"Facilities for filming and processing motion pictures in color, however, have been and are insufficient to meet the demand," the complaint further stated. "By June 25, 1934, Technicolor had acquired substantial control of professional color cinematography in the United States and of the interstate and foreign commerce incident to the business of color cinematography."

So much for the charge of monopolizing the industry. But we were also charged with conspiracy. The complaint continued.

"For a period of several years, Technicolor and Kodak have respectively acquired various inventions, patents, and patent rights relating to the monopack methods of color cinematography and were in the beginning engaged in independent efforts to develop and perfect this monopack method. At that time the manufacturing and processing of monopack film for color cinematography had not yet been sufficiently perfected to enable either Technicolor or Kodak to exploit certain monopack methods commercially. The prospective development of the monopack method of control by others than Technicolor threatened Technicolor's control of professional color cinematography."

Pointing to the series of agreements between Technicolor and Eastman that had cleared up our earlier patent problems, the complaint alleged that this was a "conspiracy through agreement" between Technicolor and Kodak to control the color motion picture

field and shut out all others from competing--that is, to restrain and monopolize the business in violation of the Federal antitrust law.

Of course, we did not have a monopoly on color. There had always been other processes in use. In the coming year, we were contracted to produce over fifty feature productions, but rival processes such as Cinecolor and Trucolor were being used in almost equal number. In addition, Technicolor had in the past offered to license its process to anybody--had, in fact, once licensed it to 20th Century-Fox, who never actually built a laboratory or employed the process. Why was this lawsuit being mounted?

A few months later, as we were getting ready to go to court, Time magazine published an article that suggested another reason.

FAST COLOR. *To Hollywood, Technicolor is a magic word. On movie marquees, it automatically increases the gross of a film as much as 25 percent. But during the booming war years, the world was not so magical to Technicolor, Inc. Hampered by strikes and shortages, its earnings were just so-so.*

Last week, Technicolor, Inc. proudly announced that the old magic was finally working for it, too. In its annual report, the company reported record net profits of $1,422,752 in 1947, more than three times those of 1946. What was even better, Technicolor was booked up solid for at least another year, even though it is expanding production 44 percent.

Technicolor's success was a typical Hollywood one-man show, by dour, dignified Dr. (of physics) Herbert T. Kalmus, 66, who plays table tennis, wears dark worsted suits and keeps pretty much to himself. . . .

There are only 25 Technicolor cameras in existence (21 in Hollywood, four in England), and they belong to the company. It does not rent them, sell color film, or lend advisers. It simply "sells a service," i.e., films the production for movie companies. The charge is a basic price of 6.22 cents a foot for final prints (last year's footage: 222,017,439).

JAUNDICED VIEW. Kalmus's ambition is to have all A films made in Technicolor. The biggest obstacle at present is his own company: it needs six months to get out color prints and moviemakers hate to wait that long. Otherwise, most movie-

makers would probably be glad to make all their A pictures in Technicolor.

The Government takes a different view. As owner of the one-time German company, General Aniline and Film Corp., the Government now has a three-color process of its own. It claimed that Technicolor deals with moviemakers--and others --were making it hard to market General Aniline's product.

Last August the Government charged Technicolor and Eastman Kodak, which the Government charges has cross-licensing agreements with Technicolor, with conspiracy to monopolize the industry. But Dr. Kalmus does not profess to be worried about the suit. He insists that his color processes are well known and no secret. Said he: "The only secret knowledge we have is know-how, and you can't break up know-how by court order."

--Time, March 22, 1948

That the United States Government had become the owner of a three-color film process through its defeat of Nazi Germany was true; I came to accept that there was an element of self-interest in this unfortunate lawsuit, as well as in the Government's indirect and underhanded approach to me at the outset of proceedings. There was no conspiracy between Kodak and Technicolor; there was nothing but wholehearted, vigorous and costly research work on the part of both companies for the benefit of the entire industry and the public.

The lawsuit was to drag on for three years, consuming a great deal of valuable time in the preparation and trial of the case. But the day finally came when Hugh Fulton stood up in court to give his statement, which is such a fine defense of the company as well as a masterful history of important steps taken in the past that with the reader's indulgence I will repeat it here.

"This case does not require the Court to determine any new question of interpretation of the Antitrust Law, nor are we asking a reconsideration of any principles on any rules established by recent cases. We are perhaps fortunate that we did not engage in any of the business practices which the Supreme Court has re-

cently condemned in other suits nor do any of our agreements contain any of the provisions which have been declared unlawful in other cases. This case involves only a determination of the facts and their application to the law as it has already been established.

The charge here is that Technicolor is a monopoly and that, although it rose to its position of dominance in the industry by perfectly lawful means, it has retained its position by unlawful means--by a conspiracy with Eastman Kodak Company. The Government's trial attorneys did not prepare this complaint. If the Government attorneys who prepared this complaint had been even halfway familiar with the facts, they would never have filed it. The only reason they had for charging Technicolor with being a monopoly is the admitted fact that it is and for many years has been the largest processor of color motion pictures in this country.

Unless that in itself is a crime, the Government has no case.

The story of Technicolor is simply the good old American story of the man who built the better mousetrap. The evidence in this case will show that the reason why Technicolor has done more business annually than any of its competitors is because it put out a better product.

We will show that the development of a motion picture in color has been a tremendous scientific achievement and that the success of Technicolor has been due primarily to the ability of the president and founder of the company, Dr. Herbert T. Kalmus, and to Technicolor's highly trained and proficient staff. No amount of desire or intent to monopolize, nor any number of agreements intended to monopolize, could possibly result in the production of a color motion picture. It took the Technicolor Company more than twenty years to develop a product which was even acceptable to the motion picture industry, and it took another three years before it did enough business to pay back its investors.

The date of the beginning of this alleged conspiracy is very definitely set by the Government as June 25, 1934. That is the date on a written contract between Technicolor and Eastman Kodak. The complaint and the Agreed Statement of Facts concede that there was no agreement between Kodak and Technicolor prior to that date, no conspiracy, and no attempt to monopolize. The complaint therefore concedes that whatever position Technicolor had at the time of signing the agreement was lawfully attained.

166

In order for the Court to determine whether that agreement was illegal, it will have to know something of the background of Technicolor. The Court will also have to know something about Dr. Herbert T. Kalmus, who founded the company in 1915 and who piloted it along the very rough and long road to success.

During the nineteen years from 1915 to 1943 Technicolor achieved a considerable measure of technical success but was still a financial failure. It did not become a financial success until the beginning of the war when the entertainment business, like many others, received a shot in the arm from the great increase in expenditures occasioned by the preparation for war.

Technicolor was born in Boston, Massachusetts, the growth of one of many ideas of a group of brilliant young scientists who engaged in business under the name of Kalmus, Comstock & Wescott. Dr. Kalmus was a professor of physics and had taught at the Massachusetts Institute of Technology.

The idea of producing a motion picture in color for the rapidly growing motion picture industry presented an interesting challenge. The young men obtained financial backing and produced their own motion picture in 1917. As far as we know it was the first motion picture in color produced in this country.

The problem of producing a motion picture in color was infinitely more difficult than producing one in black-and-white.

From the scientific standpoint, there can be many different ways of applying physical laws so as to develop a method for making a color film. Inventors around the world had tried various methods but none had achieved commercial success.

The various methods for producing color film may be divided into two major divisions, additive or subtractive. Technicolor has tried both methods and its present process is a subtractive method.

At the outset Technicolor had to decide a certain direction. It had to determine, first, to what extent it could depart from the use of standard equipment and materials and secondly, how it would attempt to divide the problems of reproducing color between the manufacture of film, the laboratory procedure and the theater projector. At the outset Technicolor tried to work with raw film of standard dimensions and use special cameras and special projectors.

For its first picture, Technicolor had to invent a camera and a projector. The camera had two apertures and used a two-component film.

This meant that only two of the three primary colors were recorded, so that while this early film was in color, it was far from natural full-color reproduction.

The projector had two apertures as well, where color was produced by passing a beam of light through a green prism and a red prism.

It was very difficult to get the two beams of color light exactly in register and the unsatisfactory result was color fringing.

In those early days Technicolor had in mind two principal methods of attacking the color problem. One was by the monopack process where several different emulsions, each suitable for a different color, are contained on a single film base; the other was the imbibition method in which a separate film is used for each color and then both are printed on a blank like a photoengraving.

The monopack method required the film manufacturer to solve all the problems, while the imbibition method loaded the problems on the processing laboratory.

For several years Technicolor experimented in finding a way to produce a commercially successful color motion picture film and finally succeeded in 1922 in producing a feature film, 'Toll of the Sea.' It was not until 1923 that Technicolor signed a contract with a motion picture producer to use the Technicolor process.

The problems Technicolor encountered in that production almost ended the young company's venture.

Technicolor had changed its method to a type of imbibition method which consisted of two gelatin reliefs on thin celluloid which were welded together back to back. This was a subtractive method and still unsatisfactory as the double-thick film had difficulty going through an ordinary theater projector. It was not until 1927 that Technicolor finally succeeded in making a single two-color imbibition print.

During the twelve years when Technicolor pioneered in its endeavor to produce a commercial color process, it had no competition from other color processes. Its competition was with black-and-white film--and its competition has always been with black-and-white film.

In 1927 when Technicolor first obtained a color print which was at all commercial, black-and-white motion picture photography had already reached an advanced stage of development. Producers had learned a lot about black-and-white photography but knew nothing at all about color. Not only did color cost a great deal more, but many producers felt that color detracted from the story shown on the screen.

The event that helped Technicolor to sell the industry on the use of color was the advent of sound in 1928. Producers were compelled to make many radical changes in established methods of photography and production, and Technicolor took advantage of the opportunity to convert them to the use of color at the same time.

Technicolor had opened a small plant in Hollywood in 1924. When it began to obtain substantial business in 1929, it increased the capacity of its plant. However, the rush of business in 1930 found Technicolor unable to accommodate all its customers. The complexity and difficulty of producing a motion picture demanded a specially trained and skilled staff. New workers had to be found and trained with enough speed to handle the flood of business. But before the company could adjust itself to this new situation in which for the first time in fifteen years customers were coming to Technicolor, the Depression struck an almost fatal blow.

From the middle of 1931 until the year 1935 Technicolor did not make a single feature film.

Meanwhile, Dr. Kalmus continued to be aware of the fact that color pictures would never reach a pinnacle of success until they were made with the three components or three primary colors which would yield full, natural color. As additional components were added to the process of color production, the problems increased in geometric proportion.

In spite of tremendous difficulties, Technicolor succeeded in inventing and making a camera capable of taking three pictures on three strips of film simultaneously. It then developed the method of printing from those three negatives on a blank in the same manner that color printing is done in the printing of newspapers. There was nothing new or novel in this method. The idea was always available and still is available for anyone to use, but the process is so complicated and difficult that only a scientist with

unusual qualities of perseverance would attempt it.

To take a piece of newspaper and print three different colors on it from plates is a simple problem, but to take a strip of film about one thousand feet long and approximately an inch wide and print upon that from three other films, each adding a different color, and have the printing so accurate that the image can be magnified one hundred times on the screen with clarity and definition is a staggering achievement.

This technical achievement was matched by Dr. Kalmus's ability to obtain financial backing over seventeen profitless years.

This is the story of Technicolor, up to the point in 1934 when the alleged conspiracy began."

Hugh took a brief recess here, and I sat thinking about the years that his words had conjured up. I had witnessed and been a part of almost the entire evolution of the motion-picture industry. The first movie I ever saw was as a boy, just after the turn of the century, in a Boston nickelodeon. I joined a small group of people who passed through a curtain into a little room where we peeped though a hole to watch a one-reel spectacular. The jerky black-and-white film had no sound except for the voice of the barker at the door, inviting passers-by to see the great spectacle for a nickel. That small screen has grown until it fills nearly one side of a large theater; sound surrounds the viewer; and all the colors of nature are shown with extraordinary faithfulness. The audience almost feels a part of the picture; and I have been part of this process.

Hugh was about to attack the main point of the Government's case: the so-called conspiracy with Eastman. The fact is, without suitable photographic materials--negative and positive--neither black-and-white photography nor Technicolor could have passed from stage to stage as it has done. Technicolor had invented and developed (and cast aside) four different processes before the fifth one was reached. And to make this research and development possible, we received the closest and most willing cooperation from Eastman.

Whenever I dealt with officers of that company--Mr. Lovejoy, Mr. Hargrave, Dr. Chapman, Dr. Mees, Dr. Staud, or any number

of research associates--I was always met with cordiality and sympathy. They were keen to remedy defects or create new materials or do whatever they could to help solve our problems. I consider Eastman--and Ted Curtis--as among the greatest friends the motion picture industry ever had.

Technicolor was been completely dependent upon shipments of raw stock from Eastman to operate its plants. This was the situation during its entire history and it was emphasized during the time of restriction of raw materials during the war. We tried to maintain an inventory of one month's supply at the Hollywood plant, about 14 million feet; but at one point, about the middle of August, 1944, we had completely exhausted our supplies. Eastman got a freight car to us on August 23 and prevented the plant from being shut down. One of the questions the Government was ready to ask me under examination was why Technicolor bought its raw material exclusively from Kodak. The answer was that no one else could make a suitable product for our use, and get it to us under any and all circumstances.

Hugh was ready to continue. Silently, I applauded him. All the preparatory work we had done was worth it--he had a full understanding of Technicolor's history.

"Since the Government has chosen the agreement with Kodak as the basis for its charge, it will be incumbent upon the Government to prove the illegality of the agreement. But I believe the Court will find nothing in the conduct of Technicolor and Kodak before or after the execution of that agreement which in any way constitutes an attempt to monopolize or restrain competition in the industry.

This will sound strange to the Court, but in 1934, the year of the agreement, there was no color motion picture industry. There had been one from 1929 to 1931, but the Depression marked an end to that. Between 1931 and 1935 not a single feature picture in color was made in the United States.

Prior to 1934, Technicolor had tried out three entirely different principles of producing color motion pictures. In 1934 it had developed the three-component method and was endeavoring to

interest producers in the new system. Now, it might occur to the Court that it is unusual--though possible--for a company to conspire to monopolize an entirely new product or process; we wait to hear the Government's proof. But your Honor, this agreement of 1934 had nothing at all to do with this new process, Technicolor Process Number Four. It had to do with an entirely different process!

Technicolor had been working since 1920 to develop a type of film called monopack. If developed, it could be employed in the ordinary cameras used for black-and-white film. And if it could be made at all, it could be made with all three primary colors, long a goal of Dr. Kalmus. But at this point in time a monopack film had not yet been produced, and Technicolor proceeded to operate with their own special Technicolor cameras. The 1934 agreement dealt solely with monopack, which had nothing to do with the three-strip camera process.

So you see that the agreement not only did not relate to any existing industry, it did not even relate to an existing product. The principal point of the agreement was that as a result of it, Kodak and Technicolor were going to work together to try to develop monopack film.

The evidence will show that there was nothing Technicolor wanted in 1934 more than a successful monopack film. The manufacture of film was not Technicolor's business and never has been. There were three film manufacturers in the United States in 1934--Eastman, Ansco and du Pont. None of them made monopack film. Ansco and du Pont had not even begun to work on it. It didn't exist. Many inventors had tried. One Technicolor staff member--Leonard Troland--had obtained a broad patent in the field in 1931. From 1931 to 1934, Technicolor was the sole owner of the rights in the Troland patent, to make monopack film if they knew how to do it. Neither Troland nor Technicolor were film manufacturers; their efforts would be limited to the invention of the method--the process--and the production of sufficient film to demonstrate the applicability of the invention in practice. But they were a long way from actually having a monopack film which could be used commercially.

"Lacking monopack, the only way Technicolor had been able to produce a three-component picture was by the invention, devel-

172

opment and manufacture of very cumbersome special cameras which used three negatives instead of one. Additionally, they were expensive; Technicolor cameras cost about $20,000 each to manufacture. Because of their complexity, regular studio cameramen did not know how to operate them, thus requiring Technicolor to supply cameramen. This meant that instead of simply serving as a laboratory which processed negative delivered to it by the studio, Technicolor had to be part of the staff producing the picture from the very beginning. This presented tremendous business problems and resistance from customers which took years to overcome.

"That was the situation in 1934 when the monopack agreement was made. The Court will have no difficulty in finding that the purpose of the agreement was not a desire to suppress development but exactly the reverse.

"And since the Court will find that the parties did endeavor to develop a commercially successful monopack, the next question is whether there was an intent to monopolize it if it could be developed. And I will say quite frankly that Technicolor thought it had a right to monopolize such a product, since it owned the patent rights, but Kodak would not agree to that. Instead, Kodak as a matter of policy would not make any exclusive agreement with anybody with respect to any product manufactured by it.

"And Technicolor was in no position to strike a hard bargain with Kodak regarding this patent. Technicolor was a very small company in 1934. Its purchases from Kodak were only a little more than one percent of Kodak's sales of film to the motion picture industry, and that was only one branch of Kodak's operation--and not even a major branch at that. Kodak was working on competing color processes with customers who purchased a great deal more from Kodak than Technicolor did. In 1934, Kodak was actively working with Paramount on an entirely different color motion picture process.

"The reason for the 1934 agreement was never monopoly. It was to settle a patent controversy. Here, Technicolor and Kodak were on opposite sides. Technicolor backed Troland's position, and Kodak backed their own Mannes and Godowsky, who had joined the company to work on the development of a monopack type film. I won't go into all the details of the dispute or all the reasons for the settlement, but will simply say that a patent license arrange-

ment was made which was dictated by the necessities of the situation and the good faith and business judgment of the parties concerned.

The prime reason for Kodak's entering into the agreement was that it was about to market under the name 'Kodachrome' a monopack type motion picture film good enough for amateur use. Its patent counsel had warned that there was a great danger that Kodachrome would infringe on the Troland patent. It made sense for Kodak to license its product and pay Technicolor a royalty when it had the opportunity to negotiate a reasonable fee, rather than risk an infringement suit. Since Kodak was interested in the rights only for amateur use, a 16 mm. film, and Technicolor was interested only in the professional field, which meant a 35 mm. film, Technicolor was actually giving up nothing at all and receiving a royalty for it.

This is not a picture of two giants getting together to monopolize an industry. This is a picture of a little fellow--Technicolor--being in the very fortunate position of having something the big fellow needed and was willing to pay for. Kodak made 85 percent of all the sales of film used in the motion picture industry in 1934. Technicolor had no business at the time, it had lost a quarter of a million dollars in 1932, another quarter of a million in 1933, and still another quarter of a million in 1934. It needed Kodak's royalty payments to help keep the company alive while it continued its efforts to develop a commercially successful color motion picture.

A second aspect of the agreement--one which the public has more directly benefited from--was that it brought a closer relationship between Kodak and Technicolor and facilitated the development of the 35 mm monopack. This took many years' work, and even now the results obtained by monopack are inferior to those obtained by Technicolor's special cameras and laboratory processes.

Ansco began work on a monopack-type of film in 1937, and after eleven years brought out a commercial product. Du Pont began work on a monopack in 1936 and has not yet brought out the results of its research. And the Government will not be able to show that Ansco or du Pont or any other competitor was hindered by the 1934 agreement between Technicolor and Kodak.

There is a provision in this document giving Technicolor

exclusive right to use any monopack film developed under the agreement for three years. The Government contends that this constitutes restraint.

The question is whether, given the circumstances of this case, this short period of limitation is unreasonable and can be called a crime.

Remember, at the time Technicolor owned all rights to the Troland patent, and could have kept it entirely to itself. Since it had such a right, it would also have the right to contract with Kodak to manufacture film exclusively for it under this patent, but Kodak would not agree to make film exclusively for Technicolor because of its long-standing policy of not dealing exclusively with any one customer in any field.

In view of the fact that Technicolor had spent a great deal of money before 1934 and intended to spend a good deal more in cooperation with Kodak to invent a satisfactory monopack film, it seems perfectly reasonable to ask for some compensation for its investment.

The Government has also charged conspiracy between Kodak and Technicolor in their imbibition agreement of 1936. As a consideration for Kodak's investment in the development of a special raw stock for use in Technicolor's imbibition process, Technicolor agreed to purchase at least 50 percent of its raw stock imbibition requirements from Kodak. This served as a reassurance to Kodak, because if Technicolor did not buy it there would be no market for the film. On the other hand, this promise by Technicolor in no way involved any kind of restraint as it was already buying most of its raw stock from Kodak before the agreement was made.

Now we come to the point of these agreements. Even if the Government has any case at all based on the 1934 monopack agreement or the 1936 imbibition agreement, judgment must still be for the defendant. The 1936 agreement was canceled in October 1944 and the pertinent provisions of the 1934 agreement were canceled in December 1945. The Troland patent itself expired in 1948.

This court action was brought in 1947, and it is now five years since either of those agreements was in existence. This is an equity suit intended to enjoin conduct or cancellation of illegal agree-

ments. The Government cannot enjoin the performance of agreements which have been out of existence for more than five years!"

Naturally, under the weight of Hugh Fulton's logic and clarity, the Government's case collapsed. On February 27, 1950, I communicated the following to the press and the trade journals:

"Dr. Herbert T. Kalmus, President of Technicolor, today issued the following statement with respect to the proposed consent decree submitted to U.S. Judge William C. Mathes which terminates the Government's case.

"'The decree does not terminate any contracts between Technicolor and its customers, nor does it affect any existing contracts between Technicolor and its customers regarding projects on which photography has started. It does give customers the option to cancel existing contracts for future films, but Technicolor believes that few if any of its customers will employ such an option.

The decree purports to terminate certain contracts between Technicolor and Eastman. Actually, we have not operated under any of these contracts for several years.

Technicolor has been instructed to grant licenses under its patents. In the event that such a royalty-paying license is entered into, Technicolor will supply know-how to the licensee. In fact, Technicolor has long been willing to license its patents.

Technicolor is extremely proud of its history as a pioneer in the use of color in motion pictures. The name Technicolor has always stood for highest quality and will continue to do so. Nothing in the decree permits the use of the name Technicolor without the permission of Technicolor.

We have agreed to this decree because we believe it offers a practical settlement with the Government, and avoids the time and expense of further court action. As set forth in the decree, Technicolor does not admit that it is or has ever been a party to any violation of the antitrust laws.'"

So the long ordeal was over. The result of it--the consent decree ordering Technicolor to license its process and to set aside a certain number of cameras on a first-come, first-served basis for filmmakers other than the major studios--was to have little effect.

Because during the three years while the case dragged on through the courts, another event, much more wide-ranging, had occurred.

Eastman's long-awaited single-strip color negative and printing film stock--the monopack we had all been searching for--went on the market in 1949. Soon smaller, lighter cameras loaded with the new color negative film began appearing on Hollywood movie sets. Before long the public was seeing new names on the credits of color motion pictures--WarnerColor, Ansco Color, DeLuxe, Eastman and others--and also seeing new names for the laboratories that handled the developing, processing and printing of the film. Now, anybody could make a color motion picture. Technicolor had finally lost its edge in the world of color film.

In my opinion, the case, and the decree, had little if any practical effect on the industry. New technical developments in the industry and not the antitrust action brought about the further evolution of the motion picture industry. And Technicolor had its place in the new world of wide screens and spectacular effects. Technicolor's day was not over.

Mr. Technicolor

CHAPTER FOURTEEN

Farther Along the Road

The year 1953 was a banner year for Technicolor. With the demand for color film at its height, British Technicolor showed a profit for the year of over £950,000, and the American Technicolor companies showed a profit before taxes of over $7 million. We turned our eyes to the European market.

The idea was to provide American companies--and others--with a modern laboratory in France that could make Technicolor prints for French distribution and avoid shipping internegatives or dupes, which always give inferior prints, and to offer these same facilities to French producers and filmmakers, thus encouraging the use of Technicolor. Kay Harrison and I met with representatives of the French motion picture industry and financial interests. The company we set up was patterned after the British one, Technicolor Ltd. American Technicolor was to provide the patent licenses and the know-how; the French group was to provide the financing. Societe Technicolor was formed with a capital of one thousand million francs, with Technicolor Motion Picture Corp. owning half the stock and French interests owning the other 50 percent.

Upon the insistence of the French investors, the operating management of the French laboratory in Joinville was put in French hands, and whether it was their national pride or their tendency to be impatient with essential technical details, the French plant never did as well as its Hollywood and London counterparts. In addition, in the early and mid fifties, we ran into a gradual decline of feature film production in general due to the amazing development of television. This was most noticeable in the United States but also in England and to a lesser extent in France. In the end these problems led us to the decision to close the Joinville plant and turn our attention to Rome, to a group of Italian investors led by Gianni Agnelli, a powerful and wealthy industrialist who owned Fiat autos and Ferrania Film Products.

Agnelli agreed with me early on that we shouldn't repeat the mistakes of Societe Technicolor; the result was that a strong group

of technicians from Hollywood and London were dispatched to oversee the technical aspects of starting up the laboratory. Rome had become an active film center, perhaps doing a greater volume of feature length production than Hollywood. As plans for the European Common Market, then in the talking stages, developed there seemed to be greater power and profit potential for both the British and the Italian companies. And as Kay Harrison said to me later, "Foresight, hindsight, or nearsight, the fact remains that had Technicolor not expanded into France and Italy, there would not have been a service available to American producers that enabled them to have their release prints for Europe made there."

In America, as people began to stay home and watch television rather than go out to a theater to see a film, filmmakers developed their own counter-attractions. During January and February of 1953 the motion-picture industry was turbulent with activity-- nothing like it had been seen since the days of the change from silent to sound some twenty-five years before. Eight new types of presentation came along, and each affected Technicolor's photography and laboratory practices.

After sound and color, the next huge step had been the monopack film, which eliminated the necessity of the old unwieldy Technicolor special cameras. Now I was watching the next leap forward--the projecting of pictures on a much, much larger screen.

Technicolor got involved in the wide-screen techniques of Cinerama and Cinemascope, the increased-area negative processes Technirama and Vistavision, the Technicolor Double-Squeeze system, Todd-AO, Ultra Panavision and the MGM 65mm process, Three-D or stereoscopic pictures, Super Technirama-70 and--aligning ourselves with future development--color television.

Cinerama was the result of years of untiring research by Fred Waller of Paramount's special-effects department. In 1939, at the World's Fair, Waller presented Vitarama, an eleven-projector wide screen system he had invented in 1937. It was a sensational attraction at the Fair, but not practical for commercial use in theaters. During World War II, he adapted the system for use in gunnery training, using the multiple screens to simulate combat conditions.

Cinerama is a process utilizing three cameras and three projectors to record and project a single image. At twenty-six frames

per second, the images blend together to produce an illusion of vastness, giving the audience the effect of peripheral vision, which is a normal component of seeing. We don't see just the things directly in front of us. Normal vision includes what we see out of the corners of our eyes.

The idea extended to sound as well. In motion pictures, television, radio and the phonograph, sound ordinarily comes from one direction while in natural life it comes from all directions. In Cinerama, sound comes from many directions, providing a sensation of reality. This multidimensional effect was developed by Hazard E. Reeves, a pioneer in sound and electronics.

The image projected in Cinerama is almost a complete half circle--actually, 146 degrees wide and 75 degrees high, not very different from the corresponding 180 and 90 covered by the human eye. No single lens can cover such a field of vision without distortion. The Cinerama camera has three lenses, each small and so positioned that each takes a third of the scene to be photographed, each exposing its own reel of negative film.

The center lens points straight ahead; the left lens photographs the right side of the scene and the right lens photographs the left side. A rotating shutter whirls in front of the lenses at a point where their lines of view cross, insuring simultaneous exposures of the three films. Single controls adjust focus and settings on all three lenses at once. These lenses have a short focal length--27mm--which gives very great depth of field. This is the essential Cinerama effect--the depth of field which makes pictures look sharp from directly in front of the camera all the way to the horizon.

Cinerama requires three projectors in three separate booths, the one on the right covering the left third of the screen, the projector on the left covering the right third and the one in the center projecting straight ahead. A curved screen adds to the illusion of reality and because this screen is made of more than a thousand vertical strips of perforated tape--set at angles like the louvers of a vertical venetian blind--it prevents reflected light from bouncing off the curved screen.

There is one further problem to solve. If you ran these three pictures from three projectors side by side to make one large wide picture, you would expect to get a line of demarcation where the

pictures join or overlap, and you'd expect your total effect to look "wiggly." Cinerama controls this effect with what technicians call "gigolos," tiny comblike bits of steel along the edge of the film track in each projector which constantly jiggle up and down at a very high speed. The rapid movement of this little saw-tooth gadget fuses and fuzzes the edges so that they blend together to the eye.

My old friend Merian Cooper produced the first feature length picture in Cinerama. It was Cooper who had introduced me to the Whitneys, who then invested a fortune in Technicolor, and it was he who persuaded David Selznick to try the three-component process for *Gone With the Wind*. Eleanore and I have long counted Merian and his wife Dorothy among our closest and dearest friends.

Technicolor made all the prints of *This Is Cinerama*, but there were many new and difficult problems in their manufacture. We were still processing prints a few days before the premiere--in fact, right up until opening day. In New York City, while the opening reels were being projected in the theater, special messengers were racing to the theater with some of the later reels for that performance! Viewers were enthusiastic about the thrill-filled travelog narrated by Lowell Thomas, which took the audience on a roller-coaster ride and on a plane flight over the Grand Canyon, among other spectacular scenes.

We improved our technique for eliminating interpanel motion in time to do a really satisfactory job on two new Cinerama pictures, *Wonderful World of the Brothers Grimm* and *How the West Was Won*, both for MGM. John Ford directed an all-star cast in the latter, including George Peppard, John Wayne, Henry Fonda, Gregory Peck and James Stewart. The great cast, first-rate photography and lovely Alfred Newman score made it a spectacular Cinerama presentation.

An entirely different wide-angle system was in the works at 20th Century-Fox. Instead of using three cameras and three projectors, the process employs one camera with a special optical attachment for the lens; in the theater, it uses one projector with a corresponding special attachment. It is called Cinemascope, and is the invention of Frenchman Henri Chretien. He exhibited this as early as 1927, but his invention was neglected until 1952, when it was acquired by 20th Century-Fox. Chretien's auxiliary lens in

front of the regular camera takes in one-half the focal length in the horizontal direction that it takes in the vertical direction. This results in a lateral compression, or anamorphosing, of the image. The image, or picture, is compressed or squeezed in a horizontal direction. Simply, Chretien's lens squeezes a wide image into a standard frame through distortion during photography; the image is opened out by a similar reversing lens during projection. This allows wide-screen processes to be recorded on standard film stock.

On the negative, the objects in the picture appear tall and thin, but when projected through the special lens a clear wide screen effect is produced.

Aspect ratio is the ratio of the width to the height of the picture. The standard original ratio we were used to working with was 1.33. In many theaters, Cinemascope's aspect ratio of 2.66 didn't quite work; it produced long, ribbony pictures and, in close-ups, made faces look fat.

Robert Gottschalk got interested in the problem and attempted to remedy it. His company, Panavision, came up with 35mm squeeze lenses that are probably the best that can be used with 35mm film. Super Panavision--also called Panavision 70--utilizes 65mm film without distortion, and Ultra Panavision utilizes 65mm film and an anamorphic lens. The first feature production in CinemaScope was *The Robe*, from Lloyd C. Douglas' novel, starring Richard Burton. It was simultaneously filmed by the regular process, and it is this "flat" version you'll see on television.

Technicolor worked with 20th Century-Fox long and hard to solve the problems early CinemaScope posed. Audience reception for *The Robe* was so enthusiastic that more than one thousand theaters in the United States rapidly equipped themselves for CinemaScope, and soon were showing CinemaScope pictures in Technicolor, including *How to Marry a Millionaire*, *Beneath the Twelve-Mile Reef*, and *Three Coins in the Fountain*.

In 1955, an improved version of CinemaScope using 55mm film provided better definition and less distortion than earlier efforts. The first feature in CinemaScope 55 was *Carousel*, a lovely film adaptation of Rodgers and Hammerstein's musical.

In 1953 Technicolor had begun to use a modified camera in which scenes are recorded on two full frames, or double the negative frame size of a standard camera. A larger negative, we

reasoned, would improve the definition of Technicolor prints when projected on these new enormous screens. This system was introduced by Paramount in 1954 as VistaVision. The first VistaVision production was *White Christmas*, with its memorable Irving Berlin score.

We were working in many areas, converting our three-strip cameras for use in photographing increased-area negative, installing processing facilities to manufacture dye-transfer prints or the new Eastman Color positive prints that were more and more in use, and developing special optical printers to accommodate the image forms required for the many new types of theater presentations. The new optical printers made it possible for a producer who had photographed his picture with an anamorphic lens to order from Technicolor not only anamorphic prints but also ordinary flat unsqueezed prints. Or, if he had photographed with ordinary lenses, he could order ordinary flat prints or anamorphic prints.

We had already successfully developed a new wet printing process for making high quality, reduced grain, dirt-free prints. The first feature to use this wet print was *Pal Joey*, with Frank Sinatra.

We even thought of a process that could start with an increased-area negative which could then be printed or rephotographed in the laboratory to yield prints suitable for large-screen projection, projecting 35mm prints with a screen of any size or shape, 16mm projection, and television, and with any existing sound system--all from the same original negative!

But one of the most interesting questions we set ourselves to answer was this: In large negative photography, what is the optimum size negative? W.E. Pohl, our technical director in Hollywood, had found that qualities of definition and clarity observable on the screen do not improve indefinitely as the area of the negative increases from that of the normal 35mm width. These qualities improve until they reach a maximum, where improvements fall off or cease.

Technicolor scientists believed that maximum improvement was reached when the anamorphic factor was 2 to 1. We could get this factor by squeezing the photographic image in two stages: first by a factor of 1.5 to 1 during the photography, and then a second squeeze by a factor of 1.33 to 1 in the laboratory during the process

of making the release prints. This we called the Technicolor Double-Squeeze system, and because the dimensions of the prints were the same as those for CinemaScope, they could be projected in any theater in the world that was equipped to project CinemaScope.

Other new wide-screen processes came along. Todd-AO filmed *Oklahoma!*, *Around the World in 80 Days*, *South Pacific*, *Can-Can*, and *Cleopatra* in Technicolor. MGM's Camera 65 used Technicolor in *Raintree County*, and Panavision, also a 65mm process, produced *Ben Hur*, *Exodus*, *West Side Story*, and other films in Technicolor.

Working out the equipment and manufacturing operations required by Cinerama and CinemaScope and the others occupied my attention and the efforts of the Technicolor technical staff for many, many months. Meanwhile, other new ideas were popping up. One of these was the three-dimensional or stereoscopic movie.

Although we produced several 3-D movies in Color by Technicolor or with Prints by Technicolor, I felt that because these films had to be viewed with special glasses, they would be popular only so long as their novelty value lasted.

The most remarkable wide-area film we worked on was Technirama. Everything about this 70mm print was new: The cameras, the lenses, the film printers, the lab equipment, the theater projectors, the stereophonic sound system, the theater screen and even the seating arrangement in the theaters. Some of the best photo-physicists, optical designers and craftsmen in the world worked on this process.

Walt Disney had been the first to use Technicolor's three-color process back in 1932, and it seemed altogether fitting that he should pioneer Technirama-70. His feature film, *Sleeping Beauty*, proved to be his most expensive and elaborate animated feature.

Encouraged, United Artists produced *Solomon and Sheba*, starring Yul Brynner and Gina Lollobrigida, with spectacular battle scenes, massive temples, sweeping panoramas and crowd scenes. Spokesmen for UA called the process "unequalled in depth of focus and clarity."

In practice, when photographing 70mm negative, the 35mm negative runs horizontally in the Technirama camera, allowing a large negative frame to be photographed--about two and a half

times the area of the ordinary cine frame.

The lenses of the Technirama camera incorporate an arrangement of glass prisms and mirrors which compresses the wide panoramic view sideways before it's recorded on the large negative frame. This device eliminates distortions and losses in visual quality for large screen presentation. It was designed for Technicolor by the brilliant optical scientist Dr. A. Bouwers of Holland.

In printing, the 35mm Technirama negative moves horizontally (as it did in the camera) through one head of the printer and the image is projected onto a 70mm positive film running vertically in the other head of the printer. This optically decompresses the image, producing undistorted pictures with amazing depth and clarity on the positive film.

Spartacus was filmed in Technirama-70. It was the most expensive motion picture made in Hollywood up to that time. The picture racked up 167 shooting days and employed 10,500 people in 251,837 man-hours--a record for local shooting and employment. Kirk Douglas and Laurence Olivier starred in this great spectacle based on historical fact.

Working to stay abreast of the latest developments in film-making, we did not ignore the home screen. Technicolor holds a number of patents covering the making of color prints for color television and the color television camera.

Busy as I was, I took a moment to mark the fact that in 1959, the year of *Ben-Hur*, for which Technicolor won another Academy Award, I turned 78. For nearly fifty years I had been President and General Manager of Technicolor. And I was still doing a long, hard day's work every day, and often working on holidays and Sundays as well, and I was still filled with the desire to engage in something of greater significance than anything I had yet done. There was so much I wanted to read, to write, to see and do--and but little time left!

Since turning 65, I had several times thought of resigning from active participation in the affairs of Technicolor and had gone so far as to formally tender my resignation to the Board of Directors. Always before, I had been persuaded by the directors and

others to remain in office.

But this time there was a different feeling in the air.

Some weeks earlier, a call came from a man in Chicago asking me how he might acquire 51 percent of the stock of Technicolor, Inc. I was startled, but replied that I was not able to offer such a block myself nor could I do it through friends; the stock of the company was widely distributed and I was not at all sure that such a block could be put together except perhaps on the open market, which would increase the price substantially. During the conversation it began to dawn on me that the caller's interests were identical with the interests of Mr. Patrick J. Frawley and his associates, who had already indicated an active desire to acquire control of Technicolor and take over its management.

I had no personal reason for combating that ambition; however, I was deeply concerned about the welfare of the company itself--my "baby"--and of those I had brought into the company as investors, employees and customers.

This was my state of mind when Jack Clark told me he had been approached by Joseph Patrick of New York City and that Patrick's demands were that I resign, that Clark become President, that Frawley, Patrick and their associates come into control and that we resolve this in a meeting to be held as soon as possible.

I was rather taken aback at this approach, and took a step I had never taken before. Through the years I had never at any time felt that there was any divergence of interest between myself and Technicolor, so I had never employed special counsel to represent me, but in order not to embarrass George Cohen, the company attorney, I now engaged separate counsel. My attorney, Homer Crotty, joined me in meeting Clark, Frawley, Jacobs, Patrick, Ettinger, Cohen and others on December 4, 1959, for the meeting they had requested.

Joe Patrick delivered an impassioned speech which boiled down to an emphatic restatement of the three demands already mentioned.

I immediately responded, remarking that I had no quarrel whatsoever with Patrick and the others on their first point because I had already some time past tendered my resignation to the Board of Directors. Nor had I any objection to the second point, because for years I had been preparing Joe Clark to become my successor

187

in office.

As for the last point, it was hardly up to me to decide whether or not they should come into control of the Board and of the business; these were matters for the shareholders and the directors themselves to determine, and I, as a shareholder and member of the Board, would simply cast my vote on those matters as I was sure all the others would--as I thought to be in the best interest of the company.

Patrick, Frawley and Jacobs stared in amazement. Apparently the facts I had just stated had never been properly presented to them. No response to my remarks was forthcoming; the meeting adjourned with a tacit understanding that I would press the acceptance of my resignation by the Board. On December 31, 1959, my resignation was accepted and my contract, which had been in force for 22 years, was ended. It was arranged that I continue with the company on a consulting basis for another three years.

But as it developed I was not happy with this arrangement. I was afraid it would mean that the new people would frequently call on my experience, and that these consultations would gradually involve me more and more, unless I made frequent trips to New York, London, Rome--which, among other things, was what I had resigned to avoid.

And, too, I thought that if a number of Technicolor employees came to my office from day to day to consult with me, it would give the appearance that I was still running the affairs of the company. The new men did not want that, and neither did I.

Another bone of contention arose. As long as I worked on a consulting basis after retirement, I was to receive a specified salary. Some of the new directors expressed the opinion that the salary paid to me was too high. It became apparent that the only way I could settle that issue would be to engage in and win a proxy fight at the next stockholders' meeting. Such a proxy contest would be a difficult fight which, if won at the first meeting, would probably have to be won again at later meetings. I had no desire to spend my remaining years in such a battle.

I therefore retired on August 31, 1960, retaining my pensions, certain office space and secretarial assistance--but with no active duties nor responsibilities, no authority, and no salary.

Frawley and I both felt it to be in the interest of Technicolor

that a solidly cooperative and friendly relationship exist between us--between the old and the new regimes. This was expressed one day when Frawley warmly urged me to become Honorary Chairman of the Board of Directors.

I would have enjoyed serving in such a capacity. But I declined on the ground that if my name appeared on the company's letterhead as an officer or director, it would imply that I had some responsibility for the company, and I wanted no such responsibility nor the authority that would have to accompany such responsibility. Let the new men--bringing youth, energy, ideas, strong financial standing and the habit of success--have that authority and responsibility.

I had much to do. It was time to turn my attention to another side of my life: A happy marriage, a loving family, all the things I had never had enough time for--music, books, sports, travel.

And another task: An account, as accurate as memory can make it, of the years of work spent in bringing color to the screen. It will begin with that first piece of film, processed in a railway car and flickering its green-orange images in a way that only promised the glorious color to come. It will include the evening of February 19, 1940, that night of triumph for *Gone With the Wind*, when I stood before the members of the Academy of Motion Picture Arts and Sciences, clutching the statue that had just been placed in my hands by David Selznick, and said:

"Mr. Chairman, Members of the Academy, Guests:

"I am happy to accept this award for and on behalf of Technicolor. It has been my privilege to lead the men and women of Technicolor, and I am sure there is no group of workers more loyal to the highest ideals of the motion picture industry and the Academy.

"We know 'The play's the thing'--and the players. But we also know that there are other valuable ingredients, among them color.

"So it is the job of Technicolor to pursue its research and to make color ever more available to the industry by widening the range of its service, constantly improving its quality and lowering its costs.

"We dedicate ourselves to these tasks, and we are honored to accept this award as a token of your encouragement."

It will be a long story, spanning the decades from the early flickering light of the Nickelodeon to the spectacular wide-screen productions of today. It will be a technical story, because in bringing natural color to the screen, one process was perfected only to be abandoned when we saw greater possibilities farther along the road.

And it will be a personal story. I was there; I helped to make it happen.

CHAPTER FIFTEEN

Weathering the Storm
Notes by Eleanore King Kalmus - Part One

In telling the story of his public life, Herbert Kalmus never mentions the private fears, the torture of his first marriage, or the personal disappointments that were inseparable from his triumphs. His aim was simply to tell the story of Technicolor--how it began, how it was kept alive--and leave his own agonies out. But these are an essential part of his remarkable story, for they arose from the same depth of character as did his work and his life.

I will try to fill in the missing pieces.

Doctor (I always called him Doctor, both before and after our marriage, as did all of Hollywood) had happy memories of his early life, enjoying the advantages of a loving, busy, cultured home as well as the neighborhood life of a regular, all-round boy. His mother's death when he was eight did not mean the loss of home and friends, but his father's death three years later swept it all away. Young Herbert went to live with his stepmother's family, knowing from the moment his residence was changed that he would not be eligible for Boston Latin School and therefore unable to prepare for Harvard.

When he left that unhappy home and found a job, he makes it sound quite ordinary for a boy of sixteen or seventeen to be entrusted with one account book after another until he is carrying the entire bookkeeping enterprise for a large company. At seventeen, he bicycled across England and Germany looking for his father's people, but found no trace of them.

Nothing in his life produced the same texture of recalled happiness as his four years at MIT. His studies were absorbing and his friendships were close. The future, in a nation hungry for scientific and technological advances, seemed limitless. And he was in love.

In his junior year at MIT, Herbert met Natalie Dunphy at a school dance. He was twenty, and she was twenty-four. She was working as a sales clerk and some time model in Boston. "She was small, had red-gold curls and a vivacious personality," he recalled. He was entranced by her way of throwing her head back and

laughing. The sober young student fell wholeheartedly in love and they were married in 1903, during his senior year.

With this love story began the power struggle to take over one of the biggest corporations in the United States. Herbert Kalmus was to devote his formidable energies to creating Technicolor, the process which saved a staggering motion picture industry in the 1930s. He was never a public figure. Even in Hollywood, in the days when it was a one-industry town that thrived on gossip and personalities, his was a ghostly presence, one of those whose prodigious work went on behind the scenes.

Natalie, on the other hand, put her name on the screen of every motion picture Technicolor produced. Hers was a name known to millions, and even at the heart of the motion picture industry, moviemaking professionals carelessly attributed to her the success of the vital photographic process. "Technicolor? Oh, yes. Natalie Kalmus." To her clings the aura of twenty years of the most successful movies ever made. *Gone With the Wind*, *Snow White*, *The Red Shoes*, *For Whom the Bell Tolls*, *The Wizard of Oz*,--all carry the legend, "Color Consultant, Natalie Kalmus."

And who could have predicted that the sympathy and pity that prevented him from rejecting her during their early estrangement would result in a later wrenching, treacherous woman. The battle was to rage for five years in the domestic courts of Massachusetts and California. And although Natalie did her best to embarrass her former husband with her revelations in the nation's newspapers, their true story remained hidden.

In following his autobiography, the reader has not a hint that when the young graduate accepted a teaching job in California, the trip West was in fact his honeymoon. The two young people must have taken great pleasure in San Francisco and the towns across the Bay, ferrying over to Sausalito for long walks, watching the glorious sunsets, dining in fine restaurants and enjoying the beauty and vitality that have always belonged to that city.

Nor can the reader catch a glimpse of Natalie as she stands at the rail of the transatlantic steamer, her arms linked on one side with her husband and on the other with his friend, Daniel Comstock. The threesome sailed for Europe with high hearts. The two young men had fellowships that paid their expenses and were looking forward eagerly to their academic assignments. There would be

time as well to take in the museums and galleries, the restaurants, the theater, and a chance to travel.

There were plans for Natalie, as well. Herbert encouraged her to enroll in school in Zurich and helped select one with courses he thought would interest her. She never did enroll in that school-- or any other of which there is a record. Yet she must have used the opportunities she met with in Europe to be exposed to art; she must have used the time she spent strolling through museums; everything she saw must have educated her eye to color, line, design. Those months of informal study, absorbing what Europe had to offer, were no doubt the background for her later work as color consultant for the Technicolor Company.

But Zurich was the scene, as well, of the first quarrels of any substance. Natalie may well have resented the hours Doctor spent in his laboratory. She may have resented the admiring women assistants at the University. Or the focus of her complaints may have been the days and even weeks he spent exploring the country with Dan Comstock on tandem bicycles, trips from which she was excluded. In the end, she returned to Boston before the two-year sojourn in Europe was over.

Natalie never told him that she was pregnant. He found out by chance that without consulting him she had gone to a European doctor and had an abortion. It was a deep, deep wound, and even thirty--forty--fifty years later he felt it as a devastating pain. He was convinced that it was only the first instance of several when she did not go through with giving birth to his child; he was never told of her pregnancies or their termination. It was a strange thing--so early in the marriage--to keep such information from a husband.

When graduate school ended and exams were over, Doctor was eager to return to MIT and teaching. The young Kalmuses established a little home in Boston and began to entertain. Herbert was devoted to Natalie's mother, and to her older sister, Sara, who lived in Doctor's Cape Cod house until shortly before her death. Natalie's younger sister, Eleanore, was often with them as well. She later married and adopted a beautiful baby boy, Donald, who remained close to Doctor's heart always. Donald Smith became Bob Riley's outstanding assistant in the sales division at Technicolor, and we were later close to his beguiling daughter, Sally.

The fledgling firm of Kalmus, Comstock and Wescott had its beginning in Boston, and it was not long before the young scientists began to focus on what would become a primary problem: How could color be reproduced on the motion picture screen? Natalie participated in the early activities, assembling interiors and costumes and props. Indeed, she must often have been the focus of the special Technicolor camera, standing in as model when tests were needed. There is no mention in Doctor's autobiography of Natalie's participation in the making of *The Gulf Between*, the first picture photographed in Technicolor and produced by Technicolor itself to show the industry that it could be done. But later court records testify that she did travel to Florida with the converted railway car-laboratory and took charge of coordinating the costumes and sets used in the film.

These years of new challenges and new responsibilities for Herbert were also years of tension at home. I have some documentation of those years. In the files, there is considerable correspondence between Herbert and Natalie at the time when she was confined, for emotional difficulties, to a sanitarium at the Mayo Brothers Clinic in Rochester. Her sister Sara was with her, and writes appreciatively to her brother-in-law, thanking him for his devotion and care. The letters Doctor wrote to Natalie over the next few years, when he was alone during her illnesses and recuperations, tell how much his absorption in research helped him to overcome his loneliness.

Natalie's illnesses seem to form a pattern; when she disliked what was going on or where she was or what she was doing, an incapacitation condition would remove her from the scene. In 1907, after a year in Switzerland, she came home to Boston because of illness. When Herbert was teaching in Canada, she made one trip of only a few months to Ontario, pleading illness the remainder of the time.

These interludes came to represent a relief to him after a time, because when they were together her unpredictable temper was no longer a private thing between them but was unleashed in public. Her instant tantrums turned into vicious attacks, even in front of her husband's friends and business associates. Her jealousy manifested itself in accusations of infidelity with any female who came into their orbit; she knew how to spark his anger and then fan the

flame into rage. His friends realizing that Herbert was a calm and rational man when he was away from his wife, did all they could to comfort him.

In all, the Kalmuses seldom lived together during these years of hard work and accomplishment. Publicly, he explained her behavior as a result of emotional problems. Privately, Herbert felt a deep responsibility for Natalie, loved her, cared for her, and protected her; but when they were together for any length of time, she would erupt again, causing him deep, raging pain.

The years from 1919 to 1921 witnessed two breakthroughs in the KC&W laboratory--the development of an early Sonar system for the Navy and Technicolor Process Number Two. During these demanding years, the marriage was reaching the breaking point. They sought a divorce.

Why did Natalie consent to the divorce petition? True, she was miserable in the marriage; but did not want to lose Doctor. Her deepest intent was to be free and yet to cling.

It was possible that she had become terrified of the anger she invoked in him. Later, in the horrendous deposition she gave the Court during the five-year battle she waged to gain control of Technicolor, she spoke of her fear. She told about an evening walk in the woodlands, one of his favorite places on the Cape. They began to argue, and the battle became so violent that he raised his hickory walking stick. She claimed that she was sure he intended to kill her. She ran away and hid and did not go home that night. Knowing Doctor, I am sure he merely threatened. My daughter Diane says with assurance, "Knowing Pop's temper, I think he could have bopped her!"

Obviously these two people could no longer share a life. Natalie admitted she wanted a divorce. Relieved, Doctor agreed to the grounds of mental cruelty on his part, an acceptable reason in Commonwealth divorce courts. There was no scandal. Natalie had what she wanted, and he had his fervent hope--"Freedom," he explained, "after many years of a stone around my neck."

The testimony in divorce court was fierce, but Herbert was able to contain most of it without undue publicity by simply giving Natalie much more than she might ordinarily have been granted by the courts. He divided to the penny his share of the company's profits to that point; he gave her a substantial settlement in cash;

$7500 per year alimony as long as he lived; their entire household of goods; and a considerable block of Technicolor stock.

Natalie was jubilantly radiant the day of the final decree, signing her acceptance with a flourish. But as she watched Herbert walk away from the courthouse, something in the bearing of that tall figure caught her eye. She said to Dan Comstock, "That bastard has something up his sleeve..."

It was true. Herbert Kalmus was on his way to California. On the day of his departure, his partners were at the train to see him off. They were all in triumphant mood. "Whoever thought eleven years ago that we'd be worth a million dollars today?" someone asked.

As Herbert ran for the train, he called back, "Hollywood, here comes Technicolor!" And Dan Comstock waved him out of sight.

<div align="center">***</div>

Shortly after the divorce was final, Natalie's sister showed her the Boston Herald with a front-page story with a photograph. The caption read: "Millionaire Inventor Plans Color in a Motion Picture with Douglas Fairbanks and Mary Pickford to be Called *The Black Pirate*." Sarah asked innocently, "Isn't that a wonderful picture of Herbert? He looks younger and better than he has in years!"

Natalie snatched the paper from her and read the story. Her reaction was bitter. "I knew it! I knew all along... I didn't get what I was entitled to, and now--oh, the dirty, double-crossing--." She ripped the paper to shreds.

Sarah tried to calm her. She reminded her that she was just beginning to find herself. "You seem so pleased with your life alone." Natalie shrugged off her consolation. "We'll see. . . ." she said.

In 1922, Technicolor's Hollywood plant was in construction at 1006 North Cole Street. Now Technicolor would be able to offer rush print service to the studios. Doctor was on the site one day, complaining about southern California, to the amusement of the crew. "This hot, damned, burned-out blasted desert furnace of a country," he was saying, when he stopped short. Across the site of the new studio he saw an apparition: approaching him, picking her

way delicately through the building materials, was a beautiful, smiling Natalie, whom he had not seen since the divorce. Startled, he could only stare.

With Natalie was Mrs. Comstock, Daniel's dignified and beloved mother. Both women were smiling and calling out to him. Finally he was able to speak. "To what do I owe this unexpected visit?"

"Herbert, dear, I have something to tell you. It's extremely important. I have come with Natalie all the way from Boston to talk to you." Mrs. Comstock reached his side and lowered her voice. "Herbert, Natalie has been given a year to live by the doctors. She is a very sick girl."

"I'm very sorry to hear that. Natalie, what has happened?"

"Oh," said Natalie reluctantly, "you remember, Herbert, that I always spent a lot of time in hospitals and sanitariums, but I thought I was all over that. Now the Boston doctors tell me that my heart. . . ." She fluttered her hand over her heart and allowed her champion to take up the story.

"You see, Herbert," said Mrs. Comstock, "I felt that if you knew this, you would help her stay in California, where the weather is so mild. This is the only place where the doctors feel she could be active and occupied. Since she gave so much of her life to traveling with you and sitting in on conferences on Technicolor, I wonder--could you give her some sort of part-time position here in Hollywood?"

"Mother Comstock, you have asked for the only thing I am unable to do. . . ."

"Dear, I don't like to remind you, but when you graduated you told me to remember all my life that you were so grateful for being a family member during your college days that there was no favor I might ask that you would not grant. Herbert, I am not a young woman and this trip has been severe for me, but I could not sleep at night if I did not do this for Natalie during her remaining time. I think you owe her your help. She has promised me that she will not infringe on you in any way. Haven't you promised this, Natalie?"

"Yes, indeed, Mother Comstock. Perhaps there's something I could do. . . two or three days a week. . . in your new color department. . . to make me feel useful. . . Please, Herbert?"

"I ask this of you as my final request," urged the older woman.

Doctor looked intently at both of them. "For you, Mother Comstock, and against my better judgment, I'll find something for Natalie to do. And I sincerely hope it will make her life happier. I don't agree with this, but I'll do it."

The decision was to bring Doctor thirty years of grief.

What could he say? Reluctantly, the compassionate man agreed to find something to keep Natalie occupied in the color consulting department of Technicolor. The company was doing everything it could to encourage the industry to try color. Many elements were involved--lighting, fabrics, paint, hues and shades of color, makeup tints--and the regular black and white crew needed advice in producing a color film. Natalie, with her eye for strong color, her experience with Technicolor, and her strong theories on color harmonies, could contribute to that department. In fact, it was Natalie who tempered the desire of early producers to flaunt the most vivid hues they could produce on the screen. Natalie spoke often of what she called "the law of emphasis." "Nothing," she said, "of relative unimportance in a picture should be emphasized by color." She knew that a bowl of crimson roses in the background could detract from a star's impassioned speech. It was Natalie, too, who introduced the art of modifying colors so that the eye saw the desired shade.

Under the strong lights required for Technicolor filming, white constantly changes in value and tone, picking up and absorbing the reflections of surrounding colors. White also creates glare: a white blouse can reflect so much light that an actor's face can be eclipsed. Natalie found that when fabrics and paints are dyed a neutral gray, these problems can be avoided and the result can appear white on film.

Natalie had strong opinions on color as a register of mood or identity. She liked costumes that built up the screen personality of an actor, and she relied on color and color changes and balances to build a mood in a scene. The practices she established in her department during the mid 1930s strongly affected the art of color motion pictures.

198

And once she was ensconced in the consulting division, Herbert rarely entered "her" territory. The staff learned not to appeal to Dr. Kalmus for a reversal of one of Natalie's decisions. As she built a large and capable staff, she became one of the best known and most influential of the company's employees. Indeed, she was probably the only individual in the entire company whose name was known to the outside world. Until 1948, her name appeared as "Color Consultant" on the credits of every motion picture made in Technicolor.

"I recognized that Natalie was the boss and I never had any trouble with her," says Hal Stern, who received two Oscars during his years with Technicolor. "I always thought Natalie and Doctor were married. I knew that what she chose for sets, designs, costume colors and so forth was the way it would be." If someone in the color department went to Doctor with a contrary idea, he was simply informed that Doctor always upheld Natalie's choices.

As Herbert Kalmus was known to be a perfectionist, and felt that an improper or garish use of color only detracted from his process, he was happy to have a strong color advisory department linking the studio's color experts with the studio's art directors, set designers and wardrobe directors, believing that the better that department functioned the better the final production would be.

The busiest years were the years after the advent of sound, when Doctor managed to link the conversion of sound activities of the big studios to include color. The plant was busy, and the industry was fast accepting Technicolor's superiority.

Of course, Natalie was aware of this success. She also observed that various attractive young women frequently accompanied Herbert Kalmus on his business trips to the east and to Europe. This surprised and irritated her, but she decided to bide her time and use these excursions to her advantage.

During the years since his divorce from Natalie in 1921, Doctor had made several trips to Europe with various women friends. He was, after all, a free man, and he saw no reason why his arrangements with Natalie should compromise this freedom.

Knowing his schedule, Natalie caught Doctor at a conference and gave him a greeting from her mother. Doctor asked about her family: he had always been fond of them--they had been his family, too, during his marriage to Natalie. "How is Mother Dunphy?" he

asked.

He was unprepared for Natalie's gambit. "Herbert, Mother misses the Cape. The hot Boston summers are very trying for her. Could she and the family stay at Fernbrook while you're in Europe? Even two weeks would be so refreshing. You've always been so generous, dear, and you know how they love you..."

Doctor was no match for Natalie. He was no better prepared when she made her next advance.

"I was wondering...my little apartment is so suffocating these hot nights--I can scarcely breathe! There's always a cool breeze on your lovely hill top. Could I entertain Technicolor clients there while you're away? The cook and butler and the gardener are on hand anyway. Isn't that a good idea...?"

Eventually, to the outside world, it appeared that Herbert employed Natalie at Technicolor and allowed her to use his homes at Cape Cod and Bel-Air. But he did these things out of open-hearted innocence. Never for a moment did he suspect that his generosity and discretion would enable her to assume the role of a "wronged wife."

Natalie, however, was quick to see the advantages of their unusual relationship. It was a classic case of the cunning mind outwitting the educated one. Playing her part as the beautiful woman executive working alongside her brilliant husband, she nurtured her jealously and waited for her chance.

Later, one judge after another would ask him, puzzled, "But why did she share your homes if you weren't still married?"

I heard gossip--it was impossible, in Hollywood, not to hear gossip. A friend who had been a close companion of Edna May Oliver, an outstanding character actress remembered as Aunt March in *Little Women*, Aunt Betsey Trotwood in *David Copperfield*, and for her Oscar-nominated performance as the Widow McKlennar in *Drums Along the Mohawk*, told me of two incidences. One evening Natalie was a guest at a dinner party to honor a distinguished visiting conductor. Natalie, in a vivacious mood, took command of the conversation. But the more she talked, the more apparent it became to everyone that her musical education was inadequate to the occasion. Miss Oliver had to work very hard during the remainder of the dinner to orchestrate the conversation away from Natalie. Another time, when Natalie and Edna May

Oliver were guests in a director's home Natalie tried to pretend that she was a much closer friend of Miss Oliver's than she actually was, in an attempt to deflect some of the star treatment in her own direction. Natalie had a case of Hollywood fever.

In the protracted period of time when David Selznick was waiting for his contract with United Artists to run out, he began his meticulous preparations for shooting *Gone With the Wind*. He and Natalie had more than one difference of opinion. Natalie, as color consultant, was a compulsory part of the Technicolor package, at an extra $1,000 a week. Natalie possessed notoriously strong ideas about color--indeed, there was some talk on the sound stages of Hollywood that many of Natalie's dictums were the result of personal taste--that what she didn't like she claimed the Technicolor cameras would not like either. On the set of *GWTW* she was rather high-handed and undiplomatic, and used here authority to scuttle any piece of wardrobe or furniture or set dressing which, in her judgement, would reproduce poorly on the screen. She created turmoil by tossing out entire sets. The fight over the mulberry wallpaper was a case in point.

Selznick had appointed William Menzies as art director for the movie, with his first duty to serve as arbitrator of all differences of opinion between his team of designers and Natalie.

It had been decided to have a mulberry wallpaper in the dining room at Twelve Oaks, which would be seen briefly through an open door during the barbecue scene. But Natalie stormed in with her dictum: No mulberry! The color was too close to the men's beige coats, and the actors would "disappear" against the background.

Filming color tests, Menzies proved that Natalie was wrong --the two colors maintained separation. But Natalie dug in her heels; finally the walls were painted a pinkish-beige.

But Selznick couldn't take any more. As a result, Doctor told me, there was a definite understanding between Technicolor and the Selznick office that Natalie would not at any time be present on the *GWTW* sets. She would, however, receive screen credit as Technicolor's Color Consultant--as usual. Doctor told me no more about these two provisions--except that both were meticulously carried out.

Natalie spent that time in Technicolor's English plant, where her work was well-regarded and where the staff was eager to

benefit from her experience. It pleased her to be there, and Doctor was happy that Natalie was in England by her own choice. He was even more delighted to hear that she was engaged to be married, and that her fiance was in England as well.

She sent several dispatches back from London, and her enthusiasm for the English scene is apparent in her quotes for a New York Sunday Times article. She wrote:

The social life of the Hollywood colony in London is not without its excitement. The arrival of Irene Dunne and Joan Bennett on the Queen Mary threw London into a perfect turmoil...Irene went on to Paris to sojourn at the home of Eve Curie, daughter of the renowned discoverer of radium... Next week takes us to Ireland on location...then the entire color unit will prepare for the long voyage to the Far East with Alexander Korda for location work on Lawrence of Arabia.

...Your globe-trotting Technicolor scout,
Natalie M. Kalmus.

This civil arrangement broke down in 1943. It began with Doctor's discovery that Natalie had stolen some private correspondence from his locked briefcase in his study in Bel-Air. They were personal letters between him and a young lady he loved.

"He's pushing me out of my home!" Natalie exclaimed to anyone who would listen. She had an advantage--she knew that in the eyes of the world, they shared these residences.

Doctor's complex Yankee mind had accepted the compartmentalized nature of their arrangement, but Natalie was aware all along that many people assumed that she and Doctor were still married. Only those closest to Doctor--his friends and close professional associates--knew otherwise. He had long described himself as a divorced man.

Natalie threatened a suit. Doctor realized then that there would have to be an agreement in writing, legally witnessed, between him and Natalie. Eventually, in February, 1944, she signed an agreement, handwritten by Doctor, in which she acknowledged their 1922 divorce, accepted an impressive sum of money to cease her threats, and agreed to surrender to a Kalmus lawyer the four stolen love letters.

In a brief period of eight months, that small fortune was lost at the races. Natalie grew belligerent, threatened another suit, declaring that she had been pressured into signing the February agreement, that Herbert's lawyers had deceived her, and that she had not been represented by her own counsel.

One day she stormed into the Technicolor office of Dave Shattuck, the company treasurer, in a rage. In her hand she clutched the issue of Time magazine that announced the government's suit against Technicolor and Kodak. Natalie focused on one paragraph. "Just listen to this!" she said.

"Though the Kalmuses were divorced in 1921, Natalie's name still appears on all screen credits for Technicolor. She is credited with being a top color expert herself and was in charge of the Color Control Department, which advises directors on proper clothing colors, for years. One accepted story is that her abnormally sensitive eyes perceived colors no one else can."

"Yes?" asked Dave. "What's wrong with that?"

"I think it's pretty funny, that's what. It's all in the PAST TENSE! They make me sound like a has-been. I'm not going to stand for it."

Natalie's contract with Technicolor was to expire in 1948, and she could already sense Hollywood's has-been treatment. She hoped to force Doctor to renew her contract. And she had an ace.

George Lewis, Doctor's New York lawyer, had testified, "We tore up the letters, flushed them down the toilet in her New York hotel room, and I assume they are now in the East River." But Natalie had pulled another trick. She had withheld one of the letters, the most personal and heartfelt, the one that she described as the "nastiest" of all.

Doctor was greatly disturbed at her behavior and its effect on the personnel at the studios. He sought the services of one of America's outstanding divorce lawyers, Frank Belcher, known in Los Angeles as "Mr. Spring Street."

Doctor and his lawyers worked on an agreement which Natalie ultimately signed in February, 1945. Again she vowed that she and Doctor were indeed divorced and that, for another impressive sum, she would cease her threats on Doctor's life and character. None of the people on Doctor's team knew then that this agreement would trigger a sensational lawsuit that Natalie would

hurl at the company and Herbert Kalmus in 1948. Nor could they dream that it would take them another five years in the courts to vindicate the terms of this particular agreement. Their feeling then was that at last Natalie was satisfied; there would be peace. She would retire from the firm in 1948 when her contract ran out with a sizable pension, alimony for her lifetime, and a large cash settlement. They told themselves, "The storm is over."

One evening in 1945, I drove across Los Angeles to meet Margaret Ettinger, a noted public relations executive. Margaret knew everyone in Hollywood. She was Louella Parsons' niece, and they were close. As I drove through the blacked-out city toward the Players' Club on Sunset Boulevard, I could feel that the war was finally going to cease. I was fortunate to have gasoline for my trip; I had been recruited to train air hostesses in the Department of Aeronautics, and that entitled me to a precious ration.

As I pulled into the Players', I had my first taste of "in" treatment. The parking attendants were waiting for Miss Ettinger's guest. When one of them opened the Players' door for me, I glimpsed people dining, dancing, glamorously dressed--a contrast to the quiet, darkened streets. Margaret was waiting, and led me to her table, introducing me to dozens of people on the way. She was a striking woman, almost six feet tall, statuesque and graceful. She possessed a remarkable voice, so appealing that if you heard it once you never forgot it.

When we'd talked business and almost finished our dinner, she said, "One of my clients has invited us to drop by his home later. I've told him about you--about the column you write and the classes you teach. He's dying to meet you. He's in a festive mood. He told me he was enjoying the fragrance of jasmine and magnolias in his gardens, that he was celebrating release from a difficult personal matter as well as the approaching end of the war."

"Who is this mystery man?" I asked as we drove through the Bel-Air hills.

"He's the chairman of Technicolor. I am the company's public relations director. He pays me to keep his name OUT of the press!" She talked on, and I could tell she admired and respected this man

enormously.

"Here we are." Margaret drove through open gates and turned into a long avenue of cypress. I saw a tall white-haired, handsome man in the distance, a figure of solitude beside a white marble well. Impulsively, I said, "Margaret, that man waiting for us is the loneliest human I've ever laid eyes on. There's ice around him. Let's do something about him, shall we?"

"Good evening, Margaret," Doctor called out. "And how do you do, Miss King? I can't wait until tomorrow morning to read your column. I could use some charm. There are just two kinds of men in the world, you know: the charmers and poor hardworking grinds like me."

"Don't you believe it, Eleanore," Margaret laughed. "Doctor is the most dangerous ladies' man in Hollywood." Protesting, he invited us into the house for a drink, leading us through some of the largest, gloomiest rooms I had ever seen. There was, however, a gigantic, cheery fire burning in a huge marble fireplace. His butler, Charles, brought our drinks to the fire and we carried them with us to the gallery.

It was that evening that I first saw the Doctor's collection of paintings. He had just finished having them illuminated to his satisfaction, and he suggested that Margaret and I come and look at them in their new light. He escorted us across a beautiful courtyard to his theater gallery, which he called the projection room because it was there he gathered friends to see new movies and old favorites.

Walking down the hall, taking in one canvas after another, I was overwhelmed. I realized immediately that almost every painting was of a religious nature. And yet Margaret had earlier made a definite point of saying that Doctor was an agnostic!

As I walked with him from painting to painting, sometimes standing beside him to gaze at a detail, I could feel they were almost pulling him into the frame. When we approached the incomparable Bassano painting of Christ in His Passion with, in the foreground, Peter, James, son of Zebedee, and Young John sound asleep, as in the right background Roman soldiers are seen approaching with their flares, I found myself making the irrepressible response, "Can you not watch one hour with me?"

Doctor bent to catch my words. He seemed interested, and

asked me to explain what I had said. I realized he had not even a rudimentary religious training. But the story of the Mount of Olives interested him.

When we returned to the living room, Margaret and Doctor began to talk about the agreement that had recently been handed down in the government's antitrust trial that I was to learn more about later. But I was determined to keep my earlier word to Margaret and do something to lighten the atmosphere. "It's only three weeks until the seventeenth of March--almost time to celebrate Saint Patrick's Day," I announced.

I seated myself at the piano and played and sang several Irish songs, and to my surprise Doctor joined me on the bench and began to play along. "I grew up in an Irish neighborhood," he laughed. "A daughter in the family next door sang these same songs, Miss King."

"Eleanore, please."

On the way home, Margaret said, "Eleanore, he is smitten. I've known him many years and have seen him with many women. He is simply bowled over. Are you unattached?"

"Unattached? I've been divorced for three years, but I'm sort of waiting for handsome young engineer to come home form Europe."

Despite that, I found myself the following afternoon at the Hollywood Park Race Track, in Doctor's box, cheering along with him for the horses we had picked. Afterward, we had dinner at the brown derby. And the next morning, in typical Hollywood fashion, Margaret called to gossip.

"He said he'd had a delightful day, and was particularly impressed with the way everyone seems to warm to you, even the waiters at the Brown Derby. So I told him a bit about you--that you are an independent woman with a career and two daughters to raise, and about your gallant fight to help your child conquer polio. And I told Doctor that as you two walked side by side through his vast door, both tall, slender, elegant, I thought the gods could not have contrived a more beautiful couple. My dear, I hope this friendship brings nothing but happiness."

It did bring happiness. Over the next few years, Doctor was in Los Angeles only a few months each year. Then, he would call unexpectedly. We both enjoyed walking, golf, playing double piano. We liked to dine in quiet, out-of-the-way seaside restaurants, away from celebrities. I encouraged him to read to me from his favorite books. And I loved his stories about the early days of the cinema--I have been a movie buff always. Those times were like holidays in my busy life. Doctor was extremely wary of any commitment not solely his; as I learned about his earlier life, I understood the defenses he had built up. I respected his emotional timetable; and I liked him immensely.

Natalie's sixth sense where Doctor's women friends were concerned apparently failed her when it came to me. There were two reasons for this: first, there probably has never been a Hollywood romance more carefully concealed than ours; and second, Natalie was so busy unfurling a new sensational court case that she had no time for other intrigues.

Natalie filed suit in October 1948, thereby breaking her pledged silence of the legal agreement of February 1945. She sued both Technicolor and Herbert Kalmus for half the earnings of each, and demanded an accounting. Her grounds for this claim were as the rightful wife and employee. She claimed the 1921 divorce was a farce and that she was entitled to half of everything!

Natalie's lawyers dispelled any illusion that they might accept anything less than a partner's share. The hard core of their position is contained in the opening two paragraphs of their brief to the Court:

...the factual background of this controversy discloses that Appellant and Respondent have spent a lifetime together and through their association and common effort have built up the present outstanding Technicolor organization and in so doing have made Respondent a millionaire. Truly, they should be known as "Mr. and Mrs. Technicolor". Admittedly, they were married for almost twenty years and admittedly, so far as outward manifestations generally are concerned, their cohabitation changed in no material degree subsequent to their purported Massachusetts divorce in 1921. In fact, this living and working together for almost forty years in not denied by Dr. Kalmus. What he does deny is simply that subsequently to the purported divorce in 1921, he ever shared Mrs.

207

Kalmus' bed. Upon this slender basis he would strip from the deprived Mrs. Kalmus all of her marital rights, or their equivalent, in the fortune that he has thus accumulated with her by his side and through her aid.

All the anguish I sensed in Doctor through that fall and winter originated in his divorce fight. Then one day Frank Belcher telephoned: "We have good news; we've won a round."

After nine exhausting days in the Superior Court of Los Angeles, on December 10, 1948, Judge Elmer Doyle denied Natalie legal costs and fees "alimony pendente lite"--pending litigation. In addition, Judge Doyle issued an order that, during the waiting period, Natalie would be enjoined and restrained from "engaging in any course of conduct designed or intended to intimidate, humiliate, harass, vex or embarrass Herbert T. Kalmus, either in his private life or his relations with Technicolor."

She was also forbidden, in the language of the court, from "either in the presence of Herbert T. Kalmus or out of his presence, threatening to murder or kill or to do great bodily harm to him;" "Threatening to ruin or destroy Herbert T. Kalmus;" "Threatening to cause Herbert T. Kalmus to lose his job;" "Stating or claiming that Herbert T. Kalmus has attempted to ruin Natalie M. Kalmus or to destroy or defame her or to drag her in the gutter or to cause her to lose her position at Technicolor." These Court directives imply a vindictive state of affairs.

During the holidays, Natalie began to have lawyer trouble. On February 10, 1949, she appeared as her own council in pro per. And in fact, she was most effective. She announced that her attorneys had withdrawn because she was unable to provide the substantial funds they claimed were necessary to prosecute the appeal.

Being denied legal fees and costs intensified Natalie's fight. In her deposition, covering more than two thousand pages of transcript, she gave specific instances over the years when she and Doctor cohabited, in their homes and while traveling. As proof, she produced 219 exhibits and fifty-nine witnesses.

One by one, Frank Belcher relentlessly cross-examined each witness. A domestic legal battle unfolded that every law student in America studied. The fierce battle of Kalmus vs. Kalmus raged for five years. Each contestant fought every step of the way.

At one point--May 1949--Natalie sought postponement of the case, claiming that she had suffered an acute gallstone attack and had been taken unconscious to Massachusetts General Hospital, where she remained for three weeks. She would be unable to attend the trial and testify in her own behalf--a postponement that would affect the Doctor's case adversely.

When she was hospitalized for a second time, Frank Belcher assigned two detectives to trail her, one in New York and the other in Boston. On the days when she was supposedly too ill to appear in court, the reports attest that she was attending the races. She walked with her customary vigor and pushed her way successfully through the crowds in the subway and at the race tracks. She did later, however, check into Massachusetts General where, Court records show, "The Hospital physician stated: 'The history as given indicates a personality which is likely to complain out of proportion to the existence of actual medical disease. The patient is said to have gained weight from late 1947 and maintained a weight of 120 pounds despite the claim of vomiting which is said to occur almost daily for the past five to six months...it is difficult to say how much of her trouble was functional and how much organic...patient insisted on leaving the hospital on May 3."

Despite this light thrown on her veracity, Belcher was not able to shake her claim that she and Doctor had reconciled "a few days" after the divorce decree was final. Why had she not clarified her status at that time? the Court asked. According to Natalie, there had been no reason for her to take any action, as Doctor had assured her "It would not be necessary for me to consult with my attorneys as he would take care of it--he would have his attorneys prevent the divorce decree from being final." Natalie was claiming that, as far as she knew, she had actually still been married all those years!

"But then why did you accept the financial settlement involved in the agreement? Why did you continue to accept alimony checks from Dr. Kalmus each month for twenty-six years if you thought you were still married to him?"

But Natalie clung to her story.

Belcher made a brilliant move: he secured a postponement of the Massachusetts hearing until after the case was tried in the California court. As the fight continued into the spring, Belcher

won round after round through every court including the California Supreme Court. Doctor began to breathe a little easier; he even lost a nervous tic he had developed under the stress of the court case.

I knew little of what was going on at the time; the monopoly suit and the "divorce" case were heavy burdens that Doctor bore almost alone. I saw him from time to time; I thought of him often. My work took me to Hawaii, when I had press accommodations on the first sailing of the Lureline after the war. I thought of him in Hawaii in 1947, and in Ketchikan, Alaska, in October 1948, I thought of him as I sat with friends in a nightclub, listening to the words of a song.

"For it's a long, long time from May to December,
And the days grow short as you reach September..."

As I listened, the difference in our ages became completely unimportant to me.

No sooner was I home than Margaret Ettinger asked me to come round to a dinner party. Doctor was expected. She met me at her door, apologizing, "He's been detained at the Cape." I was acutely disappointed and must have shown it because she told me later, "That was the first time I realized you really cared."

I didn't hear from Doctor until Thanksgiving morning when he called. "I'd like to walk through the garden with you."

Leaving our twenty-six pound turkey to my sisters, I drove to Bel-Air with a light heart. We had our walk in the garden, and two hours later, returning home with my car full of Doctor's hothouse orchids, I felt a quiet certainty that my life would be bound up with his. For as I thanked him for the flowers in the courtyard where I had first seen him, I paused and put my hands in his. With no preamble at all, thankful that we had found each other, we said the Lord's Prayer together on that enchanted Thanksgiving Day.

We saw each other often during the next months. His long black limousine, parked discreetly some distance from my classrooms, became a familiar sight to my students.

We were to be married September 16, 1949. Knowing my feelings, Doctor had patiently petitioned the Los Angeles Roman Catholic Dioceses to be married in the Church. Because he was

over sixty-five, Doctor could take advantage of the Pauline Privilege, but he had to prove that he had never been baptized.

The Church cautioned absolute silence about our plans--that meant, in Hollywood, not allowing Hedda Hopper or Louella Parsons or their informers to see us together. Fortunately, I lived in old-fashioned Lafayette Square, fifteen minutes south of Hollywood but light years away from the spotlight.

By August there were blue skies ahead. The petition to the Church would go through. I sold my house, resigned my teaching job at the University of Southern California, and canceled the coming season's personal appearances.

I had not once thought of Natalie.

Suddenly, on Saturday afternoon of the Labor Day weekend, Natalie...erupted. That is the only way I can describe it. She had been completely unaware of Herbert's approaching marriage and had learned of our plans only when she was served with a routine paper by the Boston Diocese, asking for a simple signature by return mail signifying the date of their marriage, 1903, and attesting that she was a baptized Christian and that Herbert was not. Instead, she flew to Hollywood and demanded an audience with the Los Angeles Roman Catholic Chancery Court.

Natalie Kalmus proved herself one of the actresses of our time. She had rehearsed her role enough--during her depositions and court appearances--and she had her part down pat: a vulnerable, defenseless woman wronged by an evil man.

She hammered away at the fact that Doctor's approaching marriage would not be recognized in Massachusetts because of her pending action to vacate the 1921 divorce. She portrayed vividly for the Chancery members the resultant scandal for the Church if they allowed this marriage to proceed. And she threatened national press coverage of her story!

At noon that day, Doctor and I had been asked to expect a telephone call around five o'clock. We jubilantly anticipated the great news. It is hard to describe the shock, astonishment and disbelief at Monsignor Blackwell's words.

"I'm sorry Eleanore. Wait six months. Natalie made a tremendous impression on everyone. You are all so prominent, so--well, headline prone. Can't you wait six months...?"

An hour later Mary, my older sister and my godmother as well,

telephoned Monsignor. She informed him that the family could not tolerate the scandal of Natalie's threats. She explained my position to him--that I had sold my house and resigned my professional duties. She told him that we would be married in a civil ceremony when Court opened Tuesday at eight o'clock. And she added, "We are not going to allow an embittered woman to destroy two valuable lives. My little sister has a lot of happiness due here."

Doctor was warmed by my sister's prompt action. "What did Monsignor say, Mary?"

"He asked me twice, in amazement, 'What kind of a clan are the Brodies and the Reillys?'"

Doctor laughed and took me into his arms, and we waltzed around the living room. We had promised Monsignor we wouldn't be bitter. We understood the situation. It was the chance we had taken. Doctor had said to him, before hanging up the telephone, "It seems, Monsignor, we've all forgotten one thing. Eleanore and I are hopelessly in love, and we've waited so long...."

We had one day to prepare for the marriage that Natalie thought she had scotched.

This world has never presented a happier or more handsome bridegroom than Doctor as he walked to my front door at 7:10 a.m. on the morning of September 6, his wedding day. He was wearing oyster-white linen, and he shone. His tie--Technicolor blue--was for luck, he said. Diane and Cammie were charming and somehow grown-up in their "afternoon" dresses. And I wore a aqua silk serge suit with a small brimless hat of tiny aqua iridescent shells covered with a small aqua tulle veil. It was what I had planned to wear on my last day of class, but the rushed ceremony made it impossible to wear the Adrian sapphire blue silk dress and matching hat by Rex that were on order.

I don't even remember the drive to City Hall. The civil service was swift and efficient. My daughter Diane was my witness, and Bob Riley stood by Doctor. Margaret Ettinger was there with the press.

Anyone looking in on our wedding breakfast at Perino's would have thought that the sixty guests had gone loony--everyone had the air of walking about four inches off the floor! My assistant, Wilma McClennan, said to me, "I never saw so many good-looking men in my life!" referring to Doctor's Technicolor associates.

Perino smiled as we slipped away early. Doctor led me a few doors south on Wilshire to Howes', here we chose a wedding ring--we'd borrowed Bob Riley's for the ceremony. A wide platinum bracelet set with diamonds caught my eye; my new husband snapped it around my wrist. It dazzled me twenty minutes later at home as I typed my last deadline from Lafayette Square. I had so much to do before Doctor called for me at my little house for the last time. We would leave by train for the Cape, and spend our first weeks together there. Then Diane and Cammie would meet us in New York and we would all sail for Europe.

The long secluded trip across country was golden. The Cape, when we reached it, was deserted, and we had it to ourselves. We circled the dark, quiet streets of the village, watched the coastline from a tiny fishing boat, walked for hours on the beach. I wore a long scarlet duvetyn coat with a hood. I thought, "This is Charlotte Bronte country," except that instead of moors we had winds carrying the fragrance of cranberries. It was what all honeymoons should be.

Our hurried civil service marriage caught Natalie off guard. Somehow she had thought we would have to wait. Her rage exploded in sensational press releases on front pages of newspapers around the country. Evidently, "Mr. Technicolor's" romance was news. She stormed, she wept. Three weeks after our marriage, she filed a motion in Los Angeles to set aside the California State Supreme Court decision of June 1 on the grounds that it had been a obtained through mistake, inadvertence, surprise and excusable negligence. Oh, the papers were full of it.

When we arrived in New York from the Cape, the desk clerk at the Waldorf whispered to me, "If she can't have him, no other woman will!" But we felt it was all far, far away. We were still looking down on earthly creatures from a very, very high pink cloud. Even when the maid said, "Hedda Hopper's down the hall--she asked me if that's all your own hair!" I just laughed, and told myself that life in a fishbowl had begun.

We sailed on the Queen Mary on October 14. It was Doctor's first vacation ever!

The English countryside was beautiful, even in winter, as we drove from Southampton to London. But as we entered the city, I saw the impact of the Blitz. It had been four and a half years, and

London was immaculate--because the empty spaces were cleaned up; homes were blank spaces, whole blocks were gone. In the vicinity of the war plants, there were miles of what must have been row houses; the Germans obviously wanted to destroy London, and they had blitzed it inhumanely.

I had read every word about the war in four daily papers and three weekly magazines. I thought I understood. I didn't. I had admired the English people throughout the war. But after forty-five minutes in their country, my heart was completely theirs.

We stayed at the Dorchester, in a suite that overlooked the chimney pots of London. From there, Diane and Cammie and I explored the city--but we were always back for tea! An inveterate gourmet, Doctor found an enchanting place in London to dine--the Caprice. And once a week, we walked to Cunningham's Oyster Bar, where they remembered Doctor from 1937.

The Technicolor people were warm, sincere and hospitable. The roof of the Technicolor plant held anti-aircraft weapons, and all Technicolor personnel helped to defend London from that roof. And like the American company, they made training and war propaganda films as well as precision instruments for the air force.

"Someday London will seem like a second home to you," Doctor promised me, "and you will love it as I do."

After London, we took the boat to Paris, where the use of the largest Cadillac in Europe--with driver--was the wedding gift of the London office. We embraced Paris, the Loire Valley, Rome, Capri and Monte Carlo and the girls went to ski with friends at Davos. We sailed for home in mid January, and in February were back in Los Angeles. Hyacinths were coming into bloom in our Bel-Air garden.

CHAPTER SIXTEEN

On Angel Wings
Notes by Eleanore King Kalmus - Part Two

My new life proved interesting. I was getting to know my new husband. I was beginning to be a hostess, and loved mixing my old friends with Doctor's industry people. There was a staff of twenty-five to help with the demands of Technicolor entertaining--I administered it all like a master accountant. I put a few silver streaks in my hair, to minimize the difference in our ages, and found that I liked the effect. I continued to write.

The accumulation of money was never one of Doctor's principal aims. This became apparent to me early in our relationship. Before our marriage, he carefully explained his finances. Almost apologetically, holding my hand, he said, "Darling, if I had ever imagined I would marry again, I would have done things so differently. I would have sharpened my pencil." I connected his words with a story he told me about Eversley Childs, who years ago had said to him, "Young man, you can make millions with your Technicolor."

"But Eversley, I have enough," Doctor had replied.

Childs looked at him skeptically.

"I'm worth about two million dollars, and my salary is two-thirds the size of L.B. Mayer's, which is the highest in Hollywood. I believe he's in the top five in America this year."

"Chickenfeed," returned Eversley.

But it was accomplishing his dream that was important. Technicolor had to become commercially successful in order to accomplish its ends; but beyond that, Doctor sincerely felt that he had "enough."

I was rather pleased than not, because I wanted to continue writing my newspaper column, which meant a lot to me in financial and personal satisfaction.

We went to the races together. Our driver would pick up a racing form for us the night before each race. After dinner, Doctor would invite me into his study--called the Tower, because of its height and octagonal shape--and quickly run through each race,

215

handicapping as he went. I learned a lot from him and enjoyed the spectacle--the crowd, the flowers, the brilliance of the day, and the Doctor's pleasure when he won.

Santa Anita meets during California's winter months. We attended two or three afternoons a week sometimes with the "think tank"--Doctor's Technicolor pals. We ran into Eddie Soule, Doctor's early mentor. Doctor rarely made a bet without saying, "I wonder which way Eddie is betting?" And Lou Wasserman, later Chairman of the Board of Universal Studios, would huddle with Doctor until nearly post time. Doctor always funded me before the first race and later handed over my winnings, which went into an old-fashioned knit "money sock" friends had given me. Doctor would teases, "Everything goes into Muzza's sock--nothing comes out!"

One evening at a small dinner party, I heard Doctor behind me asking for his driver and car. I whirled around. It was Danny Kaye, imitating Doctor's elegant New England cadence exactly. Danny laughed at me, delighted to have taken me in. "His voice has always intrigued me. Eleanore, you have made my evening!" I have one perfect recording of him speaking--just one. I remember his voice so well--his remarkable diction, enunciation and vocabulary, all with a Boston flavor.

He was a courtly man. His formality, instead of putting people off, endeared him to them. And he was the same to everyone. In our household, he stood whenever a female staff member entered his study. When my devoted personal maid, Takoka Nomi, introduced Doctor to her mother, his graciousness and charm stayed with her forever. And younger generations were never put off by his seniority; when my daughters first introduced him to their friends, the word passed around: "He's a perfect darling!" And he was.

We were absorbed by the garden and greenhouse. "Enjoy the flowers," said Doctor. "In three months we'll be off to Europe and then the Cape until November."

"The girls can't miss another semester of school!"

"Let them finish and then join us at the Cape. It will be their first visit."

Those three months at home were a sort of ecstatic bedlam. I lost track of the time of day and the day of the week--and I had

been a time-and-motion graduate! I found myself wondering where my standards of efficiency had gone--and then I found myself thinking what a strange standard efficiency was! Happiness had quite gone to my head.

First, as he left for work, Doctor would bring an oberon blossom--the one I picked from his prize tree every night and left by his toothbrush--to me to stick in his jacket, like a boutonniere. Then it would be ten o'clock, and then after lunch, and it seemed that a few minutes later I would hear Doctor's horn at the bottom of the hill--which meant it was seven-thirty! I'd dash into one of my new smashing Dior hostess gowns, buttoning it as I flew down all sixty-two stairs, just making the front door before he did, with hopefully a little of my eight a.m. makeup still in place.

Life at Bel-Air was like being shaken up in a big box--and happily contributing to the shaking! I've lived and worked in many places, but nowhere else is the pace the same. I'm sure that this intensity is responsible for much Hollywood tragedy.

Happiness attracts. Ours was contagious. We celebrated our life together, and the whole town celebrated with us. There were rounds of parties, and it seemed that everyone in Hollywood came to Sienna Way for dinner and a movie.

This quickly assumed a ritual aspect. The Technicolor film rolled at exactly 9:15. Only Doctor and I had set places in the theater--he at the controls, I beside him. Guests sat wherever they like, the household if they were not busy elsewhere fitted themselves in, and my daughters managed to squeeze in with a few of their buddies. We were a great collection of movie buffs.

Our lives, too, took on a pattern: six months on Siena Way, followed by six months spent between New York, Boston, England and Europe, with as much time as possible spent at Fernwood on the Cape. And, following each business trip abroad, Doctor treated me to two weeks alone with him in a spot of my choosing--Spain, Portugal, the Rhine, Holland, Belgium.

Does it sound like a dream? Perhaps it was, for we had a rude awakening. In late 1951 I was alarmed by signs of emotional stress in Doctor; he developed a quick jerk of the head, to the right and back again, that frightened me. His recurring nightmare--that Technicolor film was going up in a great conflagration--returned.

I called Margaret. "I haven't seen him like this before," I

worried. "What is going on?"

The answer was Natalie.

Natalie had wisely left Hollywood after our marriage. Ruling out a has-been role, she returned to Boston--and no city on earth is less "Hollywood" than Boston.

There, she kept her lawyers busy. She must have had enormous stamina to withstand her repeated court disappointments. Her petition for Hearing of the California judgement and decree had been denied on May 8. On June 11, her petition was denied by the California Supreme Court. And the decision she was waiting for, on her petition to the Supreme Court of the United States for a writ of certiorari asking for more speedy justice or that errors or irregularities be corrected, was denied in January 1952.

Natalie had arranged that each court appearance was covered by the press as the scandalous charges were reviewed. Now she was placing all her bets on the Commonwealth Courts. This was to be the culmination of her campaign, and she was prepared. Her day in court came on a beautiful spring day in Boston, May 12, 1952.

Natalie lost. The Justice of the Superior Court dismissed Natalie's petition. He ruled that the California Judgment was entitled to full faith and credit and that the parties were divorced by a valid decree.

Doctor had no joy in his victory. As his counsel congratulated him, he watched Natalie exit the courtroom and knew that the beautiful, enraged woman would not give up. And indeed, only seventeen days later that determined woman appealed the Massachusetts Superior Court's decision.

It seemed there would be no end to the suit and the toll it took on Doctor's nerves. Her strategy was clever and dangerous. Only Doctor's ability to compartmentalize his thinking kept him balanced during the long years of Natalie's relentless persecution, from the fall of 1944 when she began until the summer of 1953, when it was all over.

As long as Doctor was thinking about Technicolor, about the races, about bridge, entertaining, golf, and household matters, he was almost the happy man I had married. But the strain was making inroads. And it seemed that every time we relaxed, Natalie's new team of lawyers made an all-out attack, skillfully hurling words that made newspaper headlines.

After months of hearings and the harassing flow of documents from Natalie, we received a tremendous shock. Justice J. C. Wilkins in Massachusetts issued a summary of his findings: "According to our view, the California decision did not take the position contended for, and we do not reach this question. We are of the opinion that the plea should not have been sustained. Exceptions dismissed. Decree reversed."

"Does this mean," I quavered, "that she has won?"

The Court decision permitted Natalie to file her exceptions. the case would have to go to trial again. She had kept the enemy open and bleeding.

The outside world saw only Doctor's usual dynamic self. His family and his team at Technicolor knew better. There were weeks when nothing seemed to help. He worked, tended his garden, entertained, but he bled. I counted it a good night when he got more than two or three hours' sleep.

The Yankee traders on both sides began their prebattle skirmishes. Natalie had employed Jonathan Sears as her counsel, a lawyer with a reputation for cementing deals. He was a Gary Cooper cowboy in Ivy League get-up, tall lankly, likable on sight. One day, with his usual understated casualness, he dropped by unannounced on Sumner Babcock, Doctor's distinguished Boston counsel. Two of the ablest lawyers alive came face to face.

Sears didn't sit down. He didn't remove his hat. "Hi, Sumner," he drawled. "I have only a minute, so I might as well jump right in and give you the bad news.

"Natalie wants her alimony doubled. Instead of $7,500, she wants $15,000--and wants that payable for the duration of her life, not his.

"and she wants a lump sum payment of $125,000. You know, Sumner, it ought to be worth that to Kalmus to get rid of that woman...."

"Doctor will never pay that," Sumner Babcock said with stiff formality. "Of course I'll talk with Kalmus and his counsel, Belcher. But I warn you, they may throw up their hands and reject everything."

Sears paused in Babcock's door and turned. In a confidential tone he tossed off his parting words: "You'll never put Doctor Kalmus on the witness stand."

When this scene was repeated to Doctor, he asked, "Was he trying to frighten me or was he merely fishing for information?"

Doctor talked to his California lawyers and called Babcock from the Cape, where I could listen. "Sumner, I've talked with Frank Belcher and George Cohen in California. They both think Sears' performance shows he doesn't like his case and that he would accept much better terms than his present offer indicates.

"You and Belcher have made the point that Sears and Natalie are several years away form getting a dime--and in the end might not get much of anything. They realize this.

"But, by the same token, I am several years away from being free of this problem and having peace of mind. It's Belcher's opinion that their case is worthless. Suppose we call their chances in court zero. I still would pay a considerable sum to be rid of her ability to sue any time down the road. Any settlement we would make would accomplish that, wouldn't it?" As I listened, I realized that Doctor was closing in on the problem.

"Let's make a counteroffer of the additional alimony plus a lump sum of $50,000. What do you think their reaction would be? Even if we wind up at $75,000, I would be satisfied to settle. How can we reach that point, Sumner?"

They talked on, making arrangements. Then Doctor said, "So far we have talked about what we are going to give them. What are they going to give us? We're dealing with a woman who's as changeable as a weathervane. I'd like to talk guarantees."

Later that evening, George Cohen advised the Doctor from Los Angeles: "Allow the alimony increase but only until your death. If you're willing to double her alimony, she should be willing to take less cash."

When Babcock took the counteroffer to Sears, the man smiled. "I have closed many deals that started farther apart than that. Tell Doctor it might work...."

Sears gave Natalie the facts, with no embellishment. When she balked at accepting less than $100,000 as a cash settlement, Sears suggested, "You could get yourself another lawyer."

Natalie wavered. She respected Sears and knew she was fortunate he had taken her case. "How much less?" she asked.

"I think I can get ninety thousand. That's a handsome sum. You have your pension from Technicolor, $11,000 a year. With

your alimony upped to $15,000, and the interest from the cash settlement...at your age, I hope I'll have as much."

Natalie looked at him for a long time before she spoke. "When do we sign.?"

Sears smiled. Natalie smiled. It was done.

When Sears delivered his news the next morning in Boston, Doctor jumped up from his chair and strode back and forth. "I'll be damned. Are you positive she won't change her mind and start all over again?"

She didn't. Six days later Doctor and Sears met on the little railway platform of Buzzards Bay on Cape Cod. The two men signed and exchanged papers in twenty minutes, with the precision and formality of a major peace treaty. Then Sears ran to catch the train to Boston and Doctor returned to the automobile where I was waiting. As he approached, I ran to meet him as though he were returning from war.

Natalie did not appear in court for one of the most important events of her life: the final signoff petition. There was no press; no coverage.

Doctor's freedom transformed him. He had the energy of a thirty year old. He returned with joy to his work, and tripled Technicolor's income in the following years. One evening Doctor mused out loud about his early marriage: "This is 1953. I met Natalie in 1901. So for some fifty years, I've had her like a weight around my neck. In down-home, New England idiom, she was the cow who gives milk and then kicks over the pail. I often thought if I'd had women in my family--mother, sisters--I might have met and married a different kind of girl.... But then, if the average man would admit it, the woman he would marry at forty wouldn't be the girl he chose at twenty."

I learned, long after the battle was over, that Natalie felt herself the victor in the end. She had fought continuously for nine years, and in her own words, "I finally shellacked the mean old sonofabitch at his own game." She gloated only in private to her racetrack friends; the contract had stipulated silence.

Natalie outlived Doctor by two years and was buried in her family plot in the Centerville cemetery on the Cape.

In 1962, Doctor and I attended the celebration of Samuel Goldwyn's eightieth birthday--and his fiftieth year in the motion picture industry. It was a gala affair at the Beverly Hilton Hotel. Doctor's friend George Jessel was toastmaster, and there were jokes and tributes and reminiscences from Bob Hope, Jack Benny, Frank Sinatra, Jimmy Stewart and others. A great deal of the history of Hollywood was represented there that night. But all through that scintillating evening, and the well-deserved tributes to Goldwyn, I was deeply sad for the gallant genius sitting beside me whom Hollywood never honored with a dinner, a tribute, a memorial. He, too, had served the industry for fifty years, as faithfully and as productively as any; but it was his modest and unassuming way to shrink from the spotlight.

He wouldn't have wanted a better testimonial than one I read recently in the Hollywood Reporter. Robert Osborne, writing of his experiences at the Deauville film festival, mentioned his pleasure at the retrospectives, which, he declared, being shown in Technicolor prints,

"unexpectedly paid homage as much to the glories of three-strip Technicolor as to the filmmakers involved. In fact, it has been worth anyone's trip to France just to see the vivid colors (in their original intensity) splashed on the screen by Rouben Mamoulian in his richly Technicolored 1941 version of Blood and Sand, *shown as part of the retrospective of Rita Hayworth films. The same can be said for RKO's 1947* Sinbad the Sailor, *shown during the Douglas Fairbanks Jr. homage, also exhibited in a three-strip Technicolor print, and--like* Blood and Sand--*ablaze with undiluted color. By contrast, films such as MGM's 1952* Scaramouche *and the same year's* Prisoner of Zenda *have had to be shown in faded Eastmancolor and/or Metrocolor prints, robbing the features of much of their splendor (and, indeed, much of their reason for existence)."*

With good reason, Doctor relentlessly opposed the tendency of his famous trademark to evolve into a common word in our vocabulary, spelled with a small "t." The word he coined had to have a

capital "T"--Technicolor! The tendency for a proper word to slip into common use is irresistible, however, and reflects the propensity of the world to take for granted the appearance on the screen of natural color. Audiences that have become accustomed to color rarely realize how it enhances their pleasure. When the great stars write their autobiographies they never mention the effect of color on their careers. Betty Grable had made twenty-seven films before she appeared in Technicolor, but it was as if the public had never seen her until then. The motion picture industry itself seems unaware of Doctor's contribution. We hear again and again of the advent of sound. But for Technicolor, which preceded sound, there have been no histories.

I keep two television sets, one color and one black-and-white. Often, just before a favorite program, I turn the first set on for a moment or two. Then I turn to the color set. This little ritual protects me from the amnesia of forgetting the magic and the wonder of color.

<div align="center">***</div>

The French plant was one of his few failures. I never saw him work harder, but Technicolor closed its doors in Paris.

But his Italian venture was successful, and I enjoyed a ringside seat. I watched Doctor and Giovanni Agnelli (he never used his ancient title of "Prince") pursue their discussion in the beautiful round living room of our suite in the Excelsior in Rome. I listened to these two industrial giants pick their way diplomatically over points of business. They made their deal within an hour, and it jelled almost miraculously.

Soon after, Doctor invited me to join him on a drive into the Italian countryside. I knew his purpose: he was looking for a location for the plant somewhere near Rome. We drove through the ancient landscape, when suddenly Doctor glimpsed what appeared to be a medieval convent in the distance. He asked the driver to turn off the main road onto the narrow one leading to the convent. There, we got out and walked. When we had covered about a mile, Doctor said, "Here. Here's a spring. Isn't it lovely? Running water is good luck. We'll put the plant here."

And he did.

Two years later, when the plant was ready to open, we were in Rome again, this time because there was an operating problem in the processing. For some reason, the film coming off the two print machines was a hairbreadth out of balance. Doctor spent fourteen consecutive hours with the engineers, the technicians, and even the architects of the magnificent new building, trying to locate the source of the problem.

Finally--after walking back and forth "like a lion," according to the Italian executive--Doctor called the engineers forward and asked them why the two print machines were not spaced as the blueprints indicated. The engineers, mystified, produced the designer, who explained.

"Ah, yes! I rearrange them so that they would be symmetrical. they look so much better that way!"

Directing the engineers to reposition the print machines, Doctor walked all the way home to the Excelsior laughing to himself. "They're not symmetrical!"

It was Doctor's way, all his life, to solve problems himself.

Since we were in New York several weeks a year, Doctor wanted to find permanent accommodations in the city. He had outgrown the suite in the Waldorf towers, and thought the Plaza would be suitable, but his agents reported after several months that they could not get what he wanted.

One Sunday, Doctor walked me up to the desk of the Plaza, introduced himself and described exactly what he wanted to the reservation clerk. In twenty minutes, he had an L-shaped apartment, newly decorated in shades of coral, on the 14th floor. It had a foyer, a living room and a trunk room, two bathrooms--one facing Fifth Avenue and one on the park, where we could see skaters on the rink and hear the animals in the zoo at mealtime. The suite had belonged to the late Huntington Hartford. It was sometimes uncanny the way Doctor could find exactly what he wanted.

Another time, Doctor had lost the head gardener at Fernbrook. Several months passed, while Doctor's agents reported no prospects for a replacement. Then, on our way to play golf, we detoured into the beautiful grounds of a nearby estate. Doctor introduced himself to the head gardener, and in about ten minutes the two of them had come to terms. The man was at Fernbrook for years.

Soon after he had won his domestic suit against Natalie, Doctor resumed his petition to marry me in the Church, a step which Natalie had prevented in 1949. But this time there was a difference.

One evening at the Cape--one of those long northern summer evenings, when the light had lingered over the cranberry bogs--I sat listening to Doctor play some of his Bach favorites. Suddenly he stopped and turned to me, taking my hands in his, and said, "Eleanore, I want to become a Catholic--to be converted."

Happy as I was in our life, Doctor knew me too well not to realize how disappointed I had been to marry in a civil service. I had tried to keep my grief from him. At the same time, I knew how sensitive he had been, as a young boy, to his father's intolerance for his grandmother's religion. And yet, how tenaciously, through all that was to happen to him, he clung to the Lord's Prayer, which his grandmother had taught him.

"Darling, you aren't becoming Catholic for my sake?"

"Never. That would be impossible. This is my own heartfelt wish."

I was surprised, but I knew he had always been interested in the Church and never failed to attend Mass with me wherever our travels took us. He was as moved at our visit to Fatima in Portugal as I. I knew that his childhood, in a nonreligious home, had left him with a feeling of loss. And knowing him, I knew the depth of his yearning and decision.

My joy during the following months has had few parallels in my life. We were to be in New York, so I telephoned my friend Irene Dunne in Los Angeles and asked her to introduce Doctor to Bishop Fulton Sheen. Because of their heavy schedules, the two met evenings in our apartment at the Plaza.

They went at it with vigor. There were long, intense arguments, lasting until the small hours of the morning. Once, I caught a glimpse of Bishop Sheen, who was only about five feet two inches, standing close to the Doctor's six-foot-three, looking up and shaking his fist in Doctor's face, shouting, "I will talk logic with you until you talk faith with me!"

After the Bishop left each evening, Doctor seemed refreshed, in spite of the intense arguments. Finally, Doctor came to me one

evening, smiling. "Darling, is it too late for champagne?" I understood that his conversion would be accepted.

Bishop Sheen suggested that when we returned home, Doctor should confer with a priest for a thorough review of Catholicism, that he resubmit his petition to be married in the Church, and that we keep our hopes in strictest silence. Our hearts were full of happiness as we headed for California.

Doctor sought out Father Augustine Murray of St. Martin of Tours. His choice surprised and pleased me; Doctor did not know Father Murray very well, but for a year I had consulted Father every Thursday, and that hour gave me the consolidation and strength to go through the last difficult year of Natalie's court case.

The time Doctor and I spent in Father Murray's study retains the glow of a precious jewel. Doctor was an eager student, embracing each step. I began to fathom how very, very long he had been seeking his Creator.

Still, I was unprepared for the telephone call that came on Easter Monday.

"Is this Mrs. Herbert T. Kalmus?"

I assured the caller that I was.

"This is the Chancery Office calling to tell you that your Dispensation has arrived from Rome."

"Would you--oh, sir, would you mind repeating that ?"

He did.

"You mean, we can be married in the Church?"

"Well, isn't that what this has been all about?"

"WHEN?"

"As soon as you like."

I couldn't wait to call Doctor. He said that he would call Father Murray and we'd be married as soon as I could dash over to the Chancery Office and sign the papers. I hurriedly called Irene Dunne to see if she and her husband Frank Griffin would be our witnesses--yes!--and I dashed off in just what I'd been wearing when I answered the phone, a French blue Pierre Balmain suit, no jewelry, no hat, flat shoes. It seemed that our second wedding was to be as hectic as our first--but this time we were rushing toward a happier ceremony. At any rate, that was my wedding outfit an hour and a half later when we were married--truly married, at last.

We took off for a mini-honeymoon in Las Vegas, where the highlight of that glorious weekend was going to Mass together and taking communion with the rest of the parish. How I had suffered these past years, feeling him pounding in my heart, and not among those to receive the Eucharist.

Then the beautiful years began at the house on Sienna Way. Doctor enjoyed Diane and Cammie and their friends, and planned one happy occasion after another for them: dinner dances, engagement parties, wedding feasts--and no grandfather was more ecstatic than when the new generation began to come along.

Throughout our marriage, Doctor was a thoughtful, tender, appreciative and generous lover. He filled our home with flowers: rubrum lilies; every sort of rose; sweet violets. He grew a handsome hedge of oberon, a flower that is the smallest orchid in the world. I placed one in his buttonhole every morning as he left me with a kiss.

I had encouraged Doctor for several years to retire, but I wasn't prepared for it when it happened. Perhaps he wasn't either. He said to me on the evening of his resignation, "Dear, I gave a lot of thought to fighting this. If I had, I would have beat them. But I have many things to do these last few years."

He went on, speaking his thoughts aloud. "Sometimes I feel that if I had poured the money, effort and research into any other project--the fight against cancer for example--I might have found a cure. I am convinced that's what it takes: one person, directly in charge of research and finance, staying with it until it is licked."

The evening after it was definite that he had relinquished control of Technicolor, Doctor called from the courtyard as I stood waiting for him at the door. With outstretched arms he proclaimed, "For forty eight years I've been the Father of Technicolor--forty eight years!" We embraced and kissed, and I felt the vigor with which he faced this new existence.

For he was just as busy as ever. He began the manuscript of his autobiography. He watched the stock market. When we breakfasted at eight in the Tower, he had already been dealing with his stockbroker in New York for three hours. Often his masseuse or tailor had a morning appointment. He went to his new offices at Technicolor around ten and was rarely home before seven unless we had plans for the races or golf. We entertained, but no

longer for business reasons, and enjoyed sharing our movie eve-
nings with friends and family.

Doctor's faith seemed to help him shed his anxieties. He slept
soundly; the old nightmares went away, and the usual problems of
the day failed to upset him as they used to do. Sundays, especially,
were fair; they were family days, shared with Diane and her
husband Terry Mullin and their children and Cammie and her
husband, Ned Pollack, and their baby. We had been to ten o'clock
mass at St. Martin's of Tours--Doctor, in his regular third front
row, knew every word. After lunch on the terrace, we were off to
play golf--Doctor playing only nine holes, but putting great zest
and fun into it. After dinner, we played bridge or ran a film; happy,
carefree evenings.

In 1961, doctor and I made a trip to Japan and Hong Kong. He
loved the Far East and kept saying, "The world should see more of
this in color." He did, however, have difficulty folding his great
height onto a Japanese mat.

The following year we accepted Cardinal Spellman's invita-
tion to spend a month at Fernbrook. Doctor had sold the Cape
house to the Cardinal two years before. We were overjoyed to find
it much as we had left it, with its Persian rugs and the ancient
grandfather clock on the landing. We gloried once more in the
brilliant red of the leaves and the crisp October sun. I did wonder
why Doctor insisted that the Cardinal's housekeeper pay for every
grocery and liquor bill from the Cardinal's household accounts--
Doctor had always been so generous! After he was gone, I found out
that he was just being his old practical self--for the State of
Massachusetts said that we must pay taxes on Fernbrook inas-
much as we had retained "visitation rights." Those receipts showed
that we were strictly guests.

On July 2, 1963, I mention to Doctor that I had an appoint-
ment for a checkup with our internist, John Eagan, who was Chief
of Staff at St. John's Hospital in Santa Monica. Afterward, I
thought I might drop by to see Diane and the children.

Doctor surprised me by saying, "I think I'll go along too.
Eagan can take a look at me. I feel all washed up."

In the courtyard, he volunteered, "I'll drive with you,
Eleanore." I sensed that something was wrong because he never
ever called me "Eleanore," but always an endearment; and he

always preferred his own driver to my style of driving. Flattered and happy to have his company, I drove with Doctor sitting beside me, following Joseph in Doctor's car, who would bring him back.

When we stopped in front of the doctor's office about seven minutes later, Doctor suddenly lurched to one side and his face whitened. Joseph rushed to his side, and I ran to find Dr. Eagan; John said he knew as soon as heard my footsteps that it was I and that something had happened to Doctor.

"We'll take him home," John Eagan said.

The three of us got him settled and he seemed relieved to find himself in familiar surroundings. John told me he had suffered a stroke which left him paralyzed on the left side and completely speechless.

He never left his bed. He knew me, and always acknowledged my presence by some slight movement. At night, he would look at my hair as I leaned over his pillow. We all took turns sitting at his bedside, talking to him and lightly stroking him.

On the ninth day after his stroke, he seemed better. He had an appointment with his physical therapist. I had not moved from the house for nine days, but I decided to dash over to Cammie's and take care of some notes for the Executive Committee of the Red Cross that were waiting for my signature--a task that should take about forty minutes. I propped up Doctor's pillows and put on his glasses and set the newspaper in front of him. He looked at me and blinked, three times. It came to me later that he was fulfilling the farewell he had pledged on our wedding night: "With my last breath I want to touch you."

When I returned John Eagan met me at the door. Doctor had suffered a massive cerebral hemorrhage and we had lost him instantly. Even the therapist who had been lightly massaging him at the time was not aware of his last breath, so peacefully did he go on angels wings.

I answered more than eight hundred letters that poured in after Doctor's funeral. That task took almost a year. After a year and a half alone in that enormous house, I knew I had to move away, find myself again, and start writing.

But my outstanding commitment was to Doctor's manuscript. I spent four years reading from Doctor's "gray files"--every scrap of paper that Doctor had received from Natalie since 1913 and a complete copy of the entire five-year domestic court battle. Then began the real task--to combine his technical history of Technicolor with the complex human story of his two marriages--and who but I could do that?

And so I sit at my desk in a perfect doll's house in a university town full of old eucalyptus trees. It seemed that the Lord Himself guided my steps to this beautiful village, for which I am grateful as I write these last lines in memory of my "Over the Rainbow" boy, Mr. Technicolor, my love.

EPILOGUE

The classic three-color dye transfer process which Technicolor began using with the filming of *Becky Sharp* in 1935, and which was last employed with *The Godfather II* in 1974, represented the pinnacle of Technicolor quality. Newer processes as they developed tended to sacrifice color quality in favor of speed and low light filming capability.

In 1975 Technicolor sold its dye transfer equipment to the Beijing Film and Video Lab in China. For a time, dye transfer continued to be employed at the British Technicolor Labs, but it was discontinued in 1978.

Film companies which retained original dye transfers were able to salvage and reproduce for future film-going generations copies of their films with all of the splendor and brilliant color of the original releases. Sadly, companies who's dye transfers were discarded or who opted for newer, cheaper processes are now faced with the tragic prospect that all available prints of their motion pictures are fading, with little hope of being restored.

As film preservation groups labor to save the heritage of Hollywood's cinematic treasures, it is a lasting and perhaps fitting tribute to Dr. Herbert Kalmus, that the commitment he made to perfection in the development of Technicolor is withstanding the test of time. The three-color process which he developed in 1936 has been unequaled and unsurpassed over a half-century later.